Regent's Park

From Tudor Hunting Ground to the Present

PAUL RABBITTS

AMBERLEY

First published 2013
This edition first published 2014

Amberley Publishing
The Hill, Stroud
Gloucestershire, GL5 4EP

www.amberley-books.com

British Library Cataloguing in Publication Data.
A catalogue record for this book is available from the British Library.

ISBN 978 1 4456 4375 5 (paperback)
ISBN 978 1 4456 3531 6 (ebook)

Typeset in 11pt on 13.5pt Sabon.
Typesetting and Origination by Amberley Publishing.
Printed in the UK.

CONTENTS

Acknowledgements 9
Introduction 11
1 Early Days and Rural Pastures 17
2 Hunting Grounds and the Tudors 21
3 Growth and Expansion 29
4 A Royal Partnership: The Prince Regent and
John Nash 37
5 Regent's Park: A Lesson in the *Picturesque* 65
6 Nash to Nesfield 79
7 The Demand for Parks 149
8 The Twentieth Century: A Park for the People 171
9 Decline and Revival 197
10 The Management of a Twenty-First-Century
Royal Park: The Park Today 221
11 Primrose Hill 241
12 Regent's Park: A Literary Park 251
13 The Nash Legacy: The Liberality of the Genius 263
Notes 269
Bibliography 277
Index 280

To Mum and Dad,
David and Morlene Rabbitts
With love and gratitude

Acknowledgements

I have had so much pleasure in pulling this book together. After initially starting out as a wider book on parks, my fascination with Regent's Park became all encompassing. I have had considerable help, advice and encouragement from so many people during the research and writing of this book. Regent's Park is one of the best-known and most loved Royal Parks and as a consequence, there has been much written about it over the years, including three excellent, now sadly out-of-print studies by former park superintendent A. D. Webster in 1911, Nash historian John Summerson in 1934 and Ann Saunders in 1969. All are very detailed and have been significant sources for this book and are worth finding if you want to know even more about this fantastic landscape. However, what I have tried to do is to compile a complete history of Regent's Park and to search beyond the Nash era and in particular look at the contributions of others, including William Andrews Nesfield and Markham Nesfield, who are sadly often overlooked. I have many to thank. As ever, Stewart Harding and David Lambert of the Parks Agency have

been encouraging. I must also thank Richard Flenley and John Adams from landscape architects Land Use Consultants, Philip Norman of the Garden History Museum, Nick Biddle the Regent's Park Manager, and Nicola Gale at Amberley Publishing, who encouraged me to write this book. Images for this book have been sourced from a variety of locations and acknowledged appropriately. Many are from my own collection and a significant number obtained from the Royal Parks themselves. I would like to thank my many friends and colleagues at Watford Borough Council who have also shown continued interest and encouraged me to keep going. Special thanks to my lovely wife Julie, and my amazing children Ashley, Holly and Ellie, and extra thanks to Julie and Ellie for tolerating my frequent Regent's Park ramblings and for accompanying me on yet another foray into this most magnificent of Royal Parks.

Introduction

London has many parks and gardens and much of the city's character stems from these many open spaces within it. Over centuries, despite threats of enclosure and increasing urbanisation, London has managed to retain, create and develop green spaces, from large swathes of Royal Parkland to small private and enclosed squares, to commons, heaths, botanical gardens, cemeteries and municipal parks. Altogether London can claim to have over 67 square miles of open space, among which are 1,700 spaces that are over an acre in size. A large proportion of these are accessible to the public. Few cities of the world provide as much open space for both nature and people as is found in London.

London today has six Royal Parks in or near its centre, green oases in the middle of the city. Two of these parks are relatively small: St James's Park and Green Park lie at the heart of the British establishment, divided from each other by the Mall and bordered by Whitehall, St James's Palace, Buckingham Palace and Piccadilly. Hyde Park is much larger. A Royal Park from the time of the Reformation, it was opened to the public

by Charles I in 1637 and became the favourite parade of fashionable society. To its west, Kensington Gardens were laid out in the years after 1720.

These parks, added to the much older park around the royal palace of Greenwich dating from 1433, were established before London had begun most of its massive outward growth. The sixth of the inner city's Royal Parks, the Regent's Park, was not created until the early nineteenth century, when the tide of building started to burst London's boundaries.

The Royal Parks are, however, a fascinating dichotomy. They are quite literally living reflections of Britain's rich, vibrant and often stormy history of dramatic social change. Across their combined 5,000-plus acres can be found reminders of the times when Church and Crown eyeballed each other's power with bitter envy and cautious nervousness; of the later years when powerful regal dynasties made decisions based on national security, empirical strength and sometimes just pure whimsy; of the exciting times of enlightenment. Education and exploration of unfamiliar sciences and worlds; of the more recent periods of reform as new social classes began to develop a say in the way in which their country was run; and of current democratic political structures and international trade and communications systems which have turned the world into the global village that it is today. Effects and reflections of hundreds of years of fluctuating fortunes and power struggles abound across the parks via their buildings, designs, aspects and functions.

Yet the Royal Parks, and indeed many of our parks

across the country, have become reminders of all these lavishly lived centuries. While the world frenzies on around them, the function of the parks of London has been to offer a constant refuge from that very strife and toil. Kings and queens, politicians and scientists, working men and women, locals and tourists, all in their time have sought in the parks brief respite from the struggles of the everyday, and many have left something behind – a building, a new tree, a footprint – to mark their time there.

Thus it is that the hideaways of history have, ironically, become mirrors of that very history from which they offered an escape. There's no doubt that escape is what the parks provide. They have always been oases of beauty, stimulation and contemplation within the hurly-burly not just of London life, but of working and personal lives too. Once, kings hunted in them to help them forget briefly about threats from ambitious dukes or impoverished war chests, and thereby take time to relax and refresh themselves for the challenge. Today, accountants, shop assistants and students lunch in them for the same reason – except that vexing dukes are now replaced by difficult colleagues or forthcoming exams, and empty war chests by departmental budgets.

Ask why these parks are so important to people today and you will receive a range of different answers. Many go for the buildings or perhaps the wildlife or floral displays or to attend an event. But every single answer is likely to have one similar sentiment: 'going to the park gives me a chance to get away, to think and be by myself'.[1]

However, once, and only once, has a great plan for London, affecting the development of the capital as a whole, been projected and carried to completion. This was the plan which constituted the 'metropolitan improvements' of the Regency, the plan which embraced the Regent's Park layout in the north, St James's Park in the south, the Regent Street artery connecting the two, the formation of Trafalgar Square and the reconstruction of the west end of the Strand, and the Suffolk Street area; as well as the cutting of Regent's Canal, with its branch and basin to serve Regent's Park. The whole of this immense plan, which gave a 'spine' to London's undeveloped West End and had a far-reaching effect on subsequent northward and southward expansion, was carried out under the presiding genius of John Nash. It was Nash's achievement to seize and combine a number of opportunities which presented themselves with apt promptitude at the beginning of the Regency.[2] Of the six Royal Parks, the Regent's Park perhaps has the most diverse and fascinating history. Indeed, as parks historian David Lambert was recently quoted, 'Regent's Park, that place has got a big history.' From its origins as part of the ancient Middlesex Forest and a hunting park for Henry VIII, established in 1538 as Marylebone Park, to one of the most impressive exercises in town planning in English history and its establishment as the Regent's Park thanks to its principal architect John Nash, it does indeed have 'a big history'.

This book tells the story of the Regent's Park, its origins, its past and how the history of England is so intrinsically aligned to it, to its principal designer and

the Prince Regent himself. But Nash did not achieve his great vision alone. Surveyor John Fordyce, landscape architect William Andrews Nesfield and the architect Decimus Burton all contributed to these 'metropolitan improvements' of the Regency period. It also describes the terrible tragedies that happened within the park and how, in 1946, Nash's legacy could have been lost forever as well as how the development of municipal parks across the country relates so closely to this incredible parks story. It is an unbelievable story.

Early Days and Rural Pastures

Found on the northern slopes of the Thames valley, barely 3 miles west of St Paul's Cathedral, is the parish of St Marylebone, covering over 1,500 acres stretching from Oxford Street at its most southerly end to the Edgware Road at its western side, with its remaining boundaries less well defined. Rising gently to the north are found the heights of Hampstead, Highgate and Harrow.

Geologically, to the north the subsoil is heavy London clay but to the south the clay is covered by a layer of gravel known as the Taplow Terrace. This had a major impact on the landscape at that time and the development that ensued. The northern half was heavily wooded, hard to drain and lacked springs of water close to the surface, while the southern half was covered with light and sporadic vegetation much more easily cleared with primitive tools of the time, was easily drained and was provided with springs of fresh water. It was the southern half of the parish that was therefore much more suited to settlement and cultivation, while the northern half was scarcely habitable until tools were

available to fell trees and clear the land. Originally part of the Great Forest of Middlesex, it is described by William FitzStephen, who in the twelfth century wrote his *Description of the Most Noble City of London* as a region replete with 'wooded glades and lairs of wild beasts, deer both red and fallow, wild bulls and boars'.

The parish is also divided significantly by the Tyburn stream which ran from Hampstead in the north, splitting into two as it headed south, joining the Thames at Westminster and Vauxhall. Both banks of the Tyburn and all the lands eastward formed the manor of Tyburn. It was here that the first village of Tyburn grew up close to where the stream crossed Oxford Street. The village was exceptionally well linked to the capital, with Oxford Street and Watling Street, the main roads from London, heading west and north-west. The village of Tyburn and the manor both belonged to the Abbey of Barking, a house of nuns in Essex founded around AD 666 by St Erkenwald, Bishop of London, for his sister, St Ethelburga, who was the first abbess.[1]

Destroyed by the Danes but re-founded by King Edgar, it was here that William of Normandy stayed soon after the Conquest. Tyburn, though not mentioned by name, was included in the Domesday Book, compiled in 1086, where it is described as belonging to the convent. It also appeared that the Abbess of Barking did not live on the manor and by the middle of the twelfth century the whole manor had been leased to the de Sanford family for an annual rent of 30 shillings, which the convent received until the Dissolution of the Monasteries.[2] The de Sandfords were influential and it was Gilbert de

Sandford's daughter Alice who married Robert de Vere, Earl of Oxford, and inherited the manor when Gilbert died in 1250 and built a manor house with garden some time before 1279.

Over a period of time there were many changes, with the village centre moving northwards from the church to the manor house, and in 1400 a new church was built opposite the manor. The area at the time was subject to many robberies, hence the reason for relocating the church, which 'was in too lonely a place'. It marked, however, the opening up of the lands to the north, as woodland became pasture and arable land. With the moving of the church and its proximity to the Tyburn stream, it was rededicated and given a new name – Marybourne or Marybone – meaning Mary's church by the burn.[3] The manor however passed through a number of owners after Alice de Vere died, with several descendants continuing to assert their claims to the land. But it was the new resident lord of the manor who took up residence before the end of the century who had a major influence on Marylebone, a senior member of Henry VII's new civil service called Thomas Hobson. It was Hobson who was instrumental in the early development of the Marybone estate. He was one of seven auditors of the Exchequer, a trusted senior official, holding positions of influence and financial advantage. He turned one of his many talents to acquiring fine estates for himself, and when they became available he bought up portions of the manor of Marybone.

During the 1490s, Sir Reginald Bray, Chancellor of the Exchequer and Hobson's superior, exchanged

various lands, among them some in Tyburn, with George Neville, heir to the Earl and Countess of Abergavenny, and bought other property in the London area from Thomas Styllington, Bishop of Bath and Wells. He paid Styllington £133 6s 8d and on 4 June 1499 he sold all that was in Marybone to Thomas Hobson for £266 13s 4d, a significant profit. By the time Hobson died in September 1511, he had acquired the greater part of the manor.[4] In his will, Hobson instructed that the manor of Marybone with 'all the messuages, lands, medowes and pasture lying in Marybone, Lilleston, Westbourne, Charyng, and Eye' was to belong to his wife Joan for her lifetime, thereafter passing to their son Richard; she was instructed to 'sell noo woods but that she shall spend reasonably w'out any wast'. If Richard died without a child, then his executors were to sell the manor 'the which hath cost me in purchase and in building a thousand pounds and bistowe the money as shall advise them'.[5]

Hobson was clearly a very important man, if not the most important in the parish, and more than likely the first real lord of the manor that Marylebone had ever had. Sadly, Hobson's son Richard died at the age of twenty-four and left a two-year-old son, Thomas, and young wife. Thomas became the ward of William Hollys and life went on within the village. Thomas eventually became a merchant and left for Brittany.

2

Hunting Grounds and the Tudors

It was however the Dissolution of the Monasteries that changed it all. In 1526 Henry VIII fell in love with Anne Boleyn. Anne's insistence on being queen rather than just the king's mistress, and the unwillingness of Pope Clement VII to sanction the annulment of Henry's marriage to Catherine of Aragon, led to England's break with Rome and to the English Reformation. Henry gained not only his divorce and Anne, but also the entire lands and property of the monasteries. Among the monastic lands was the manor of Tyburn. The Dissolution of the Monasteries lasted four years to 1540. Two thirds of all the land was sold to the laity and the money squandered in vanity wars against France. With the destruction of priceless ecclesiastical treasures it was possibly the greatest act of vandalism in English history. The only church revenue at Tyburn was the 30 shillings a year due to the Abbess of Barking, and Henry appropriated this, but he wanted the land as well.[1] The ageing king was still enjoying hunting, with parks at Hampton and Nonsuch as well as Hyde Park near Whitehall, but desired one other to the north. It

was this that led him to acquire the whole manor of Tyburn and to impark as much of it as possible – the beginning of Marylebone Park. Marylebone suddenly found itself as the gateway to the nearest royal hunting preserve to London and the manor house transformed into a king's resting-place.

The area which the king desired and selected covered 554 acres and was an almost circular shape, with no real reason for it as it was not based on manorial boundaries nor any observable local physical feature. There appears to be no logical reason as to why these boundaries were determined. The whole area was valued at £92 12s 3d a year, of which land worth £70 15s 2d was to be imparked, while the manor house itself and home farm were intended to provide accommodation and fare for the king when he wished to hunt, and for whoever may become keeper of the park. The compensation offered was seen as certainly reasonable and it was unlikely the young Thomas Hobson would have or could have objected. He received in return several houses elsewhere, including substantial properties on the Isle of Wight where he eventually married and settled permanently. Henry's first keeper of Marylebone Park was Sir Anthony Denny, a Privy Councillor and keeper of Westminster Palace. Denny would stay from time to time but it is not known if Henry ever stayed at Tyburn himself. From the outset, the park was certainly well looked after. It was soon surrounded by a ring mound, later topped with fencing, to keep in the deer to be hunted for the king's pleasure, with ponds dug along the Tyburn for their water and lodges for their keepers.

Henry VIII died on 28 January 1547 and it was Denny who warned the monarch of his approaching end and advised him to make his peace with God. Denny was rewarded with a place on Edward VI's council of advisers. Outliving Henry by two years, the manor reverted to the Crown.

The Tudors' impact on Marylebone Park was substantial. Edward inherited Henry's love of hunting and he was responsible for considerable works including trenches 'for the conveying the water into two ponds which yf it had nott ben don wode have byn the dethe of many dere'. The park with its new fencing and ring mound was clearly private property and any poacher or man searching for firewood did so at his peril. Edward was now also entertaining at Marylebone and during 1551, an embassy from Henry II arrived in England with hunting parties 'att Hidde and Marybone pks'.[2] On Edward's death and after Lady Jane Grey's short reign, Mary Tudor succeeded the Crown and granted the lands and manor at Tyburn to Sir Henry Sydney, and ultimately lands which included Marylebone, for his allegiance to her. Marylebone village had also grown by 1554 and had sixty-six households with some 400 inhabitants. The very same year, the very existence of the park was threatened by the queen's policy of economic cutbacks, for the Treasury was empty at Edward's death in spite of all the wealth of the Church that had been poured into it. Mary, who had just been married to Philip of Spain, decided with her Privy Council 'to desolve the Parkes of Maribone and Hyde and having bestowed the dere and pale of the same to their Maiestie's use,

upon a due surveye of the groundes of the saide Parkes so to distribute the parcelles thereof to the inhabitants dwelling thereabouts, as may be mooste to their Highnes' advauncement and commoditie of their loving subiectes'. Nothing ever came of this economy; the survey was never completed and the parks were never sold.[3]

Mary died in 1558 and was succeeded by Elizabeth, who by 1560 had appointed Thomas Savage in the office of keeper of the park. He was the last working keeper of the park and by 1564 he was succeeded by Sir Edward Cary of Berkhamsted, a groom of the Privy Chamber and Master of the Jewel Office. The keepership remained with Sir Edward's family through four generations.[4] During this time, the park was extremely well maintained, with an immense amount of work carried out. Bridges and fences were repaired, lodges maintained and the river 'neatened', with new hedges planted. However, the land around the park was dangerous too, with frequent robberies and bodies found in fields to the west of the park.

Elizabeth made great use of the park and was a frequent visitor, entertaining many visitors including Russian ambassadors and the Duke of Anjou, spending the night at the manor house. On her death in 1603, she was succeeded by James I, who was also a keen huntsman, and the park continued to flourish. Despite the nearby dangers, many of the landowners around the park were men of substance and great importance. To the north, St John's Wood was also Crown land and was let to Sir William Wade, Governor of the Tower of London, and to the south Edward Forsett had a

thirty-year lease of Tyburn. Forsett had been a Fellow of Trinity College, Cambridge and held a post in the Office of Works and was MP for Wells from 1606 to 1611. He eventually settled in Marylebone, living in the manor house, and became a Justice of the Peace in 1612. On the death of James I in 1625, Charles I succeeded to the throne as the country became embroiled in one of the most traumatic periods in its history. Charles as a result had little time for hunting, let alone his parks. By 1642, civil war had become a reality, and the citizens of London had turned out to dig trenches and throw up earthworks in Hyde Park against attack from the king's forces which were at Oxford. Marylebone Park was untouched until the following year due to a bitter winter and the need for fuel after the 'House of Commons ordered to be cut down the underwood within 60 miles of London in the King's and Queen's parks, and those belonging to any bishops, prebends, deans or chapters; a select committee being appointed to distribute it among the poor'.[5]

By 1645, Charles was desperately short of funds and was looking at ways he could raise and use any royal possession that could be used as security. In May, Marylebone Park was pledged to Sir George Strode and John Wandesford, the Royalist Ordnance Commissioners, in return for supplies of gunpowder. Both were committed supporters of the king but paid dearly for their loyalty. All of Strode's fortune in stock was confiscated by Parliament. He died somewhere abroad, having lost his wife in 1645. Likewise Wandesford left the country in 1646, returning in 1649, and managed to

retain some of his estate. However, neither was in any position to reclaim Marylebone Park. The same year, Charles was executed and Cromwell succeeded. Within days of his death, an Act was passed legalising the sale of all his lands. Cromwell was desperate for funds and immediately set up a committee under Colonel William Webb to compile and survey all the estates held by the king. The works were completed within less than a year. The reports completed were mixed but some were clear and certainly competent. The area was given as 534 acres and in it were 124 deer with 16,297 trees of mainly oak, ash, elm, white-thorn and maple, 2,805 of which were reserved for the Navy. The sale of the Crown lands was by sealed tender, the highest bid being accepted and the money paid in two equal instalments. It was the beginning of the end for Marylebone Park. Cromwell sold it to 'John Spencer of London, gent', the proceeds were settled on Colonel Thomas Harrison's regiment of dragoons for their pay. The existing ranger, John Carey, was turned out, and Sir John Ipsley put in his place. The price given for Marylebone Park was £13,215 6s 8d, which included £130 for deer and £1,774 for timber, exclusive of the trees which were marked for the Royal Navy. Cromwell probably knew the park very well, as some years before his uncle had permission to hunt in any of the royal forests. The warrant is dated 15 June 1604, 'to the lieutenants, wardens, and keepers of the forests, chases, and parks, to permit Sir Oliver Cromwell, Knt, Gentleman of the Privy Chamber, to hunt where he shall think fit'.

The destruction of the park began almost at once. In

October, 1649, the Navy Commissioner was instructed to 'repair the crane at Whitehall for boating timber, which is to go from Marylebone Park to the yards to build frigates'. The purchasers of the park also began to cut down trees, as they knew that such contracts might be declared null and void if the monarchy were to be restored, and they were keen to recover their outlay with a good profit on it as soon as they could. Cromwell converted the park to other uses, as in June the same year, orders were given to put to grass in Marylebone Park all the artillery horses 'bought by Captain Tomlins for Ireland till Monday week'.[6] By the time Charles II returned to the throne in 1660, few of the 16,297 trees which were flourishing in Marylebone Park fifteen years earlier remained. Much of the park had been ploughed up and was now turned over to dairy farming. At the Restoration the former tenants were reinstated until the debt was discharged, and John Carey was compensated for his loss of keepership; but the park was never re-stocked with deer. By 1664, Sir Henry Bennett, later Lord Arlington, who had served Charles II while in exile, petitioned the king for a lease of the park. Charles granted his request and the park tenants were ordered to pay their rents to the Crown for the time being. Nicholas Strode and William Wandesford, however, were still pursuing compensation. By 1666, it was likely that it was settled out of court and Arlington was granted a lease up until 1728, with the estate declared as disparked and disfranchised. It was no longer recognised as a park, but as farmland. Arlington was incredibly influential in royal circles but by 1674,

his place at court was taken by Sir Thomas Osborne, later Earl of Danby, and in 1678 a lease on many of the royal manors and woodlands was made out to Charles Osbourne and John Knight.[7] Danby progressed through the peerage, eventually becoming Duke of Leeds, and in 1695 all the lands that had been leased to Osbourne and Knight were put in trust for him for thirty-one years from the death of Queen Catherine, now a widow and living in Portugal. She did not die until 1705, and the duke lived until 1712, so the park was in the hand of the trustees until 1736. It had now slipped from the royal hands that had created it to more working-class keeping; the new owners set to work to see what could be made from such valuable farmland so near to the ever growing and expanding capital.[8]

3

Growth and Expansion

Between the early sixteenth and early eighteenth centuries, London evolved from a compact, coherent city into a sprawling and heterogeneous metropolis, the largest in Europe. Its population grew from around 80,000 inhabitants in the mid-sixteenth century to well over 500,000 by the end of the seventeenth. By 1700 it contained nearly 10 per cent of England's population and much more than 10 per cent of the nation's wealth. London exercised an enormous influence in national politics and in the country's economic development, as it became the capital of a centralising and increasingly powerful government and the *entrepôt* of a new global trade network. It was a social and cultural capital too, a redistribution centre for material and cultural goods, and for a mobile population marked by the practices of the metropolis. Immigration, urbanisation, and commercialisation fostered new patterns of sociability, gender relations, employment, and consumption.

London's rapid population growth was largely due to migration, since the capital's unhealthy environment

reduced or stalled natural population increase. Migrants came mostly from the English provinces, and from Wales, Scotland and Ireland; substantial numbers also came from embattled Protestant communities in France and the Low Countries. A significant Jewish community developed after 1650, and people of African, Asian and occasionally American origin were also to be found in London. As London grew and spread in the sixteenth and seventeenth centuries, it became more clearly differentiated from area to area. While social and economic values had always varied from centre to periphery, a wider range of topographical variation developed, both in the kind and quality of housing and in the people who inhabited it.

With the constant changing of hands of what was left of Marylebone Park for political reward, the city continued to grow as did the village of Marylebone. Buildings continued to be developed along the Thames until London and Westminster became one. Growth was also accelerated by the Great Fire and new exclusive and aristocratic quarters were growing, including Mayfair. Eighty-four households were present in 1684 and the Forsetts were still living in the manor house. Built in 1659 behind the manor house, Marylebone Gardens, with a bowling green and refreshment rooms, were very popular. Pepys was there on 7 May 1668 and wrote in his diary, 'Then we abroad to Marrowbone and there walked in the garden; the first time I ever was there and a pretty place it is, and here we eat and drank, and stayed till nine at night, and so home by moonlight.' By 1708, the manor and estate were sold after the death

of Squire Robert Forsett and ultimately passed to the Duke of Newcastle whose daughter and husband the Earl of Oxford and Mortimer decided to develop it as a residential estate. They were keen to emulate estates built nearby by Lord Scarborough and Lord Grosvenor. The first houses went up in Cavendish Square in 1720 and from that point onwards, fields disappeared as clay was extracted for bricks and mortar.

The 1745 map of London and surrounds produced by John Rocque gives an indication of the surroundings as buildings were spreading northwards towards it from Oxford Street. The fence that once enclosed the park had gone and hay and dairy farming dominated the landscape and along with St John's Wood, were supplying the capital with dairy produce from farms such as Marylebone Park Farm, White House Farm and Coneyburrow Farm. At the turn of the century, the Marylebone area was still important for providing London with its hay and dairy produce. Leases were continually renewed until 1789, when the last lease was sold at auction to the Duke of Portland, who now controlled all the old manor of Tyburn from Oxford Street northwards to Barrow Hill, from the High Street and the park boundary eastwards to Clipstone Street and St Pancras.

London was still growing and expanding rapidly. In 1750, the population was now estimated at 676,750 and the first census of 1801 estimated it at 900,000. Houses crowded along the New Road, which was laid out in 1757 across the fields from Islington to Paddington, as London's first bypass. The road had acted as a barrier to

northern development but it was only a matter of time before this became subsumed and the city continued in its ever growing expansion northwards towards the park. The Duke of Portland appointed surveyor John White, who could see what immense possibilities there were in relation to future development opportunities. By this time, the problem of spiritual provision for the inhabitants of Marylebone had become problematic as the church was in a shabby state and the burial ground was full. The duke offered Barrow Hill for the latter, in 1793, in return for permission to drive a diagonal road to it across the park. His request was referred to the Treasury to the Surveyor General, but that very year a new appointment had been made. His name was John Fordyce, a man whose influence on the history of Regent's Park would be second only to its eventual architect John Nash himself. Fordyce re-measured the ground for which the duke had asked and found that it covered nearly 6 acres instead of 2 acres. He very quickly realised that the duke's proposed road would cut diagonally across the park, thereby blocking the natural line of development of all the streets south. The link between the two halves of the duke's estate would effectively control all future Crown development.

Fordyce, Surveyor of Woods and Forests, and Surveyor General of Land and Revenues from 1793, was a businesslike Scot intent on improving the efficiency of the Crown Estate. The Civil List now guaranteed an income for new monarchs on their succession and was no longer dependent on income from the Crown Estate. The disposition and use of royal land was therefore

now fully in the hands of the Treasury. Many reports produced by the Treasury established that the estates had been poorly administered. These reports, many by Fordyce himself, set them on a new footing. Fordyce, along with the Duke of Portland, realised the value of Marylebone Park. Fordyce therefore opposed the duke's plans, explaining to the Treasury that a burial road cut almost at random across the park could only lower the future value of the land; he advised that a general plan should be made for the improvement of the whole estate. Fordyce saw the need to offer incentives to development inside a clearly set-out plan, with ornamental water and a canal, together with markets to serve the inhabitants. Fordyce took into account the scale of the project and the need to find interim uses for the building ground. He recommended adherence to an approved masterplan and suggested that houses 'would be raised, first, as Country Houses (in detached situations), and afterwards would become, by the extension of the Buildings, Town Houses, and the Plan would at the same time be completely adhered to, and every House would be placed according to the original design'.

In 1794 he therefore announced a competition, with a prize of £1,000, circulated to all leading architects, for the best plan for developing the park. No submissions were received and it was perhaps not surprising as there was no provision to reward the work of anyone other than the winner.[1] Only one – John White, surveyor for the Duke of Portland – showed any real interest in the matter, and as he lived in the park and did not wish it to lose its pleasant rural character when the existing leases

fell in, he did not produce and enter for the competition the kind of plan, replete with streets and squares, that Fordyce had expected. Instead, White proposed that a roughly circular ring of villas, each standing in its own grounds, should be built on the perimeter of the park, the centre being kept as a pastoral pleasure ground, complete with a Serpentine Lake. Where the park neared the New Road, at its southernmost end, White proposed that a splendid crescent should be erected. White trusted 'that every object suggested by you in your printed report, may be fully accomplished' by these plans. Many of these ideas were borrowed as part of later designs although White was never acknowledged.[2]

The survey that Fordyce commissioned was incredibly detailed and gave the most detailed account of what Marylebone Park was like at the turn of the century before the beginning of the nineteenth century – open farmland with a few buildings, many of them very ordinary, a rural landscape that was soon to be replaced by one of the most successful ventures in town planning ever to be undertaken and completed in London.

Until towns had grown considerably there was little or no physical need to set aside open space specifically for recreation. The existing open spaces of the town square, the market place and churchyards remained from medieval times, and most towns were still small enough for adjacent spaces such as commons and wasteland to be accessible. In the mid-eighteenth century approximately one person in five lived in a town of any size and the population of England and Wales was of the order of 6 million. By the beginning of the nineteenth century

London was by far the largest city, with a population of over 1 million, and other urban centres were growing rapidly. Manchester, Liverpool, Birmingham and Bristol all had, by 1801, populations of over 60,000. Fifty years later the figures for Manchester and Liverpool had reached nearly 400,000, Birmingham was well over 200,000. By 1911, over 80 per cent of the population were living in towns. With the population expansion, the growth of the urban centres and the enclosure of commons, open space for recreation became less accessible.[3]

The pressure for public access to Royal Parks was partly a reflection of the fact that London was gradually growing up around them. The pattern had been forming since the Restoration when the aristocratic quarter of Mayfair, and parts of Westminster, Kensington and Marylebone began to develop around the perimeters of St James's Park, Green Park, Hyde Park, Kensington Gardens and Marylebone Park. Similarly, the villages of Richmond and Greenwich grew up around their respective parks. Such proximity was not always welcomed by the monarch who resided within. Marylebone Park had not been built but some of its acres became Marylebone Gardens, which were commercial pleasure gardens similar to Vauxhall Gardens and those at Ranelagh. The rest remained as countryside but was soon to change. The area of Cavendish Square and Portland Place grew around its grassy fields in the eighteenth century. So strong now was the desire to live near a park, away from the increasingly smoke-laden air of the city, that Nash was to use it as an argument for the economic viability of his future scheme for Regent's Park.

The existing Royal Parks for the most part remained walled until well into the nineteenth century, when public pressure, led by J. C. Loudon, was sufficient to bring about their gradual replacement by railings. St James's Park was shut every night at ten, though the numbers of counterfeit keys defeated all efforts to keep people out and it had a notorious reputation after nightfall. Railings replaced the walls of Hyde Park in 1828 and were put up along Rotten Row in 1837, reflecting a more open society and increasing appropriation of the parks by the public. Nonetheless, even by 1868, when the last wall went down, the concept of public access was still relative. By no means was everybody covered by the term 'Public': entry fees as well as selective opening hours were still used to filter out the lower echelons of society. Access to Kensington Gardens had increased once the Court was no longer based there. The gardens were opened at weekends when King George II and Queen Caroline were absent. In 1733 it was described as 'that retreat (blest with the summer Court), Where Citizens on Sunday Nights resort'. Even so it was only open in spring and summer at that period, and then to a restricted public, covered by strict rules of dress designed once again to preclude the lower orders. Restrictions on entry to the gardens remained even after they were opened daily during the reign of George III, who had ceased altogether to live in Kensington Palace.[4] But the pressure for public access to parks was to remain, and as London expanded not only was access required to existing parks, but a need for further open spaces was growing.

A Royal Partnership: The Prince Regent and John Nash

The creation of the Regent's Park was the work of three men – a civil servant, John Fordyce, an architect, John Nash, and the Prince Regent, later George IV. Fordyce was born in 1735 in North Berwickshire. He was no ordinary civil servant nor was he dependent on any man, but a landed proprietor in his own right, connected by marriage with one of the greatest landowners in the whole country. He was a man of incredible vision and energy, able to express himself clearly and ready to tend the Crown estates as well as he cared for his own land back in North Berwickshire. The reports he prepared were detailed and concise and it was his last one that had the greatest impact. It proposed that the estates should be retained by the Crown and controlled by a board of commissioners under Treasury supervision. The government agreed but as an interim measure, in 1793, entrusted matters to a new Surveyor General, who was none other than Fordyce himself. At the same time, an Act was passed authorising the granting of ninety-nine-year building leases, a measure that was to have an important effect fifteen years later.[1]

Fordyce had since refused permission for the Duke of Portland's turnpike road and had commissioned the most detailed survey of Marylebone Park and the first competition to find the best plan for its development. In April 1809 Fordyce published his fourth triennial report, in which he stated, 'Distance is best computed by time; and if means could be found to lessen the time going from Marybone to the Houses of Parliament, the value of the ground for building would be thereby proportionately increased. The best, and probably upon the whole, the most advantageous way of doing that, would be by opening a great street from Charing-Cross towards a central part of Marylebone Park.'

Fordyce had realised that the main barrier to sustainable development of the estate was its remoteness from Westminster and the streets lying between it and the Court, the Houses of Parliament and the Law Courts. He recommended that this new street should not be less than 70 feet wide, noted that several buildings would need to be demolished, and offered a reward of £200 for the best suggested line for the street. It was Fordyce who advised on aspects like water supply, sewage disposal, formation of local markets and the laying of a grand drive around the park, and the building

of some great Public Edifice, in which, as has often been proposed, statues or monuments may be placed in honour of persons who have distinguished themselves in the service of the Country ... and as no reason can exist against its being a place of Public Worship, it may serve as one, and probably the most splendid of the Churches

... It is to be hoped from the known talents of some of
the persons who have agreed to give their attentions to
this great National object, that this opportunity will not
be lost, and that something will be produced that will do
credit not only to themselves but to the Country.

Despite being in the middle of the Napoleonic wars,
Fordyce was keen to see his vision become reality. He
was probably acutely aware of whom the scheme would
be entrusted to, but sadly died in July 1809 and it was left
to others to give reality to his dream of an improved and
expanded capital that was also a national adornment.
In October 1810, a few months after Fordyce's death,
his ideas formed the basis of a set of draft instructions
prepared by the newly amalgamated departments of
Woods and Forests, and Land Revenues. The guidelines
were sent out to the respective departmental architects:
Leverton and Chawner for the Land Revenue Office and
Nash and Morgan for the Office of Woods and Forests.
Both teams were asked to consider Edinburgh and Bath
as models; accordingly, both produced schemes which
contained only hints of what was known as *picturesque*
planning. The guidelines produced contained twelve
instructions. Instruction number one requested 'the
most advantageous ... a method in which that valuable
property can be let out ... so as to produce the greatest
present yearly Increase of Rent to the Crown ... and
the largest increase of permanent value'. Instruction
number two suggested the maximisation of the site's
natural advantages if 'The Town' is to be extended,
for example the fall of the land from north to south

and brick-making soils and water supply from higher ground – and requested a detailed plan. Numbers three and four recall Fordyce's new street linking the estate to Charing Cross and extending through the park, as well as requesting plans, estimates and means of finance for such proposals. Numbers five and six request the study of adjacent estate developments and those of the cities of Edinburgh and Bath. Instruction seven advises co-operation with immediate neighbours Lord Southampton and Lord Portman. Number eight expands on Fordyce's country houses 'in detached situations' to cover the building ground by suggesting allotments of 5–10 acres 'for the purpose of forming Villas for such Individuals as might be disposed to undertake them, but upon such conditions, however, as to be resumable as opportunities might occur of extending the projected streets etc. over the whole or part of that portion of the Estate'. Number nine suggests planting of commercial oak timber across the northern land less suitable for such 'Villas' to shelter and frame development further south, and starts to design the layout of the park in that context. Number ten states, 'You will, in forming your Opinion, give particular attention to the suggestions of the late Mr Fordyce, on the subject of his reference, in his correspondence with the Treasury, and Reports to Parliament, with their Appendixes, copies of which will be sent you herewith.' Number eleven refers to Nash and Morgan, to whom the same instructions were to be delivered. Finally, instruction twelve refers to the architects' eligibility for the reward of £1,000 unclaimed from Fordyce's earlier competition, to which

there were no subscribers. Additional instructions were given with attention being drawn to a 'capacious well' on Primrose Hill for water supply, as well as a request that plans should provide for the diversion of the Duke of Portland's existing right of way across the park; that provision within the plans should take into account for a 27-acre site for a new barracks; plans and reports to be submitted by 5 March 1811 and to include 'an estimate and report [required for] making immediately a Coach and Horse Road, with a raised foot-path by the side of it, quite round the Estate'.

Leverton and Chawner began with the kind of reticulated layout familiar from London's Georgian estates – Bedford, Portland, Southampton, Portman – and then combined it with a crescent and peripheral highway as envisaged by White. They also proposed to link Marylebone to Westminster by means of a route somewhat to the east of what was to become Regent Street. It was considered a good scheme but it fell short as regards two features upon which Fordyce and his successors had clearly set their minds – civic dignity and public amenity. It was not a park.[2] It was to the designs of John Nash that they would eventually turn.

When John Nash was born, Wrotham Park in Middlesex had just been completed by Isaac Ware, an architect who, in this instance, had provided the Palladian ideal combined with rococo elements. These elements represented a growing desire to escape from the rigid discipline of the Orders; it was the end of the purists' Palladianism. By the time Nash was in his early twenties, a house of a very different nature

was rising in Herefordshire and although the dying Palladianism of Wrotham would influence his work from time to time, it was Downton Castle that proved to be the constant ancestor of all his schemes. It looked like a medieval castle, but contained classical rooms of much elegance; its *picturesque* silhouette belied its sophisticated interior. The plan was unrestricted by four walls and the exterior could be manipulated at will to enclose any number of rooms of all shapes and sizes. Once Nash grasped this principle of free planning he was never to abandon it and even his eventual London works were extensions of this principle; they were convenient shells inside which were concealed anything from an hotel to a terrace of houses, a bank to a retail store, and combinations of many other metropolitan amenities.

When he got into his stride, although he would tackle almost any challenge, Nash had two main things to offer: country houses and townscapes, both rooted in the same romantic idiom. The basic country house formula contained four common ingredients: a round tower, a long entrance-hall gallery, a spectacular staircase and a loggia or conservatory. These features were sometimes used without success, sometimes with brilliance and represent a development from neoclassical planning. The townscape formula offered blocks of residential or commercial premises disguised as classical palaces and so disposed as to produce scenes of great variety. As Nash's career progressed the country houses gave way to the townscapes and it is on these that his fame, if not his reputation as an architect, rests. Because of his lack

of respect for careful detail Nash may have considered himself fortunate to have been born at a time of social change when the parvenus were more concerned with overall effect than scholarly detail when the revolt against strict Palladianism and neoclassicism was being waged by the leaders of architectural taste. Although his training was classical he became the champion of this revolt through the doctrine of the *picturesque*; a sketchy form of this doctrine suited him very well and he made it his own. He never really understood the Orders or, if he did, he rarely applied them correctly and his critics were therefore largely drawn from the ranks of the precise classicists. Gothic he understood even less and yet, paradoxically, he combined it with classical elements in houses of immense charm; and it is partly because these houses are not 'correct' that they are so attractive. They possess all the originality, spontaneity and wit that the later 'authentic' Gothic revival houses lacked.

Sadly most of Nash's career spanned two financial calamities, one when he was a young and inexperienced speculator in London and the other at his death in the Isle of Wight. His work can be traced and appraised, but the story of his personal life is made threadbare by certain so far impenetrable mysteries. The little we do know of his character is consistent and presents a picture of a talented adventurer of relentless drive and determination; but there is little known of these basic mysteries, the solution of which would reveal his true nature and explain the circumstances of several extraordinary turns of fortune. In the early days of his

career his commissions were scattered far and wide across England, Wales and Ireland until the later burden of his London schemes claimed most of his energies.

He was described as a strange and unusual man. His appearance was best described in his own words: a 'thick, squat, dwarf figure, with round head, snub nose and little eyes'.[3] He was born in 1752, trained as an architect under Sir Robert Taylor, inherited a legacy from an uncle, set up on his own, went bankrupt and retired to Wales to recuperate. Despite his financial troubles, he was an architect of genius and flair, and as we know, with little patience for rules and regulations. He was also a shrewd businessman and a risk taker, a man of persuasion, intrigue and an excellent manager of men. In 1806 Nash was appointed as architect to the Chief Commissioner of Woods and Forests. This was a Treasury appointment and the salary of only £200 per annum was also to cover the services of an assistant, James Morgan. How his appointment came about is not known, but the Chief Commissioner, Lord Robert Spencer, was one of the Fox-Sheridan coterie with whom the Prince Regent associated and Nash's Whig leanings may have brought him into this company at an early stage. More important was that Nash was in the right place at the right time. His greatest opportunity and achievement was to be the creation of the Regent's Park and the resulting metropolitan improvements. Though he was nearly sixty when the work began and over seventy before it was completed, Nash would be more than equal to the undertaking. He had spent his maturity in designing country houses, chiefly while in

Wales, and had a friendly relationship with a group of landowners there which included Richard Payne Knight and Sir Uvedale Price. It was these two gentlemen who had evolved the theory of the *picturesque* and had applied it to the buildings on their own estates. They believed in the supremacy of the natural, the romantic and the *picturesque* over all the other types of beauty, and they believed that buildings should be related to the landscape in which they stood. The greatest exponent of their theories was landscape gardener Humphrey Repton, who endeavoured not to regulate nature, but to release the latent possibilities in the grounds of the country estates where he was employed. Repton and Nash worked in partnership between 1795 and 1802, and from him Nash learnt a great deal and was more than likely introduced to the Prince by Repton himself.

It was at the beginning of the nineteenth century that two systems of planting vied for supremacy in the arrangement of 'ornamental shrubbery': the mixed or mingled manner, a system of alternating single species in parallel rows, and the grouped manner, a system of 'massing' plants. The former was still prevalent – Loudon refers to it as the 'common' method in 1822 – having held sway from the mid-eighteenth century when an array of writers lauded the merits of alternating species that varied in colour, texture and flowering-time. Its definitive attribute was regularity, imparted by effecting an even distribution of evergreens and deciduous shrubs, and the palette of colours within a quincunx pattern. The contrast between the stiff appearance of the mixed shrubbery and the irregularity

of the *picturesque* variant of the grouped method, as later adopted in public parks, is jarring and would indeed seem strange to the modern observer. The grouped manner is mentioned as early as 1772 by William Chambers and then Loudon. It is Loudon who provides the best contemporary description of the system.

The Select of Grouped manner of planting is analogous to the select manner of planting a flower-garden. Here one genus, species, or even variety, is planted by itself in considerable numbers, so as to produce a powerful effect. Thus the pine tribe, as trees, may be alone planted in one part shrubbery, and holly, in its numerous varieties, as shrubs. After an extent of several yards, or hundred yards, have been occupied with these two genera, a third and fourth, say the evergreen fir tribe and yew, may succeed, being gradually blended with them, and so on. A similar grouping is observed in the herbaceous plants inserted in the front of the plantation; and the arrangement of the whole, as to height, is the same as in the mingled shrubbery.

By the Regency era the grouped manner was gaining in adherents, praised as a solution to the problem of displaying the increasing number of exotic plant species that were becoming available. Grouping reduced variety, avoiding the danger that the use of too many plants in one area would cause confusion, and, as Sir Henry Steuart expressed it, 'puzzle the spectator'. This concern for reconciling the disproportionate abundance

of plant material with harmony of composition became more evident as the century progressed. Repton wrote that 'all variety is destroyed by the excess of variety'. Loudon went on to criticise and censure the 'meaningless dotting' of specimen plants in Regent's Park. 'The method of mixing all kinds of shrubs indiscriminately prevails too much in modern shrubberies. Much more distinctiveness may be given by judiciously grouping them, than by following the common methods of planting.' Nash embraced this theory wholeheartedly and the first record of the use of the grouped manner in public parks was found in the writings of Prince Pückler Muskau. Visiting England in 1826, he documents John Nash's experiments with planting dense masses of shrubs in the new Regent's Park and St James's Park. By the onset of the early phase of the park movement in the 1840s, the grouped manner is being reaffirmed by the gardening press as the leading principle in the development of park scenery.

The Regency period established the *picturesque* variant of the grouped manner of planting a shrubbery as a legitimate force in the organisation of the garden. Termed *Sylva florifera* by Henry Phillips in *Sylva florifera: The Shrubbery Historically and Botanically Treated* (London, 1823), his book of instruction on the subject, the 'natural and graceful style' of shrubbery planting drew inspiration from the Revd William Gilpin's analysis of planting in the New Forest, especially the 'lawndes' which were browsed by deer into a fine turf and 'adorned with islands or peninsulas' of thorns, holly, and gorse. Gilpin's friend William

Mason may have shown the way forward at Nuneham Park, Oxfordshire, in the 1770s when he enclosed the flower garden from the landscape park with shrubbery and arranged kidney-shaped beds and other irregular shapes on the lawn. However, irregular beds were being used even before Nuneham, most notably in Robert Greening's 1752 proposal for the shrubberies at Wimpole Hall, Cambridgeshire, and in Thomas Wright's 1760 scheme for Netheravon, Wiltshire. From these transitional schemes came Nash's inspiration for the naturalistic planting campaigns of the 1810s and 1820s at Regent's Park, St James's Park, Buckingham Palace and the Royal Pavilion Grounds, Brighton. His eventual remodelling of St James's Park in 1828 perhaps best exemplified the new formula, supplanting the straight avenues with shrubberies whose ground outlines mirrored the recesses and promontories described by Gilpin for the forest lawn. Paxton's broccoli-shaped beds at Birkenhead Park (1843) demonstrated a similar predisposition towards the forest lawn aesthetic, confirming, with the aid of his later works (Crystal Palace Park, 1854; People's Park, Halifax, 1857; Baxter Park, Dundee, 1863) and those of his trainees – Kemp, John Gibson, Milner – the *picturesque* shrubbery as a leading influence in the ultimate formation of the Victorian park.

Throughout the Regency period, the Prince was immensely interested in architecture and was always planning, building and altering many of his residences, from Carlton House to the Pavilion at Brighton where Nash worked for him to Windsor Castle and ultimately

Buckingham Palace. The sudden death of James Wyatt in a road crash in September 1813 ultimately brought Nash closer to the Prince. Wyatt had been Surveyor General in the Office of Works, and a very negligent one too. At his death the responsibilities of that office were therefore divided. In effect, Nash received the royal palaces and in effect now had the complete confidence of the Prince Regent, as well as a double position in Woods and Works. Even though Nash had arrived late on the scene, he had now inherited a financial strategy for exploiting the Crown Estate. With that strategy came a major programme of urban renewal and road building. It was his job to give both strategy and programme architectural form. By the time he began work, in 1811, there was a body of thinking on the subject dating back thirty years.[4] His arrival on the scene, despite being late, is obscure. Nash's marriage, at the age of forty-six, to an ambitious young woman who was supposed to have engaged in dangerous liaisons at Carlton House, is still surrounded by mystery. There is still a tradition that Nash was in a certain respect unsuited to marriage and was merely the official husband of this girl, who subsequently appeared before the world with a considerable family of children incubated in a remote hinterland of the Isle of Wight, bearing the name of Pennethorne and of whom she was supposed to be a remote relation acting *in loco parentis*. The whole story, according to Summerson in 1945, bristles with scandal, and there is evidence that, for some reason or other, Nash and his wife participated in an elaborate social fake, presumably in collusion with

the Prince; there is not enough evidence, on the other hand, to assert definitely either that Mrs Nash was the Prince's mistress or that the Pennethornes were her children by the Prince.

However, the unimaginable opportunity offered by the development of Marylebone Park aroused both the Prince's imagination and Nash's architectural and financial interest. It was a once-in-a-lifetime opportunity for both the Prince Regent and his architect. The chance was there, not only to develop the new estate but to reorganise and redesign all the west of London with a new street that could be made into a royal mile, a processional highway rivalling the arcaded Rue de Rivoli that Napoleon was creating in Paris. 'Once and only once, has a great plan for London, affecting the capital as a whole, been projected and carried to completion.'[5] That the Prince Regent and his architect should eventually think in Parisian terms was quite understandable. Nash was in Paris in 1814, 1815 and 1818. However, when it came to planning Regent's Park, Nash would fall back on one very useful element in *picturesque* theory: surprise. Fordyce's foresight had preserved the park for planned development; now the Prince's influence put Nash in a position where he could exercise his genius.

The design submitted by Leverton and Chawner was uninspiring. They were proposing an extension of the gridiron of streets that covered the Portland estate, with a church in the middle, a barracks to the west, some large villas with private grounds to the north, markets on the east and the whole encircled by a broad drive.

They ignored the need for a new street and suggested that Harley Street should be the main link road to the park. It was dull as well as being deemed unprofitable. Nash's plan was very different. Even without such royal influence behind him, Nash's scheme was infinitely better than Leverton and Chawner's. His accompanying report was long and exciting, descriptive and full of promise. This included a large income – £59,429 for an outlay of £12,115 with a capital valuation of £187,724 when the ninety-nine-year leaseholds terminated. Nash was no fool, noting that the best parts of London were those near to the parks – Hyde Park, St James's Park and Green Park. He stated the principles behind his plan

> that Mary-le-bone shall be made to contribute to the healthfulness, beauty, and advantage, of that quarter of the Metropolis: that the Houses and Buildings to be erected shall be of that useful description, and permanent construction, and shall possess such local advantages, as shall be likely to assure a great augmentation of Revenue to the Crown at the expiration of the Leases; that the attraction of open Space, free air and the scenery of Nature, with the means and invitation of exercise on horseback, on foot and in Carriages, shall be preserved or created in Mary-le-bone Park, as allurements or motives for the wealthy part of the Public to establish themselves there: and that the advantages which the circumstances of the situation itself present shall be improved and advanced; and that markets, and conveniences essential to the comforts of Life shall be

placed in situations, and under such circumstances, as
may induce Tradesmen to settle there.

Nash's report and plans were submitted in July 1811.
At the beginning of his report, Nash rehearsed the
commissioner's 'Instructions', noting the particular
attention to be paid to Fordyce's work, and described
the relationship between the park and neighbouring
estates. The 'Lines of Communication' connecting the
park with 'The Town' were to be 'Portland place ... the
most magnificent street in London', and 'Devonshire
place and Baker street, – next in rank'. In this way
the Crown would have 'the power of preserving the
best built part of the Town ... and of establishing
beautiful termination to that, elevated and conspicuous
Boundary of the Metropolis'. The commissioners
recommended Nash's design to the Treasury. They
were not to be deceived and although they praised the
design, Spencer Perceval, Chancellor of the Exchequer
and Prime Minister, summoned him to Downing Street
early in August 1811 and told him firmly to reduce
the housing density: amenity was just as important as
profit. What Perceval demanded was another plan 'with
fewer buildings and a greater extent of open ground
... [since the Treasury, as he put it] cannot approve
of appropriating as much [land] to building'.[6] Nash
was not sparing with his architecture. He produced
panoramas showing the design in its earliest stage.
There are streets leading to the circus in the centre
of the park and all around are squares with public
buildings. Villas, many of them more like temples than

houses, are scattered in every direction, and the scene has a *picturesque* unity very different from the park of the twenty-first century. Nash was unwilling, at first, to change his design. He had a definite texture of trees and houses in mind and he felt that a frequency of buildings was necessary to provide the sense of security needed on the outskirts of the town. His plan is described in detail by John Summerson. Nash's report was masterly and tinged with such enthusiasm and optimism. He had a knack of seeming to understand the circumstances so perfectly that nothing could prevent the consummation of his plans once they were set going. His ability for analysing a problem in town planning was, in any case, extraordinary. The allurements of Marylebone Park are deftly proposed in the next part of his report, which describes how nearness of trees and open air is desired among town dwellers and how people are content to live expensively in narrow streets or along dusty roads on the borders of the town for the sake of the country scene just around the corner. Nash intended that Marylebone should have all the amenities and none of the drawbacks attending such considerations, and urges the principle 'that the attraction of open space, free air, and the scenery of Nature, with the means and invitation of exercise on horseback, on foot, and in Carriages, shall be preserved or created in Mary-le-bone Park, as allurements and motives for the wealthy part of the Public to establish themselves there'.[7] Nash is very descriptive of his park. The main approach is from Portland Place, through a large circus on the new road, linking the old fashionable area with

the new, the shape of the circus being calculated 'to prevent the impression of having crossed the New Road'. In the middle of the park, on the summit of the rising ground, is another circus, of the same internal diameter, but with houses looking outwards as well as inwards and a ha-ha all round. These circuses provide sites for the two public buildings proposed in Fordyce's memorandum. The church is to stand in the centre of the circus on the new road, the *Valhalla* in the double circus in the park, forming 'the grandest apex possible to the whole Scenery'. An artificial lake, equal in size to the Serpentine, embraces the centre of the park with 'curly tentacles'. To the east, in contrast, lies a rigid strip of water, running north and south, with a fountain at its centre and a large house halfway down the west side. This, though it is not labelled on the original plan, was the Prince Regent's *guingette* or pleasure pavilion. The *guinguette* appears on a plan as late as 1828, so was clearly not abandoned even after the Brighton Pavilion was finished and Buckingham Palace only half-built. No plans exist of this building. Around the park runs a drive or circular road as it was called despite the fact there was not a single curve in its whole course. Between this and the outer boundary is a margin with sites for terraces and at the north of the park are two big crescents; at the south is a square 'as large as Russell Square'. The rest of the park is planted with trees, and among the trees, on sites varying from 4 to 20 acres, are between forty and fifty villas, disposed in such a way 'that no Villa should see any other, but each should appear to possess the whole of the park',

reminding us how much the whole design owes to Nash's association with Repton. Through the eastern part of the property Nash produces the line of Portland Road (Great Portland Street), making a new and shorter way to Hampstead and Highgate. East of this is a strip of land devoted to commercial uses, with three markets, one for hay and straw, one for vegetables, and one for meat. In addition to the spatial arrangement of his design, Nash also highlighted the importance of pre-planting and its benefits:

But to realise the effects described, it will be necessary to form Roads and plant the Parks, they would then immediately become Rides and Drives to those of the Public to whom it should be thought proper to give keys; the effect of the whole would be immediately seen, and its allurements and inducements set in motion, and which would increase as the Plantations grew, and the Scenery improved, in so much, that if they could be even shut up for a time, the situation for Buildings would so much advance in value by the Improvements of the Scenery, that a greater Revenue would be produced than if the whole of the Ground intended for Building could be let in the first instance. And, if the spots on which the houses forming the streets are proposed ultimately to stand were also planted with such Trees as would be saleable at every period of their growth, these Trees would then sold produce a greater sum than could have been produced from the Ground let in any other way; nor would it be necessary (if such Trees were planted) that when a Street of Houses should be begun, the

whole line should be completed; (a single house might be built in any Street without injury to the general effect, by taking down only such Trees as would be necessary to make room for that particular house, and by those means, however slow the progress of forming the Streets might be, the Scenery would not only at all times be complete, but improving in beauty; and until the Ground forming the Parks should be let for building Villas, the Fences would form Enclosures to the different Spots, which might in the interim be let for grazing, for Nurseries, and such other temporary purposes.

A principal feature of the design is the canal, which enters on the east side, takes an irregular, roughly north-east course and leaves the park on the north, at which point a 'collateral cut' comes southward to a basin immediately adjoining the markets. The canal was an important aspect of the whole planning exercise, and how this linked to the wider network and the park is important to understand. One of the great engineering feats of the day was the Grand Junction Canal, which was opened in 1793. It was extended to Paddington in 1795 where a large basin was formed. This was very successful and these ongoing successes encouraged a third, the further continuation of the canal through London to the Docks, eliminating the expensive carriage of goods by road from the docks to the Paddington Basin. A design was produced by Rennie and promoted by Thomas Homer in 1802 but it was deemed too expensive and was dropped. However, the idea remained and

in 1810 was raised again by Homer, who learned of rumoured developments on the Marylebone Estate. He made enquiries and had numerous conversations with Nash that 'there was every probability of the Crown's being favourably inclined to the projected canal going through the park'. Nash was enthused indeed as he saw an easy way of supplying his lake with water but also was roused by the boldness of the plan. Nash became the driving force behind this venture. He re-examined the whole line of the canal through the park and reaffirmed that Homer's line was 'not only practicable ... but the best course the canal can take'. The whole estimated cost was £280,000 with an expected revenue of £43,000 per annum, a return of over 15 per cent. A preliminary subscription of £220,000 was raised and a committee established. Nash, in his drawings, showed the canal traversing the north-west angle of the park, not only for convenience but because he thought of it as 'a grand and novel feature of the Metropolis' and because 'many persons would consider the circumstances of Boats and Barges passing along the Canal as enlivening the Scenery, provided the Bargemen or People from the Boats were prevented landing in the Parks'. Sadly the commissioners did not agree and decided that barges were best kept out of Royal Parks, whether landed or not, and the canal was compelled to take its present course, skirting the north boundary.

However, politically, the Tory government was feeling vulnerable. Even after the plan had been shifted towards greater accessibility, Lord Brougham was able to protest

vehemently against the Crown's virtual enclosure of Marylebone Park: a building programme like this, he complained, was 'trenching on the comfort of the poor for the accommodation of the rich'. The park itself was nothing but fields, with three farms, some cottages, and two rather pretty but much frequented public houses, the Jew's Harp and the Queen's Head. It was, however, the Treasury which now controlled the leasing of Crown lands and so it was they who became the target of political attack. Perceval was therefore keen to see such criticism mitigated and was even more keen to see the percentage of accessible parkland increased. It was Perceval who arranged for the changes to Nash's proposals and ensured that agreement came via the Surveyor General of Crown Lands, Glenbervie, from the Prince Regent. Nash revised his scheme in the autumn of 1811, later published in the commissioners' report of 1812. How many actual plans Nash actually prepared and amended has often been open for debate. Summerson in 1935 hailed Nash's revised plan as a breakthrough into *picturesque* planning. However, it does appear that between spring 1811 and autumn 1812, Nash was forced to develop radically new approaches.[8]

Against a background of economic turmoil and civic unrest, the country was also fighting the largest and most expensive war in English history, against the might of Napoleonic France. However, domestic issues still caused concern for Parliament. By March 1812 a House of Commons committee had been deliberating on the future of Regent's Park for at least two years. In May 1812 the Prime Minister, Perceval, was assassinated.

The Whigs, who had hoped to regain power after the replacement of George III by the Prince Regent in 1811, remained in the political wilderness. Among their causes of discontent, particularly in the summer of 1812, was one easy target: the government's plan to redevelop Marylebone Park. They despised the idea that an ancient open space, an area of useful husbandry, a place of recreation and fresh air, was to be turned into an exclusive suburb for the rich and royal, guarded by gates, hedges and fences. They were unhappy with the canal development and the fact that Nash had a personal financial stake as did Lord Glenbervie, in his privileged position as the Surveyor General of Crown Lands. Worst of all, a barracks was to be built, or rather two barracks, one for the Royal Artillery and one for the Royal Life Guards 'to keep down the national spirit … to govern the people, not by law, but by the sword'.[9]

Perceval acted quickly. He whipped his parliamentary majority into place, managing to get the barrack Bill through in May 1812, just before he was assassinated, but he also managed to placate the opposition by making one simple key concession, announcing that 'his Royal Highness [the Prince Regent] [was] to surrender the 510 acres of ground which formed this new park, to the health and comfort of the inhabitants of this great metropolis, instead of [simply] making the greatest rent [out] of it by covering it with buildings'.[10] The Regent was already under fire. His Whig critics were publicising the extravagant expense of Carlton House, his grandiose palace with its exquisitely ornate décor, costly furnishings and priceless art treasures. He was

forever renovating it, ordering the sumptuous rooms redecorated, suggesting improvements, expanding his collections of statuary and china and Old Masters. Antique dealers, picture dealers, gilders and dyers, carvers and cabinetmakers filed in and out of Carlton House, each with an appointment to consult with His Majesty on his collections, or to obtain his approval on a point of design.

The Pavilion in Brighton was the Regent's treasured private retreat and was also undergoing more alteration than Carlton House, all under Nash and also much to the distaste of the Regent's detractors. The Pavilion was an embarrassment to them and in the words of one Whig MP 'resembled more the pomp and magnificence of a Persian satrap seated in all the splendour of Oriental state than the sober dignity of a British prince seated in the bosom of his subjects'. In the Prince's own mind, of course, the Pavilion and Carlton House were only the beginning. He wanted to make all of London a monument to his reign – and a backdrop for his personal splendour. The development of Marylebone Park was central to this.[11]

As we know, Nash had been asked to change his first plan in August 1811, with fewer buildings and greater amenity. The economy also would rule out the sort of densely packed housing programme originally conceived. Nash would respond by rearranging his terraces and villas on *picturesque* lines, with a considerable degree of public access. Glenbervie's report appeared with what seemed to be one of now three plans prepared by Nash. One of these only referred to tree planting

and is inconsequential. The other two were much more important. The first was the March 1811 semi-formal, densely packed housing programme already rejected by the government. The other plan, however, shows Nash responding pragmatically to political pressure: the barracks were removed altogether; the canal pushed to the periphery; so have the majority of the houses and terraces; to compensate, two more squares have been inserted, east and west of the central area; the Serpentine lake has replaced the canal as the axis of the park; and the villas in the great double circle have been planned with alternating aspects, some looking in and some looking out of the dominating central focus. It was this plan that was the 'intermediate' step between Nash's formal and informal plans for Regent's Park.[12] Nash's final plan was printed on 12 June by order of the House of Commons and House of Lords. Nash had finally switched to the principles of *'picturesque* beauty'. Nash's first design had been a compromise between urbanity and rurality. His second, alternative plan tipped the balance towards rurality; his third or definitive plan embraced 'those beauties of landscape gardening which his friend Humphry Repton so successfully introduced'.[13] In this scheme there are fewer villas, no more than fifty. There are fewer terraces and they are tucked away around the circumference of the park. The barracks still remain despite previous uncertainty. The circus and double circus are still included, with the monumental buildings of the church and *Valhalla* at their centres. The royal pavilion or *guingette*, with its formal basin or water garden, still remain; so do

the crescents, although these are now moved to the northern boundary. The ornamental water however is much larger, with plantations, informal clumps and shrubberies in abundance. As Nash explained, 'The leading object is that of presenting from without one entire Park complex in unity of character and not an assemblage of Villas and Shrubberies like Hampstead, Highgate, Clapham Common and other purlieus of the Town ... [But above all] the buildings and even the Villas should be considered as Town residences and not Country Houses.'[14] The canal has now been shifted definitively to the north-west corner of the park, only to emerge as a supply route to the markets and shopping areas on the eastern rim. Nash's definitive plan was designed to maximise Crown revenue while increasing the beauty and salubrity of the metropolis. He continued to explain: 'Open space, free air, and the scenery of nature will prove irresistible to the wealthy part of the Public ... an intermixture of Trees, Lawn and Water will guarantee a unity of Park-like character.' However, by now foregoing the majority of his 'Streets, Squares, Circuses and Villas', he had secured not only a greater variety of exceptional scenery, but a higher level of leasehold value. Nash's projected rental income from the new park was double that of Leverton's. And by tying this new park to an elegant New Street, linking the new park to the West End, the future worth of all these properties would be multiplied by simple ease of communication. There was a measure of sentimental regret for the old rural Marylebone Park, but no resolute opposition, apart from John White who hated

the whole thing. He had lived in Marylebone Park all his life and knew every inch of it and had his three previous designs virtually ignored. By now, Marylebone Park was part of a rich yet volatile history. The new Regent's Park was about to become a reality.

Regent's Park: A Lesson in the *Picturesque*

On 18 October 1811, a Treasury minute was issued saying that although their lordships could not

> at present sanction the Plan furnished by Mr Nash ... they concur with the Commissioners of Woods, and with Mr Nash, in thinking it highly expedient that a broad Drive or Road for exercise on horseback, in carriages, or on foot, should be immediately formed round the whole of the said property. My Lords are further disposed to assent to the idea of Mr Nash, that it may be proper to make plantations on all such parts of the Ground as are in his plan.

The same Treasury minute gave instructions for certain preliminaries suggested by Nash to be carried out. The drive was immediately made around the whole estate and the building sites were planted with young trees, the object being to 'obviate that deformity which is occasioned by the slow progress of Buildings'.

The year 1812 proved to be busy and bustling but also extremely challenging. Not all went to plan and

Nash found himself extremely stretched. The clauses of the Regent's Canal Bill were drafted early in February and sent to the Treasury. Further consultation with Nash meant further changes to include provisions about supplying the ornamental water, keeping vessels out of it, and relegating all mechanical accessories and wharves to the north bank; a further revision prevented the use of steam engines within the park. The Bill was finally placed before the Treasury in May. In the House of Commons it was badly received and Mr Creevey, who was no admirer of Nash, opposed it on the grounds that both Nash and Glenbervie, officials of the Woods and Forests, were shareholders. His proposed amendment was ignored and the Bill received royal assent on 13 July. Opposition continued and was lively. The wharfingers at the Paddington Basin demanded compensation; others complained that springs would be robbed and drainage affected, that the steam-engines at Paddington would be a nuisance, the receptacles for manure on the wharves a worse nuisance, and finally that the 300 acres of stagnant water would threaten the health of the metropolis. Their troubles did not end there. Landowners threatened lawsuits and one of them, Mr Agar of St Pancras, forcibly defended his property against James Morgan and the navigators, as the canal diggers were called, when they wished to start work, and it was Morgan who was arrested and marched before the justices for disturbing the peace. It did not end there.

The Grand Union Water Company now declared that they could not supply the necessary water. Land

on Finchley Common was purchased and that too proved inadequate. Finally in 1815, Homer, the original promoter of the scheme, embezzled most of the company's remaining capital, and though he was tried, the money was never recovered. Nash poured in his own fortune, taking out shares in his own, his wife's, and more than likely several other people's names. By 1816, the cut around the park was completed, but in 1818 Nash himself had to take up all the wharf leases for the Regent's Park basin, since the company were unwilling to honour their obligations and the sites would not let. The canal was finally completed in August 1820 and ceremonially opened by Lord Macclesfield, the chairman, with Nash being given full credit for the scheme.

The circus was also proving problematic and appeared to be heading for a disaster. The whole site was taken up in 1812 by Charles Mayor, a business associate of Nash, and the commissioners were delighted to dispose of so large a part of the undertaking so easily. The plantations, only a few months old, were removed and houses began to rise at once. By the end of 1812, Mayor went bankrupt to the sum of £22,000 and the houses he had built proved unsound, with the management of the circus completely out of hand. Mayor owed money everywhere and creditors' meetings dragged on for ten years. The houses he had built stood empty and open to the elements. The other burning issue that still remained was a new site for the parish church. There were four possible sites and Nash favoured the centre of the circus. The vestry disagreed with him and among themselves.

Eventually they settled on the southern semi-circle, with an ornamental garden to the north, and the New Road re-aligned at right angles to Portland Place. However, matters were made more complicated when the Duke of Portland decided that he wanted the new church on his land and would refuse to remove his railings from the end of Portland Place, thereby effectively blocking the new street – the main line of communication between the park and Westminster. The commissioners realised how hard it would be to obtain an Act compelling the duke to remove the railings and wrote to the vestry asking to be relieved of their promise of a site within the circus and offering any other within the park. The vestry hesitated and debated and then subsequently decided to turn a chapel which they had begun to build on a corner of the old parish church site into the new church.

As the park was laid out, beginning with the 1811–12 planting season, the framework of the existing agrarian landscape was removed, and replaced by open grazing across parkland. The park was built in an anti-clockwise direction, leading off from Portland Place up the line of what became the Broad Walk, branching west to complete the Inner Circle and east along what became Chester Road before turning northwards. Luffman's 1812 sketch plan of the first season's works charts the progress on site. Nash reported his planting intentions for the building ground to the Commissioners on 14 November 1811.

The holes for planting these Trees are 4 feet diameter and 2 ½ feet deep and are from 12 ½ to 17 feet distant

from each other according to the circumstances of the spot to be planted and ranged in the form called quincunx, the trees themselves will be forest trees – those of the great Circus on the apex of the ground and Birch and Planes the inner row Birch the second row planes the rest of the rows Birch and Planes alternately the Planes being seen in the intervals of the Birch. The Circus next Portland Place I propose to be Sycamores and Oak in the same manner of alternate rows each sort being seen in the Spaces between the other. The Long Square beyond the Circus to be larch or Spanish Chestnuts the street beyond looking north Ash and Beech. The long range beyond looking west, Spruce fir and acacia. The Crescent Limes and Horse Chestnuts, the other Crescent, Elms and Sycamore, the street from thence to the Canal Birch and Spanish Chestnut, the next street Mountain Ash and Sycamore, in any one range of Houses I do not propose to have more than two sorts of Trees because the principle of grandeur arising from the stateliness of regularity, continuity and uniformity, would be counter-acted in a great measure defeated by the interruption of Colors promiscuously and irregularly blended. If the regularity and uniformity I recommend were to extend only to a single House and the Changes alternately I think the effect would be spotty or what the French call *papillote*, two Colours in each mass I think will be sufficient for the purposes of harmony and placing one colour in the interstices between the others the best way at blending these colours.

The first phase of planting in the 1811 to 1812 season was a disaster. Both of the nurserymen hired to do the job, William Malcolm of Kensington and Jenkins and Gwyther of Portman Nursery, lost money, and were bitter about being held responsible for the heavy plant losses. Malcolm wrote on 28 February 1814, 'We planted trees against every rule of propriety. The land wet and insufficiently drained. Hollies and other evergreens planted at Christmas in a puddle and the land not enclosed.' There were persistent complaints from them about ground preparation, drainage and fencing works which may account for the apparent failure of much of the planting in the park. During the early years of the works, Farmer Willan remained in Marylebone Park Farm adjacent to the Inner Circle. His tenancy was extended on the condition that he released portions of the ground as required. The grassland in the open parts of the park was let annually by public tender for hay and pasture, and the new plantations of trees were let as nursery ground, and for potato and mangel-wurzel cultivation. The cultivation between the rows of trees was intended to drain the lines, but careless cropping ended the vegetable growing. Jenkins and Gwyther developed an extensive nursery across the Inner Circle for supplying trees and shrubs to the park. From their records and invoices, the detail of the eighteenth-century rural landscape was removed as the work progressed across the site. Buildings were demolished and the materials sold, banks, boundaries and hedges were removed, and field holes and ponds were filled up, levelled and seeded.

The second phase of planting during the 1813–14 season saw no improvements. Works coincided with the completion of the canal works around the northern edge of the park, the early lake works, and the subsequent rearrangement and extension of the circular road. The works did not augur well for the subsequent planting. Spoil from the canal excavations was spread across the northern parkland, and ground levels were similarly raised around the lake to balance the levels. Compaction and the vagaries of made-up ground created problems for later building in the area. The Marquis of Hertford failed to complete his promised villa design on the grounds that the verandah would not be supported by the unstable ground conditions. The nurserymen continued to complain about the existing local ground conditions and wrote on 6 November 1813, 'The Ground we are at present trenching is really scarcely fit to plant in as in some places the gravel is so very strong and so near the surface and in others it is so uncommonly clayey.' This was not the case everywhere for they added that 'as there is a great deal of earth to be taken off in some parts of the Park … [would it be possible] to have that thrown about 9 inches or one foot thick, upon the ground which we are now trenching'.

By 1818, however, some fortunes began to improve. John Farquhar agreed to guarantee the money for the development of the circus, and three builders took up the leases including those built by Mayor. Despite fire damage and storm damage and accusations of negligence, the whole crescent was completed and let soon afterwards. The idea of a grand circus was

reluctantly abandoned and Park Square was substituted for the northern half. Nash's relationship with the commissioners was, however, not made any easier by the accusations of negligence. He was busy with Regent Street and could not give his full attention to the park. Even Lord Glenbervie was critical. For several years the site presented 'a most extraordinary scene of digging, excavating, burning, and building, and seemed more like a work of general destruction than anything else'. Indeed, it was taking such a long time to lay out and build, that Hughson, in his *Walks through London*, published in 1817, speaks of it as 'not likely to receive a speedy completion', though it was already 'one of the greatest Sunday promenades about the town'. Other problems included the lack of takers for the villa and terrace sites. Mayor's failure had discouraged other investors and the slowness with which Regent Street developed was a further deterrent. Glenbervie reported, 'The project of the New Street seems to be in a deplorable way, and Nash I hear is held in universal abhorrence except by his royal master and dupe.'[1]

Nash remained unperturbed and resolute. He himself took up lease after lease along Regent Street and, supported by the Prince Regent, wrote sensible, soothing letters to the commissioners. His confidence was rewarded and he found the backer that at last would make Nash's vision a reality and a builder who would also have a major impact on the development of the park. James Burton and his architect son Decimus Burton played a significant part from 1816 onwards. Burton was one of the first men to employ on a

permanent basis all the trades and crafts needed to build a house. He took up a number of sites in Regent Street and soon realised he would lose money if the park failed to materialise, so during 1817 and 1818 he built himself a villa there, to a design by his son Decimus. Another villa site was taken at the same time by C. A. Tulk, MP for Sudbury, and a house, St John's Lodge, was built to the designs of John Raffield. Despite a still dour report in 1819, by 1823 and the fourth report, every site was let and the building industry was booming. The park was virtually complete in seven years. Park Crescent and Regent Street were finished and Cornwall Terrace begun in 1820. In the next few years, York Terrace, Sussex Place, Clarence Terrace, Park Square, and Hanover Terrace were built, and finally between 1826 and 1828, Gloucester Gate, Cumberland and Chester Terraces were erected. Eight villa sites had been let. By the fifth report, the commissioners in May 1826 decided that no more villas should be built. Income promised by Nash was one third of what he had promised them in 1811. They also shelved plans for Munster and Carrick Terraces and the double circus in the middle. The buildings, they felt, would 'destroy the Scenery, and shut out the many beautiful views towards the villages of Highgate and Hampstead'. The *guingette* disappeared from the plans too as George IV was now building Buckingham Palace. The park as it materialised was little more than the skeleton of Nash's original plan, but even so it was the most beautiful estate in London. As Nash imagined it, it was very different: a private garden city for an

aristocracy, shut in with a belt of terraces, dominated by the great double circus, and crowned by the outline of the *Valhalla*.

The New Street, which in essence was not known as Regent Street until after the Regency was over, soon passed its anxious phase, and by 1823 was producing an annual revenue of £39,000. The commissioners began to consider what other improvements could be made on the same lines. Nash was in demand again, and his achievement as a town planner was his paramount claim to the attention of posterity. He grasped the essentials of town planning as nobody else had done. Despite the changes forced on him, the overall plan was Nash's alone and every façade was designed or approved by him. The layout of roads and plantations and the siting of buildings were his. The interiors and construction were left to the builders and their architects. Regent's Park was in essence erected by private builders relying on private resources. The only public money that was spent was used to pay for roads, lodges, open spaces and railings. The agreed practice was for a builder or financier to take up a site on a building agreement with the commissioners for a peppercorn rent, and to erect on it a terrace corresponding to Nash's façade but internally to his own design. Once completed, a regular lease was granted for the remainder of ninety-nine years on a ground rent assessed at so much per foot of frontage. The builder hoped to have sold the houses to private buyers before or immediately following completion. James Burton, along with Nash, put most money into the park. Burton took up leases

for Cornwall, Chester and York Terraces, built Clarence and Cumberland, and most of the villas including his own, The Holme. Nash himself bought up all the leases that were hardest to dispose of to outside takers.

The creation of the park and of Regent Street made possible a reorganisation of London's West End and Nash's success had depended on the royal support he received and previously on Fordyce's preservation of the park from previous development. Only gradually did the park take on the characteristics of a popular recreational facility. As early as September 1814, the painter Joseph Farington noted in his diary that the new park was already popular with the public. 'The weather was remarkably fine today; the Thermometer at 73° ... multitudes of respectably dressed people, men with their wives and families ... walking in ... the Regency Park, or quietly sitting with Pipes and Ale in the open air at the small taverns ... almost all the men dressed in Black or Dark Blue Cloaths ... Boots [have clearly] become an article of Sunday finery even among the lower order of tradesmen and mechanics.'[2] Among the delights available in Regent's Park were two places of pictorial entertainment: the Colosseum and the Diorama. The Colosseum was a kind of *trompe l'oeil* travelogue: London in three dimensions. The Diorama was a distant ancestor of the modern cinema. Both were pictorial enchanters and creators of illusion. Like the *picturesque* itself, illusion was certainly one of the chief ingredients in that cluster of ideas and attitudes which came to be labelled *picturesque* theory. The transformation of Marylebone Park was a compound of powerful

pictorial illusions. This was certainly Nash's intention. Nash's *picturesque* vision found its perfect expositor in James Elmes, the orotund author of *Metropolitan Improvements* (1829). The architect's conception, Elmes explains, was essentially Reptonian. The choicest views of The Holme (1816–18) – selected for himself by James Burton, and designed by his son Decimus – are framed in trees and reflected in 'the glassy surface of the lake', for all the world like sketches from 'the magic pencils of Ruysdael and Claude'. South Villa (1818–19) and Albany Cottage (*c*. 1822); Holford House (1832–33), St Dunstan's (1825–28) and St John's Lodge (1818–19); Hanover Lodge (1827) and Grove House (1822–24) – mostly by Burton under Nash's direction – all act as focal magnets of a '*picturesque* group'; each to the passing spectator is part of a sequence of 'living pictures'. Each terrace of houses appears to be a palace; each villa appears to be a country seat. The spectator's progress is a trail of continuous illusion. No urban scars can spoil this sylvan scene: the gardens of Park Crescent and Park Square are even linked by a tunnel beneath the traffic of Marylebone Road. These inner gardens, notes Elmes, are not *picturesque* but even so are crammed with Reptonian devices such as 'meandering walks', 'ambrosial shrubs', 'velvet turf', 'gay flowers' and of course, 'serpentine walks'.[3] As Charles Ollier wrote in 1823,

As you rowed on the lake, the variety of views ... is admirable; sometimes you are in a narrow stream, closely overhung by branches of trees; presently you

open upon a wide street of water like a lake, with swans sunning themselves on its bosom; bye and bye your boat floats near the edge of a smooth lawn fronting one of the villas; and then again you catch the perspective on the periphery of a range of superb edifices, the elevation of which is contrived to have the effect of a palace ... [There is in fact, says Ollier] nothing like it in Europe ... [Inside the park] the inhabitant of each [villa] seems, in his own prospect, to be the sole lord of the surrounding scenery, [for] in the centre of the park, there is a circular plantation of immense circumference, and in the interior of this you are in perfect Arcadia.[4]

Nash to Nesfield

One cannot help but be fascinated by Nash's great terraces that today provide such an extraordinary architectural background to the southern and eastern expanses of Regent's Park. The stuccoed façades remain impressive but during Nash's time, stucco was not new and had been used by the Revd Mr Parker, who had discovered 'Roman Cement' at the time he was building Southgate and facing his Dover Street House, finding that it was cheaper, easier to handle, and more durable. Nash followed the fashion of jointing the stucco surface and painting it in 'fresco' to imitate Bath stone. With the many changes forced upon Nash, Regent's Park fell short of the impressive unity which its designer intended. However, in its prime it was one of the sights of London. Crabb Robinson, after driving round in a gig, passed a judgement saying, 'I really think this enclosure, with the new street leading to it from Carlton House, will give a sort of glory to the Regent's government, which will be more felt by remote posterity than the victories of Trafalgar and Waterloo, glorious as these are.'[1]

To describe the park as it evolved under Nash is a task in itself. There are the surrounding crescents, the parkland as well as the villas and lodges within the park. James Elmes describes the park in *Metropolitan Improvements* and included many engravings within.

The park is entered from Portland Place, from where the wings of Park Crescent extend. Each house had four storeys and a basement with a running colonnade with Ionic capitals unifying the whole composition. The first-floor rooms had access to the balcony above the colonnade. Nash paid significant attention to this crescent, more than any other group or building in the park, hence its stunning, restrained and dignified appearance. Park Square, which replaced the northern half of Nash's intended circus, was in fact two parallel terraces, with façades designed by Nash and built by William Mountford Nurse between 1823 and 1825. From Park Square, we come to the Outer Circle. Travelling clockwise, we pass Ulster Terrace, built by Nurse in 1824, Brunswick Place (now Upper Harley Street) and the elaborate architecture of York Terrace. York Gate, which divides the terrace, is one of the most magnificent vistas in the park. Directly opposite York Gate, a road leads into the Inner Circle. It goes over a bridge across the lake which Nash considered an essential part of his design, though it caused him much trouble. Originally, it was to have been supplied with water from the canal at little or no cost to the Crown, but when the canal's supply proved to be scarcely sufficient for its own needs, negotiations were opened with various water companies. The first two

approached refused to tender and in the end the natural resources of the Tyburn were utilised. It was turned into a lake by judicious excavation and the earth from it piled into a huge mound in the centre of the Inner Circle, which added to the scenery. The Tyburn, which had to be carried by a small aqueduct over the canal excavations, disappeared from sight as a river for it was built into the new King's Scholar's Pond sewer which drained the park. After flowing in at the northernmost end of the lake and out again beside Sussex Place, it was built into a brick culvert and vanished. Six small islands, well fenced-off, were left in the lake to add to the *picturesque* effect. In the summer of 1831, the residents complained of the smell and an agreement was made with the West Middlesex Water Company to supply 23,000 tons of water annually for £200.[2]

Continuing around the Outer Circle, Cornwall Terrace was the first terrace to be built, erected in 1821, and designed by Decimus Burton. The houses were intended for the wealthier members of society, but since they were without gardens, Burton proposed that the strip of park opposite should be encircled with a sunk fence and reserved for the use of the residents of Cornwall Terrace. The commissioners referred the suggestion to Nash who suppressed it firmly. Continuing, Clarence Terrace was also designed by Decimus Burton, who was now beginning to receive plaudits from the Office of Works and was recommended for other public works in Hyde Park.

The next terrace was Sussex Place, designed by Nash himself and an eccentric group of buildings with curved

wings, ten pointed domes and fifty-six Corinthian columns. They were not well received but sold well, probably because they enjoyed the most *picturesque* view in the whole park. Behind Sussex Place, William Smith and Burton built Park Terrace and Kent Terrace and directly in front of Kent Terrace, facing onto the park, was Hanover Terrace, which Nash designed in a more scholarly mood than usual. It was one of the finer and more expensive buildings. Behind the terrace was Abbey Lodge, a neat Gothic villa built in 1826, unlike anything else in the park. Beyond Abbey Lodge was an entrance at Hanover Gate for which Nash designed a quaint little lodge with niches for statuary, and to the north was a belt of trees through which the canal wandered, and five villas, Albany Cottage, Hanover Lodge, Grove House, Hertford Villa, and Holford House. These and the remaining villas are described later.

To the north-eastern end, we find the Zoological Society, ever present since 1828, and Gloucester Gate, different to other buildings in the locality as the architect, John Joseph Scoles, did not like Nash's façade so doubled the scale of the moulding on the Corinthian capitals. Nearby was St Katharine's Hospital, demolished in 1825 with a new site provided in the park and the previous inmates dispersed and now relying on the poor rates of Stepney. The new buildings were designed by Ambrose Poynter, a young architect whom Nash had trained and whom he thoroughly disliked. The new buildings bore no resemblance to anything else in the park, being Gothic in style and bare of stucco. Poynter exceeded

his estimate and £15,000 worth of repairs had to be done by the middle of 1833. Heading south from St Katharine's was Cumberland Terrace, designed by Nash himself and built in 1826. The terrace is magnificent and one of the most splendid of them all. It was designed as a royal prospect since it would have stood opposite the Prince's own palace had that been built as originally planned. James Thomson was the site architect and added details himself as the building progressed and the result is unusually successful. Of all the buildings that Nash was responsible for, Cumberland Terrace is considered one of Nash's greatest achievements as an architect. Chester Terrace proved more problematic. Built by James Burton, it was his last in the park. Appointed by the commissioners, Nash prepared a sketch plan for the ground plan but relations between Burton and Nash were soon to deteriorate. Nash was unhappy and complained to the commissioners, saying that the two pairs of detached houses should be pulled down describing them as 'disgusting'. Burton demanded compensation, with Nash accusing him of departing from his designs. Throughout, Burton remained dignified and ultimately the matter was referred to the architect William Wilkins. As a result, Nash was criticised for not watching the work more closely and not raising his objections earlier. The houses remained with only the statues removed. Nash designed arches to link the pairs of houses with the main terrace. Nash was clearly distracted by work elsewhere, more than likely with works at Buckingham Palace. He was also now an old man and despite these difficulties with Burton,

was reliant on his financial backing but nevertheless did make life difficult wherever he could. There had also been issues at The Holme, as well as Cornwall Terrace and Chester Terrace.

The most unusual building was of course, the Colosseum, built between 1824 and 1827 to house a panorama of London, painted by a young artist, Edmund Thomas Parris, from sketches made by an ingenious surveyor, Thomas Hornor. Parris devised an ingenious apparatus for gaining access to cupolas which attracted much attention, and led to his engagement by Hornor to assist him in the production of his panorama of London at the Colosseum, for which he had been making sketches since 1820. Upon this immense work, which covered nearly an acre of canvas and presented formidable artistic and mechanical challenges, Parris laboured incessantly for four years, completing it in November 1829. Decimus Burton had been selected as architect and designed a sixteen-sided building 130 feet in diameter, with a superb portico and majestic cupola. The building was intended to be larger but Nash objected with a view that it would be out of scale with its surroundings. Decimus reluctantly agreed to the changes. Again, the project wasn't without problems. It was intended to be finished in 1827 but Parris was still painting and a year later, Hornor and his chief backer Rowland Stevenson absconded, leaving debts of more than £60,000 behind them. Opened in January 1829, Parris was still painting, suspended from the ceiling in a cradle. It was an impressive and significant building with elaborate gardens and a Swiss cottage

surrounding it. The name Colosseum was a reference to the size of the building. It was more of a Grecian version of the Pantheon as Elmes was often keen to point out on a regular basis. Before returning to Park Crescent on the circuit of the park, an adult orphan asylum was built where the grown-up daughters of penniless officers and clergy were sheltered. Another Nash building, but very plain in design, he charged no fee for his services. St Andrew's Place was built between 1826 and 1828 with two fine houses at its blind end.[3] The other extraordinary building in the park was the Diorama, erected in 1823 by Jacob Smith. The Diorama, on the eastern side of Park Square, was exhibited in Paris long before it was brought to London by its originators, Bouton and Daguerre; the latter, the inventor of the daguerreotype (the first commercially successful photographic process), died in 1851. The exhibition-house, with the theatre in the rear, was designed by Morgan and Pugin: the spectatory had a circular ceiling, with transparent medallion portraits.

The Diorama consisted of two pictures, 80 feet in length and 40 feet in height, painted in solid and in transparency, arranged so as to exhibit changes of light and shade, and a variety of natural phenomena; the spectators being kept in comparative darkness, while the picture received a concentrated light from a ground-glass roof. The contrivance was partly optical, partly mechanical, and consisted in placing the pictures within the building so constructed that the saloon containing the spectators revolved at intervals, and brought in succession the two distinct scenes into the field of

view, without the necessity of the spectators removing from their seats, while the scenery itself remained stationary. The light was distributed by transparent and movable blinds, some placed behind the picture, for intercepting and changing the colour of the rays of light, which passed through the semi-transparent parts. Similar blinds, above and in front of the picture, were movable by cords, so as to distribute or direct the rays of light. The revolving motion given to the saloon was an arc of about 73°; and while the spectators were passing round, no person was permitted to go in or out. The revolution of the saloon was effected by means of a sector, or portion of a wheel, with teeth which worked in a series of wheels and pinions; one man, by turning a winch, moved the whole. The space between the saloon and each of the two pictures was occupied on either side by a partition, forming a kind of avenue, proportioned in width to the size of the picture. Without such a precaution, the eye of the spectator would have been estranged from the object. The combination of transparent, semi-transparent, and opaque colouring, still further assisted by the power of varying both the effects and the degree of light and shade, rendered the Diorama the most perfect scenic representation of nature, and adapted it peculiarly for moonlight subjects, or for showing such accidents in landscape as sudden gleams of sunshine or lightning. It was also unrivalled for representing architecture, particularly the interiors. Although the Regent's Park Diorama was artistically successful, it was not commercially so.

The villas and lodges were an intrinsic part of the

landscape of Regent's Park. Nash had been persuaded to reduce the number of these as part of his original plan and further as works progressed, but nevertheless these were often imposing and were a major part of the landscape.

A villa, as generally understood at the present day, is a rural mansion or retreat, for wealthy men. The palace with us, belongs to the sovereign and is sometimes applied to the episcopal residence of a bishop. The mansion implies the residence of state of a nobleman or gentleman, and sometimes the house of a lord of the manor. The villa, on the contrary is the mere personal property and residence of the owner, where he retires to enjoy himself without state. It is superior to the ornamented cottage, standing as it were between the *cottage ornée* of the French, and the mansion or hall of the English. The term is never more properly applied than when given to such suburban structures as those which are rising around us, serving as they may well do from situation as to the town, and from position as to rural beauty.[4]

Each of the villas is now described as they appeared and when first built.

The Holme was the first villa built and occupied in the park. James Burton leased the land in 1815 on the eastern side of the lake and by 1817 was building his own villa, with Decimus in place as architect. By 1818, the villa was occupied by the Burton family. Despite disapproval from the commissioners, who complained

to Nash, it was impressive with a grand Corinthian portico which led directly into a hall, its bow window with Ionic pilasters facing onto the garden, which ran down to the lake edge. A small dome provided a focal point to the view from across the water. Nash was taken to task by the commissioners and the Board stated unequivocally that 'in their judgement the whole blame of having suffered such a building to be erected ... rests entirely with yourself; The Board consider it to be your special Duty to take care that any Building to be erected in Marylebone Park should be so constructed as not only to deform but to constitute a real ornament and a substantial and profitable improvement ... of the Crown's Estate'. The Burtons remained in the park until 1831. Little is known about the occupants for the rest of the century. In 1913, George Dance, the songwriter and impresario, owned the villa having made his fortune out of royalties and tours all over England. He commissioned a cinema architect, Bertie Crewe, to extend The Holme, adding a ballroom, billiard room and a gazebo, each year giving impressive garden parties for all those who had worked for him over the past year. The next occupant was Mrs Marshall Field, later Mrs Pleydell-Bouverie, the sister of the surrealist art collector Edward James, who employed Paul Phipps, a pupil of Lutyens, to alter the villa to her requirements. Significant changes were made, including the replacement of the dome above the bow window with a balustrade, transformation of the Ionic pillars into a more elaborate Corinthian mode to match those of the entrance portico and a complete

remodelling of the interior, which was redecorated in white, silver and gold. The terrace, rose garden and shrubberies were re-designed by eminent landscape architect Geoffrey Jellicoe. During the Second World War the house was occupied by the Royal Air Force, and in 1947 was acquired by Bedford College for academic and residential purposes. It is now a private residence.

By 1819 St John's Lodge was built, having actually been started before The Holme, designed by architect John Raffield. The designs for St John's Lodge were exhibited at the Royal Academy in 1818–19. The first resident, Charles Augustus Tulk, a man of independent means, was a deeply serious person. He co-founded the Swedenborg Society, its object being to publish in English the works of Swedish theologian and mystic Emanuel Swedenborg. He also had serious concerns with the management of prisons and asylums, and sat as MP for Sudbury from 1820 to 1826 and for Poole from 1835 to 1837. He was an active county magistrate for Middlesex and served as chairman on Hanwell lunatic asylum from 1839 to 1847. He was also a staunch supporter of William Blake, buying his drawings, publishing his poems, and defending Blake's reputation after the artist's death. Tulk was not a resident for long, moving out in 1821, the villa standing empty until 1826 when John Maberley MP became resident. He then let it in 1829 to the Marquess Wellesley, eldest brother of the Duke of Wellington. The marquess commissioned Decimus Burton to enlarge the villa, adding a room to either wing. When the marquess left in 1833, Isaac

Lyon Goldschmid became occupant. He was created Baron de Palmeira in 1846 by a grateful Portuguese government for settling an involved money dispute between that country and Brazil. A man of the sciences, he became President of the Royal Society, Fellow of the Royal Geographical Society and Fellow of the Linnaean Society. His principal interests however lay in his devotion to the cause of Jewish emancipation. He was the driving force behind the Jewish Disabilities Bill which Sir Robert Grant first introduced into the House of Commons in 1830. Not only was he concerned for his own people, but for all those who needed help. With Elizabeth Fry, he worked for prison reform and for changes in the penal code. In 1841, he was created the first Jewish baronet. Between 1846 and 1847 he employed Sir Charles Barry, the architect of the Houses of Parliament to enlarge the lodge by adding a third storey and to bring the wings forward to accommodate a top-lit library and ballroom. A new entrance hall was formed between the wings and was given a grand pedimented porch with screen of pillars on either side. Interior decoration was undertaken by Ambrose Poynter who had had his early training in Nash's office and drew his inspiration from Raphael. The long ballroom glowed with gilded *cinquecento* arabesques. Sir Isaac's children shared their father's intelligence and interests. Anna Maria grew up a philanthropist, concerned with educational reform, and Francis became the first Jewish barrister, serving as MP for Reading from 1860 till he tragically died in 1878 in a railway accident at Waterloo station. His widow lived on at St John's Lodge for

another decade till 1888 when the house was let for a year to the pianist Agnes Zimmerman. From 1889 to 1900, John Patrick Crichton-Stuart, 3rd Marquess of Bute lived in the lodge. Incredibly rich, he owned estates in Scotland and Wales and had a passionate interest in the paranormal and buildings. He built or restored nine important edifices including castles, priories and churches in Wales and Scotland. Inevitably he altered the villa in Regent's Park. With Robert Weir Schultz as his architect, he added to St John's Lodge a domed circular chapel in which he kept a crystal ball and a library annexe for his theological books. The gardens were laid out with a series of terraces, conservatories and arbours for meditation. After he died, his widow remained until the First World War when the house was used as a hospital for disabled officers. From 1921 till 1937 it served as the headquarters of St Dunstan's and from then until 1958 as the Institute of Archaeology. In 1958 it was taken over by Bedford College, to provide an idyllic place of study for a new generation of students. Today it is the private residence of Prince Jefri Bolkiah of Brunei, with part of its gardens now open to the public, designed by eminent landscape architects Colvin and Moggridge.

By 1819, a third villa was being built in the park. South Villa stood on the southern edge of the Inner Circle. Probably designed by Decimus Burton, its most noteworthy tenant was the astronomer George Bishop, who had an observatory in its grounds. In 1852, Mr Bishop published a quarto volume, *Astronomical Observations taken at the Observatory, South Villa,*

Regent's Park. He became President of the Royal Astronomical Society, a Fellow of the Royal Society, and sat on the Council of University College London. When he died in 1861, the instruments and dome were removed from the observatory to his son's house at Twickenham where the observations continued. The walls of the original building remained standing until the Second World War. Between 1879 and 1883, the villa was rebuilt in terracotta brick in the style of the period. By 1908, it was taken over by Bedford College, a university college for women. Established in 1849, the premises were soon deemed as too small and new buildings were erected, designed by Basil Champneys in the style of Newnham College at Cambridge. These too were soon to be insufficient for the college's purposes. Despite vociferous protests, South Villa was demolished in 1930 and its site filled with new academic buildings designed by Maxwell Ayrton, today known as Regent's College. One small part remains, a memorial to the original elegant residence, the hexagonal gate lodge designed presumably by Decimus Burton himself.

Grove House has one of the most spectacular sites of any of the villas in the park, standing on higher ground beyond both the Outer Circle and the canal on the westernmost edge of the park. It was again designed by Decimus Burton and built by James Burton in 1823 for George Bellas Greenough, the distinguished natural scientist. Nash and the commissioners were keen that a fitting edifice should occupy this commanding position. Decimus did not fail to deliver and elaborated the simple design that he had used for their family residence at The

Holme. The entrance through a grandly pedimented Ionic portico led first into a small hall and then into a circular saloon with a coffered dome supported on eight Corinthian pillars. Incorporated was also a dining room, a billiards room, two libraries and a large bow-windowed drawing room. The gardens were equally special, taking advantage of the undulating land. George Bellas Greenough made this a centre of London's intellectual and scientific life; he was a founder member of the Geographical Society, became President of the Geological Society, stood as Radical MP for Gatton in Surrey, and served as one of the first councillors to the newly founded University College London. He died in 1856, with Grove House becoming the home of Francis Smedley, High Bailiff of Westminster. Then in 1878 it was acquired by Thomas Greer MP. In 1909, the villa became the property of the artist Sigismund Goetze and his wife Constance, whom he painted so often and so lovingly. Goetze was incredibly generous, having made his fortune as a portrait and historical painter. He spent his good fortune on many others and was a generous benefactor to the park, giving the gilded iron gates in Queen Mary's Rose Garden to the park in commemoration of George V's Silver Jubilee, and the avenues of flowering cherry trees. He took immense pride in Grove House, which nevertheless he turned into a hospital during the First World War. When Goetze acquired the house, the main drawing-room became the music room and here he repainted the walls himself with scenes from Ovid's *Metamorphoses*. He died in 1939 and in accordance with her husband's

wishes, Mrs Goetze established the Constance Fund for the presentation of sculpture to London parks; the Triton Fountain by William MacMillan in the Inner Circle was the first and one of the Fund's most important benefactions. In 1955, the villa was acquired by the Nuffield Foundation and was then known as Nuffield Lodge. A major programme of restoration and redecoration of the house was undertaken in 1973–74. Following the Nuffield Foundation's surrender of the lease in 1986, the house reverted to the name Grove House and was purchased privately, later being owned by Australian businessman Robert Holmes à Court. His estate sold the property after he died from a heart attack in the early 1990s. Grove House is still reputed to have one of the largest gardens in Central London after Buckingham Palace.

Albany Cottage appeared by 1824, also known as Albany Lodge or Regent's Lodge. It was owned by MP Thomas B. Lennard and was designed by Charles Robert Cockerell in collaboration with Decimus Burton. The relationship with Burton was not a happy one, with changes made and the property 'altered for the worse'. Elmes describes the house 'as a specimen of the English *cottage ornée*, it is scarcely to be surpassed, even in this region of architectural and *picturesque* beauty. The plantations accord with the architecture in a singularly happy manner and at this youthful season of the year, give out delicious and health-inspiring perfumes.' Lennard's residence was a true villa and no *cottage ornée*. Cockerell, visiting Amesbury House in Wiltshire, was delighted and surprised that 'the admirable Inigo

[Jones]' had adopted the same arrangement. By the late 1820s, Lennard had moved away. The new tenant was Thomas Raikes, who was a dandy and a diarist, the nephew of Robert Raikes, the promoter of Sunday schools, and the friend of Beau Brummel. He was also a City merchant and a Governor of the Bank of England. From the mid-1830s its name was changed to North Villa and became the home of Major-General Sir William Miles, who had served in the First Anglo-Burmese War. After he died, his widow remained, and from 1875 the Meyerstein family occupied the villa. A native of Hanover, Edward Meyerstein emigrated to this country and became a prosperous merchant in the City of London. Edward Harry William, one of his sons, became incredibly wealthy and was knighted in 1938. From 1895 until his death in 1923, the villa was the residence of Russell Donnithorne Walker, a trustee of the MCC as well as President of the Middlesex Cricket Club. From 1828 Lady Ribblesdale lived at the villa, whose first husband had been Col. J. J. Astor, the millionaire who went down in the *Titanic* in 1912. She married Ribblesdale in 1919, dying at the age of ninety. She renamed the house Regency Lodge but sadly from 1946 it was scarcely a villa and became the Islamic Cultural Centre and by 1975 the mosque designed by Sir Frederick Gibberd was built in the grounds.

Hanover Lodge was another Decimus Burton design, for Colonel Sir Robert Arbuthnot, a hero of the Napoleonic campaigns, taking up residence in the park in 1827. It was unpretentious in design, with a quartet of Ionic columns attached to the central bay

of the garden front. Elmes's description of the interior describes an extremely luxurious layout and design as well as 'grounds, for a town residence, which are spacious, and laid out with considerable taste and elegance'. After five years, Arbuthnot moved on and the villa became the residence of Thomas Cochrane, 10th Earl of Dundonald, a flamboyant and dramatic character with a career that was at times bizarre. Accused in 1814 of circulating a report of Bonaparte's death in order to manipulate the Stock Exchange to his own advantage, he was dismissed from the Navy and imprisoned; on his release he roamed the world, serving with the Chilean, Brazilian and Greek Navies. In 1831 he was cleared of the charge of fraud and was restored to his former rank, eventually serving as an Admiral in the British Navy from 1848 to 1854. On his return to England, he took up residence in the comparative seclusion of the park where he remained till 1845. Even more unusually, Joseph Bonaparte, Napoleon's elder brother, occupied the villa for a few months in 1840, probably as Dundonald's guest or tenant. From 1848, Matthew Uzielli, the banker and prolific collector of paintings, art, gems and glass lived in the villa. He was resident until 1897, and the house was then altered by Lutyens in 1911 for Lord Beatty. In 1926, the villa was then acquired by Ava Alice Muriel Astor, daughter of John Jacob Astor, the millionaire lost with the *Titanic*. She had married Prince Serge Obolensky the same year and it wasn't long before her mother, Lady Ribblesdale, was living next door at Regency Lodge. Astor was a remarkable woman and was prominent in artistic circles

in London, using her vast fortune to fund a number of worthy causes. Divorced in 1932, she married three further times. During the war and with the Blitz at its height, she ran her own mobile canteen serving the gun sites of an AA battery in the middle of Kent, then worked as an ambulance driver and latterly in a factory turning out radar equipment spare parts. Sadly she died at the young age of fifty-four in 1956. In 1948, Bedford College took over and thankfully Lutyens' additions were removed and the villa was restored and became a hall of residence for students. By 2012 the lodge was due to become the most expensive house in Britain, having been the residence of Conservative peer Lord Bagri, who paid £5.9 million to the Crown Estate in 1994 for a 150-year lease. Bagri spent over ten years refurbishing the lodge. A Ukrainian was due to pay £120 million, making it a record-breaker.

St Dunstan's Villa was built by Decimus Burton in 1825 for the Marquess of Hertford, who was in residence by 1829. Elmes clearly was enthusiastic about this new villa, describing it as having 'simplicity and chastity of style' and 'of beautiful simplicity'. It was certainly imposing, especially when seen from the southern garden side. The marquess was an unusual person and an avid collector with luxurious tastes and irregular behaviour. His gardens were filled with wonders – antique columns and statuary, the Meta, around which the charioteers turned, from the Circus Maximus at Rome, and more unusually, the famous striking clock made by Thomas Harris in 1671 for St Dunstan's church in Fleet Street. The medieval

church was demolished in 1830, to be rebuilt in its own churchyard for the sake of road widening, and the marquess, who had long coveted the clock, bought it for £210. He had it repaired and installed it in a specially built campanile in the grounds and hence the villa became known as St Dunstan's Villa. Hertford died in 1842, leaving a vast fortune, and the villa was left to Charlotte Strachan, Countess Zichy-Ferraris, who ultimately sold it in 1855. Henry Hucks Gibbs, merchant banker, scholar and bibliophile was the new resident, a deeply religious man, and became Baron Aldenham, taking the title from his birthplace in 1896. After his death in 1907, it was the home of Lord Londesborough for a short period of time until Otto Kahn, a banker of German origins, succeeded him in 1913. A man who loved the arts, his philanthropic nature persuaded him to allow his home in Regent's Park to be used for the re-training of war-blinded soldiers and sailors. In 1916, St Dunstan's Institute for the Blind was founded, taking its name from the villa, the lease of which it took over in 1921, whose leading light was newspaper magnate Sir Arthur Pearson, who himself became blind. He devoted himself to the care and training of those blinded in the war, setting up an establishment in St Dunstan's, and from 1921 till 1937 in St John's Lodge. By 1934, Harold Harmsworth, another newspaper proprietor, was the owner who restored the clock and reinstated it into Fleet Street. In 1936, the Woolworth heiress Barbara Hutton acquired the lease on the villa and demolished the house and built in its place Winfield House, a plain brick neo-Georgian residence designed

by Leonard Rome Guthrie of Wimperis, Simpson and Guthrie Architects. During the Second World War, the house was used by the Royal Air Force 906 barrage balloon unit and as an officer's club. Between 1951 and 1952 it was the home of comedian and actor Arthur Askey. Sold to the American government for $1, it has been the residence of the United States Ambassador ever since.

Holford House was the last to be built of the eight principal villas. James Holford was a wealthy City merchant and wine importer and applied to the commissioners in 1833 for land on the north-western edge of the park, close to the Zoological Gardens. Decimus Burton erected a magnificent mansion with a giant portico and semi-circular pavilions with cupolas at either extremity of the main façade. He lived at Holford until his death in 1854 and it was then occupied by the Regent's Park Baptist College until the outbreak of the war, when it moved to Oxford. Holford House was destroyed during the war and the site was levelled and is now part of the open space within the park.

The Doric Villa was in fact a pair of substantial houses at the eastern end of York Terrace. Designed by Nash himself, they were occupied by 1828 with an array of residents including the Reverend Henry Raikes and Miss Charlotte Finch Raikes, relatives of the diarist, Thomas, who was living at Albany Cottage on the western side of the park. At the end of the Second World War, York Terrace was found to be in the worst condition of any, and the Doric Villa stood empty and derelict, afflicted with dry rot. It has been restored on

a number of occasions and is today a fine residence overlooking the park.

Sussex Lodge was a detached house built behind Sussex Place, designed by John Nash for the builder William Smith. Its first resident was the Earl of Bective, the son of a member of George IV's circle. In 1840, Francis Grant, the President of the Royal Academy (who eventually became most famous for his study of Queen Victoria and Lord Melbourne riding together in Windsor Park), became resident. He died in 1908 and Sussex Lodge became the home of Lord Wavertree, 'one of the best and most generous-hearted of men', famous especially for breeding, training and owning racehorses. During the First World War, Sussex Lodge was equipped as a hospital for wounded officers with Wavertree resident until 1933 where he died. After his death, it was rarely occupied and was demolished in 1958 to make way for the Royal College of Obstetricians and Gynaecologists.

Abbey Lodge was built behind Hanover Terrace after an application by Mr George Birnie in 1826. No elevations or sketch exist of the Lodge but it was assumed Decimus Burton was the designer. Later drawings show a building unlike anything else in the park, a small Gothic mansion instead of a neoclassical villa. Mr Birnie took up residence calling the house Hanover Gate. By 1843, he was succeeded by Baldemero Espartero, Duke de Vitoria and Regent of Spain, hugely unpopular in his own country and hence taking refuge in England. By 1849 the house had become the residence of the de Bunsen family who lived there for over fifty

years. In 1840 Elizabeth Fry, the prison reformer, and her brother Samuel Gurney visited Berlin, taking with them Samuel's daughter, Elizabeth. On the journey, the younger Elizabeth met Ernest de Bunsen, son of Count Ernest de Bunsen, diplomat, theologian and scholar, who was Prussian Minister at the Court of St James. In 1845 the young couple were married, and as a wedding present Samuel Gurney gave them Abbey Lodge, as the house was by then called, the grounds of which joined his own residence, 20 Hanover Terrace. They lived at Abbey Lodge, raising their family until 1903 when they both died and the house became the London home and studio of the Austrian painter and sculptor Emil Fuchs until 1911 when Baroness Deichmann, the de Bunsen's elder daughter, wished to return to her parents' home. On her death, the house stood empty for a while until it was demolished in 1928 and its place taken by a block of flats which retain the name to this day.[5, 6]

The buildings defined the park and what Nash is primarily remembered for to this day. However, beyond all these buildings were the canal and the markets. Three markets had been planned but only one had been built. York Market was a meat market and was leased in 1812 by Robert Green, who eventually went bankrupt; the sites were parcelled out among other builders and speculators, and it was eventually built as Munster Square. Beyond were Clarence Gardens, intended as a vegetable market but eventually built as a residential area too. The third, Cumberland Market, replaced the Haymarket which was transferred there in 1830. The commissioners, though unwilling at first, agreed to the

move and the market continued to function into the twentieth century.

The Jew's Harp tavern had since re-opened and enjoyed a view of the canal basin. The whole of the site was leased by Nash himself in 1818. At the time, the canal company was in such financial straits that it had to cease work, the promised markets weren't built, and Nash, as Crown surveyor, had put a high valuation on the land. Nash enlarged the basin and let the wharf sites to tenants who invested in further works including buildings, roads and other necessary work. The fortunes of the company turned with the completion of the canal and Nash ultimately made a significant profit from the wharves, although he was initially questioned as to whether this was appropriate due to his position as a Crown surveyor. A select committee was appointed to probe the matter and declared itself satisfied that Nash had acted honourably. His responsibility for the canal basin was his most courageous contribution to the success of the park. Nash did however also take a wide margin of land on either side of the basin which he laid out and covered with buildings, including Park Village East, Park Village West, Augustus Street, and the now demolished Augustus Square. Nash was already an expert and versatile cottage architect and took this land for the express purpose of building a model village. Nash conceived cottage building as a pleasant pastime for an ageing architect and he would have been more than happy making such things, instead of participating in the disastrous undertaking to which his Royal master compelled him. Nash, in 1821, was ready to retire, but

at seventy-seven he was still at the beck and call of George IV and faced with designing the biggest single building of his career. Buckingham Palace cost him more trouble and anxiety than any other, and there was no time for cottages. So, although the park villages were built, they were not built in the way Nash would have liked, and probably he had little opportunity of controlling the designs.[7] By 1828, Nash's troubles were further exacerbated when he was investigated and then cleared in relation to his profits made by his speculating in Crown leases in Regent Street. Protected by George IV, who was keen to make him a baronet, the monarch died and he was denied the honour he so richly deserved. Despite the royal support, Nash was still ridiculed, but on the king's death, he was allowed to retire peacefully to his estate on the Isle of Wight where he died in 1835. Many of his obituaries were unkind, but would Nash have cared? Throughout his career, if he had worried about popular opinion, it is unlikely Nash would ever have achieved such an enduring monument. Nash had never courted popular opinion. Despite such unfair criticism, Nash's achievements at Regent's Park were held in high esteem by many. The Vicomte d'Arlincourt wrote,

The Regent's Park, above all, is a scene of enchantment, where we might fancy ourselves surrounded by the quiet charms of a smiling landscape, or in the delightful gardens of a magnificent country-house, if we did not see on every side a countless number of mansions adorned with colonnades, porticoes, pediments and statues,

which transport us back to London; but London is not here, as it is on the banks of the Thames, the gloomy, commercial city. Its appearance has entirely changed; purified from its smoke and dirt, and decked with costly splendour, it has become the perfumed abode of the aristocracy. No artisans' dwellings are to be seen here; nothing less than the habitations of princes.[8]

In reality, the inhabitants were mixed and the impossibility of maintaining it as an exclusively aristocratic area became apparent. Bankers, wealthy merchants and stockbrokers were all locals but they were also joined by more prosperous members of the professional classes, from the Church, Army and Navy, doctors, lawyers and publishers. Despite raptures from Elmes and d'Arlincourt, others were less enthusiastic.

Mr Nash is a better layer-out of grounds than architect, and the public have reason to thank him for what he has done for Regent's Park. Our gratitude on that point induces us to say as little as we can of the houses there, with their toppling statues, and other ornamental efforts to escape from the barrack style. One or two rows of the buildings are really not without handsome proportions, those with the statues among them; and so thankful are we for any diversity in this land of insipid building, where it does not absolutely mortify the taste, that we accept even the pumpkins of Sussex Place as a refreshment. We don't know what they mean nor why they are there; but there is something Eastern in their look, and they remind us, among other things, by a fantastic but not

unpleasing link in our memory, of the time when we have sat up in a tree in this very neighbourhood, reading the Arabian Nights! ... We have reason to be thankful that the Regent's Park has saved us from worse places in the same quarter; for it is at all events a park, and has trees and grass, and is a breathing-space between town and country. It has prevented Harley and Wimpole streets from going further; has checked, in that quarter at least, the monstrous brick cancer that was extending its arms in every direction.[9]

But what of the parkland itself? Public access was limited and discouraged with only limited entrances in the wealthy districts of Baker Street, Devonshire Place and Portland Place. It was ultimately George IV himself who instructed that the 'whole range and extent of the Parks should be thrown open for the gratification and enjoyment of the Public'. Despite this, Regent's Park, apart from the Inner and Outer Circle, remained fenced off from the public. Considerable portions of the parkland had been leased to various people, among them the nurserymen Jenkins and Gwyther and the Zoological Society. Residents who had houses immediately around or adjoining the park were allowed to use it, and were provided with keys at £2 per annum. Nobody else was admitted. The excuses given included the fear that the park might be used for immoral purposes and that the care of the newly planted trees precluded use. But as the years passed and the trees became more established, with no apparent change in policy, Regent's Park became the focus of sharper criticism.

It is an absurdity to think of it as a place of recreation and use by the public. It is not a public park, but a place set apart for the use of the wealthy only, and the people are permitted to grind out their shoes upon the gravel merely because they cannot be prevented. The ground is Crown land. It was formerly an open field, in which thousands found recreation and health. It was laid out with the avowed intention of converting it into a place for the public under conditions similar to those which regulate other parks, but the promise has never been fulfilled; and unless the loud voice of the people force the managers to a discharge of their duty towards them, it is too probable that it never will be. Thus it always is; that which belongs to the public, some private individual finds it convenient to take; and there is no machinery to prevent it ... until universal suffrage and annual parliaments.[10]

In 1835, 88 acres on the east, together with a narrow piece of land beside the canal, were opened to the public: the beginning of its life as a royal public park. In 1841, another 92 acres were opened, leaving only the grasslands around the villas, a narrow strip in front of the southern terraces, and the grounds of the Toxophilite and of the Royal Botanic Societies as restricted areas. 'The Park is always full, but on Sundays and holidays it really swarms with pleasure-seekers, who find in its trees, grass and flowers a very fair substitute for the fields of the country. During the summer months, a band plays on Sunday afternoons on the greensward by the side of the long avenue, and

is the means of attracting thousands of the working classes thither.'[11]

Three societies occupied pieces of ground within the park. The most ancient and least well known was the Toxophilite Society. Archery had for hundreds of years been practised by Londoners. The ground chosen for shooting was chiefly near Islington, Hoxton and Shoreditch. To encourage the use of bows and arrows, Henry VIII had ordered Sir Christopher Morris, Master of Ordnance, to form the 'Fraternitye or Guylde of Saint George' in 1537, with these archers shooting in Spital Fields. About the time of the Spanish Armada, the Honourable Artillery Company was formed, which possessed a company of archers, and for over 200 years archery was kept alive by this corps and, following them, by the Finsbury Archers. Just at the time when the corps was abolished Sir Ashton Lever formed the Toxophilite Society in 1781, and the archers of the Honourable Artillery Company became merged in the new society, which then shot on Blackheath. George IV belonged to it, and it became known as the Royal Toxophilite Society, and settled on ground given to it in Regent's Park in 1834. Five acres close to York Terrace at a rent of £125 per annum for thirty-one years was allotted, with 'ground suitably laid out, with a fine sunk lawn for archery practice'. Many younger residents joined the Society and soon became proficient with bows and arrows and social gatherings such as ladies' days and balls with bazaars became an established part of life in Regent's Park. Also by arrangement with the Toxophilite Society, the 'Skating Club' had their own

pavilion when the lawn was flooded during the winter for their use. Ironically, in 1830, the club were talking about the change of the English climate and decline of old-fashioned winters. Between 1830 and 1840 there was an average of ten skating days per winter, but between 1833 and 1834 there were none and between 1837 and 1838 there were thirty-seven days, with only eight between 1850 and 1860. Puzzling figures but a real topic for debate at the time![12]

The Royal Botanic Society of London was a significant occupier of Regent's Park, having been founded in 1838 and receiving a royal charter the following year. William Salisbury, a nurseryman and well known in his day, had suggested the creation of such a society and its location in Regent's Park as early as 1812 but nothing ever came of it. By 1827 the suggestion was made again, but this time by Dr John Robert Thornton, who declared he would be 'the happiest man in the world' if such a society were set up. Nash approved the scheme and even offered to subscribe £1,000 towards it but again it lapsed until 1838, when the Society was ultimately founded. Thanks to the efforts of James de Carle Sowerby, son of the author of the well-known *English Botany*, and assisted by Dr Frederick Farre, the Society became established and instrumental in the laying out of the gardens in the park. Eighteen acres which had been leased to Jenkins, the nurseryman who had already supplied trees for the park, were to become the Society's new gardens. Decimus Burton was once again commissioned to act as architect in conjunction with Richard Marnock, who had been curator to the Botanic Gardens in Sheffield.

Marnock was offered the post on the advice of the great landscape gardener of the time, John Claudius Loudon. Burton and Marnock laid out the gardens in very difficult conditions. Heavy clays were abundant and were extremely difficult to work with. Despite these troubles, the grounds were laid out with winding paths, a terrace on the northern boundary and several specialised gardens such as a Linnaean arrangement, medical, agricultural and manufacturing collections, an experimental garden, an American garden, a rose garden, a geographical arrangement of plants, and large borders of displays of all other varieties. The mound of earth excavated from the lake was made a feature of the gardens. Messrs Turner of Dublin built a conservatory of iron and glass, the first of its kind, and along with tents that were so large they had to be watched every night in case they blew away. These were erected for flower shows held in May, June and July and became very much part of the London scene. Loudon was initially critical of the early designs and hailed them a failure but was eventually well satisfied with the outcome. The Society became a significant pioneer in the exhibition of flowers and many continued and flocked to see them. Queen Victoria took a keen interest in the gardens, visiting often with her children, and before long club premises were built to facilitate lectures which became incredibly popular. However, the Society struggled in its early days and suffered a number of embarrassments, especially in relation to lack of funds and between 1839 and 1841 asked for the remission in rent each year, but was refused on all occasions. The Society had already

spent £12,000 on laying out the gardens but despite these heavy outlays and setbacks, the Society soon began to flourish through the nineteenth century. Its azalea shows were especially popular. However, Lady Evelyn Cecil commented in 1907,

It is always difficult to combine two objects, and this is the problem the Botanical Society now has to face. It is almost impossible to keep up the Botanical side and at the same time make a bid for popular public support by turning the grounds partly into a Tea Garden. Now that gardening is more the fashion than it has ever been, it is sad to see this ancient Society taking a back place instead of leading. It is actual horticulture that now engrosses people, the practical cultivation of new and rare plants, the raising and hybridising of florists' varieties. The time for merely well-kept lawns and artificial water and a few masses of bright flowers, which was all the public asked for in the Sixties has gone by. A thirst for new flowers, for strange combinations of colours, for revivals of long-forgotten plants and curious shrubs, has now taken possession of the large circle of people who profess to be gardeners. Apart from the question whether the present fashion has taken the best direction for the advancement of botany and horticulture, it is evident no society can prosper unless it directs its attention to suit the popular fancy. No doubt this worthy Society will realise this, and emerge triumphant.[13]

An excellent description and account of the Botanical Societies is detailed and described in 1878.

The grounds, which are about 18 acres in extent, allow of excellent opportunity for display; between 4,000 and 5,000 species of hardy herbaceous plants, trees, and shrubs flourish in the open air, and in the glasshouses about 3,000 species and varieties. The grounds were laid out by Mr Robert Marnock, the designer and former curator of Sheffield Botanic Gardens, assisted by Mr Decimus Burton as architect. In May, June, and July, floral exhibitions take place here, when nearly 3,000 medals are distributed, the value of them ranging between fifteen shillings and twenty pounds. About £1,000 is annually spent by the Society in the encouragement, acclimatization, and growth of rare plants. This garden, as we have stated above, occupies the spot said to have been reserved for a palace for the Prince Regent. It was for some time used as a nursery-garden by a Mr Jenkins and from this circumstance derived the advantage of having a number of ornamental trees, some of which are of respectable growth, already existing upon it when it was taken by the Royal Botanic Society. The numerous specimens of weeping ash, the large weeping elms, and many of the more common trees on the south-western side of the garden, are among the older tenants of the place. Although situated as it were in London, this garden does not suffer much from the smoke incident to the metropolis; and being in the midst of Regent's Park, with the ground falling away from it on most sides, while conspicuous hills and swells rise in the distance, this place is made, by a wise treatment of the boundary, to appear twice as large as it really is; for, from the middle of the garden, the fences

are scarcely at all seen, and much of the plantations blending with those outside, and with the surrounding country, great indefiniteness of view is procured.

In a landscape point of view, says the author of Weale's *London* in 1851, we may safely affirm that Mr Marnock has been particularly happy in the arrangement and planting of this garden. As a whole, the avowedly ornamental parts are probably superior to anything of the kind in the neighbourhood of the metropolis. Much has been attempted, especially in the variation of the surface of the ground, and almost all that has been proposed is fully and well achieved. We would particularly point out the clever manner in which the boundary fence is got rid of on the northern and north-western sides, as seen from the middle of the garden; the beautiful changes in the surface of the ground, and the grouping of the masses of plants, in the same quarter; the artistic manner in which the rockery is formed, out of such bad materials, and the *picturesque* disposal of the plants upon it; and the treatment of the large mound, from which so many and such excellent views of the garden and country are obtained ... Entering by the principal gate, not far from York Gate, continues the writer, the first thing deserving of notice is the very agreeable and effective manner in which the entrance is screened from the gardens, and the gardens from the public gaze. This is not done by large close gates and heavy masonry, but by a living screen of ivy, planted in boxes, and supported by an invisible fence. There are, in fact, two screens: one close to the outside fence, opposite the centre of the principal walk, and having an

entrance-gate on either side of it; and the other several feet further in, extending across the sides of the walk, and only leaving an opening in the centre. By keeping the ivy in boxes, it does not interfere with the continuity of the gravel walk, and has a neater appearance, and can, we suppose, be taken away altogether, if required. At any rate, it has a temporary look, which is of some consequence to the effect. These screens are from six to eight feet high. In a small lodge at the side, visitors enter their names, and produce the orders of the Fellows of the Society, which are necessary for seeing the gardens. After passing through the screen above described, we find ourselves on a broad, bold walk, at the end of which, on a slightly-raised platform, is the great conservatory. Before passing up this central walk, we will make the circuit of the grounds, starting by a pathway on the right-hand side. The ascent of a large mound is one of the first things that commands attention. Directly the visitor sets upon this walk he will perceive that an entire change of character has been contemplated. Instead of the highly-artificial features of the broad walk opposite the entrance, we are here introduced to an obvious imitation of nature. The surface of the ground is kept rough, and covered only with undressed grass – such, we mean, as is only occasionally and not regularly mown; the direction of the walks is irregular, or brokenly zigzag, and their sides ragged; the plants and trees are mostly of a wild character, such as furze, broom, ivy, privet, clematis, thorns, mountain ash, &c., and these are clustered together in tangled masses ... In the very midst of a highly cultivated scene, which

is overlooked at almost every step, and adjoining a compartment in which the most formal systematic arrangement is adopted in beds, and almost within the limits of the great metropolis itself, such an introduction of the rougher and less cultivated features of nature is assuredly to be deprecated. Several platforms on the face of the mound, and especially one at the summit, afford the most beautiful views of Regent's Park and its villas, Primrose and other neighbouring hills, and the more distant country. On a clear day, and the wind south-west, west, or north-west, these landscapes are truly delightful. There is a mixture of wood, grass, mansion, and general undulation, which is singularly refreshing so near London, and which abundantly exhibits the foresight that has been displayed in the formation of this mound. Unquestionably, when the atmosphere is at all favourable, the ascent of the mound is one of the greatest attractions of the garden to a lover of landscape beauties ... Descending the mound on its eastern side, a small lake, out of which the material for raising the mound was procured, is seen to stretch along its base, and to form several sinuous arms. Like the mound itself, an air of wildness is thrown around this lake, which is increased by the quantity of sedgy plants on its margins, and the common-looking dwarf willows which abound near its western end. In this lake, and in some of the small strips of water by which it is prolonged towards the east, an unusually complete collection of hardy water-plants will be found, and these are planted without any appearance of art, so as to harmonise with the entire scene. There is a rustic bridge over

one arm of the lake, which, being simple and without pretension, is quite in character with the neighbouring objects. Between the lake and the boundary fence, in a little nook formed on purpose for them, the various hardy ferns and *Equiseta* are cultivated. The plants of the former are put among masses of fused brick, placed more with reference to their use in affording a position for growing ferns than for their *picturesque* effect. This corner is, in fact, adds the writer, altogether an episode to the general scene and does not form a part of it.

The description continues,

On a border near these ferns, and extending along the south side of the lake, are several interesting collections, illustrative of one of the Society's objects, which is to show, in a special compartment, the hardy plants remarkable for their uses in various branches of manufacture. Commencing at the western end of this border, we find, first, the plants which afford tanning materials; the *Rhus cotinus* and *coriaria*, the Scotch fir, the larch, and the oak, are among these. Next in order are the plants whose fibre is used for chip plat, comprising *Salix alba*, the Lombardy poplar, &c. Then follow the plants whose fibre is adapted for weaving, cordage, &c.; the *Spartium junceum*, flax and hemp, rank in this class. The plants used in making baskets, or matting, &c., next occur, and embrace the lime and osier among others. Grasses of different kinds then illustrate the plants whose straw is used for platting. The cork-tree and *Populus nigra* furnish examples of

plants whose bark yields cork. A collection of plants whose parts furnish materials for dyeing finishes the series. Altogether, this is a very instructive border, and all the objects are labelled under the respective heads here given, so that they may be readily referred to. A large herbaceous garden adjoins the lake at its eastern end, and the plants are here arranged in beds, according to the natural system, the species of each order being assigned to one bed. Of course, the beds will thus vary greatly in size. Three or four crescent-shaped hedges are placed here and there across this garden, partly for shelter, but principally to act as divisions to the larger groups of natural orders. These hedges separate the garden into the great natural divisions, and each of the compartments they form is again subdivided into orders by walks four feet in width, the sub-orders being indicated by division-walks of two feet in width. The inquiries of the student are thus greatly aided, and he is enabled to carry away a much clearer impression of the natural system than can be had from books. This is an excellent place for ascertaining what are the best and most showy herbaceous border flowers. Further on, in the same direction, is a garden assigned entirely to British plants, disposed, in conformity with the Linnæan system, in long beds, with alleys between. In this division will be seen how very ornamental are some of the plants to which our soil gives birth; and the less informed will be surprised to find that many of their garden favourites are the natural products of some part or other of our own country. A well-stocked medical garden terminates this chain of scientific collections, and

is more pleasing than the other two, on account of the plants being much more varied. The arrangement of this tribe is founded on the natural system, and the plants are in narrow beds, which take a spiral form. Near the medical garden are the plant-houses, pits, and reserve-ground, in which all the plants are grown for stocking the conservatory, flower-beds, borders, &c. The plant houses are constructed in a very simple manner, with a path down the centre, flat shelves or stages at the sides, the hot-water pipes under the stages, near the walls, the lights resting on the side-walls, and all fixed, with ventilators, in the shape of small sashes, here and there along the top of the larger lights, on both sides of the centre. One of these houses, which is used for orchids, has no means of ventilation at all, except at the end, over the door, where there is a small sash capable of being opened. With proper shading it is found, both here and elsewhere, that orchids very seldom require fresh air. One of the span-roofed houses is almost wholly occupied with a cistern containing the great *Victoria regia, Nymphæa cærulea,* and other aquatics. From the reserve-ground a few steps lead to the large conservatory, which is more appropriately termed the winter-garden. At the eastern end of this conservatory, and in a corresponding place at the other end, there is a large vase placed on the gravel; and along the front of the conservatory, at the edge of the terrace, are several more vases, of a handsomer kind. The conservatory, which is of large dimensions, is of the very lightest description, built wholly of iron and glass. The front is simply adorned with a kind of pilaster, composed of

ground glass, neatly figured, which gives a little relief, without obstructing the light. The central flattish dome has an ornamental kind of crown, which helps to break the outline. The roof is, for the most part, composed of a series of large ridges, the sides of these being of an inverted sort of keel shape, and a transverse ridge extending along the principal front from either side of the domical portion. The warming of the building is effected by means of hot water circulating in cast-iron pipes, placed in brick chambers under the surface of the floor, and by a continuous iron tank, eighteen inches wide and six inches deep, placed in a brick chamber around the building. The heated air escapes by perforated castings level with the floor, and air ducts communicate with the chambers containing the pipes and tank, bringing air to be heated from parts of the house most remote from the heating surface. Ventilation is provided by means of sashes made to slide on the roof, and worked simultaneously by means of simple machinery, and at the ends of the house and in the front by casements hung on pivots. The conservatory is capable of accommodating 2,000 visitors, and it was erected at a cost of about £7,000. The gardens are open every week-day, from nine till sunset, and on Sundays after two o'clock; and we need hardly add that during the summer, or in the height of the London season, its pleasant pathways and rustic walks form very agreeable promenades and lounges for the upper ten thousand.[14]

Sadly, by 1932, its lease ended and the Society's funds were insufficient to meet the increase in rent demanded.

The Society disbanded and the gardens were taken over by the Royal Parks Department and renamed the Queen Mary's Garden after the concern and interest she showed when the conservatory was demolished and a number of trees were felled.

The Zoological Society is perhaps the most well-known occupier and resident society in Regent's Park. It was the first of the three societies to settle in the park, having been there since 1826. The Society was the idea of Sir Stamford Raffles, who became its first president in 1825. In three years there were over 12,000 members, and the gardens were thronged by 30,000 visitors. A pass signed by a member was necessary for the admission of every party of people, besides the payment of a shilling each. An abuse of this soon crept in, and people would wait at the gates to attach themselves to the parties entering, and well-dressed young ladies begged the kindness of members who were seen approaching the gates. From newspaper reports, we know there were monkeys, a large variety of birds, gazelles, bears, foxes, emus, llamas, zebras, turtles, beavers, goats and jackals. All were donated. In 1836, giraffes were acquired and Decimus Burton was appointed to design a special house for them. The first chimpanzee arrived in 1837. The Zoological Gardens continued to be popular with an enormous amount of prints and lithographs showing the various species displaced. Animals that were now displayed included a Cuban bloodhound, an elephant, rhinoceros, and a 'terrible man-eating hyaena'. By 1845, new open-air terraces were built which immediately benefited the

health of its carnivorous inhabitants. A change in leadership in the Society allowed the public admittance at a shilling a head but without the need of a letter of introduction from a Fellow of the Society. The gardens continued to expand and land on the far side of the canal was rented to house the increase in variety of its collections. There was a record number of visitors in 1851 when 'all England came to London to see the Great Exhibition and the Gardens were thronged again for the International Exhibition of 1862 and again in 1876 when the Prince of Wales, later Edward VII, brought a collection of animals from India'.[15] The admissions that year exceeded 900,000. A new reptile house was built and in 1868, a new elephant house was designed by Anthony Salvin and further improvements for lions, tigers and other carnivores. The Zoological Gardens were thriving and would continue to do so well into the twentieth century.

Descriptions of the Regent's Park were plentiful during the mid-nineteenth century. *Punch* described it between January and June in 1842 as follows:

The Regent's Park consists of two circles, which are intended to communicate with each other, but an experienced person is sometimes puzzled to discover how. The houses which nearly surround the outward ring are looked upon as wonders of architectural design and execution. The liberality of the genius employed is manifested in the generous conglomeration of style which is everywhere apparent. The Corinthian and Ionic are continually contrasted with the simple Doric and the

street-doric. Here stands the Colosseum, which is a very large building, and we hope it pays; but the lion of Regent's Park is the Zoological Gardens. The animals in the collection are particularly well fed and well behaved, and have strict orders never to devour a subscriber should they have the opportunity. The Diorama is also in this locale and may be seen without any difficulty by payment of a shilling. The Regent's Park is principally frequented by little boys with hoops, tradesmen who keep an animal, and men with water-cart.[16]

In 1844, Mogg describes the park in detail.

The Regent's Park, formerly known as Marylebone Park, originally consisted of about 450 acres, and its form in that state may still be traced in a line upon the Plan of London ... In its former state it was justly esteemed one of the most beautiful spots in the vicinity of the metropolis. It is Crown property; and at the expiration of the lease in 1812 was devoted to its present purpose by Nash, then the Crown surveyor. Various plans for its improvement were submitted to government; but Nash, at that time the favourite of George IV, triumphed: his object was not the public good, but his own pecuniary advantage, which, in the shape, of percentage, he calculated on receiving; and, consequently, a large portion of the property was devoted, not to the purposes of a pleasure-ground, but to a building speculation, his commission on which, with other advantages, must have been enormous. We now proceed to describe it as it exists, abridged of its fair proportions. It is too

contracted: the long range of terraces on the eastern side, if carried out to its former boundary in that direction, would have added very considerably to its beauty and extent; the continuity of this line of building, for it is little else, is much too crowded, and in the absence of occasional openings requires relief. The western side is in somewhat better taste, with the exception of Sussex Place, which is ridiculously fantastic the southern side possesses too much of uniformity to be pleasure; and the northern is the only side un-appropriated to building if we except the lodges of the Zoological Society, whose gardens are the grand attraction here. The interior, laid out as a pleasure ground, is chiefly indebted to the natural beauties of its situation and inequality of surface for the praise bestowed upon its appropriation; which, even in their uncultivated state as common fields, were universally admitted to be most beautiful. The introduction of an ornamental sheet of water is, however, in good taste; an observation that does not apply to roads laid out in straight lines and circles. A perambulation of the Park, commencing at the south-east corner of Park Square, will conduct to the following places and terraces, here arranged in regular succession. They consist of St Andrew's Place, the Colosseum, Cambridge Terrace, Chester Terrace, Cumberland Terrace, St Katherine's College, with the master's house, and Gloucester Terrace. Arrived here, a gradual sweep of the road shortly after continued in a straight line conducts to the Zoological Gardens, and thence to Macclesfield Gate; at this point the road takes another turn, and sweeping past the Marquis of

Hertford's Villa, is continued in a south-west direction to Hanover Terrace, Sussex Place, Clarence Terrace and Gate, and Cornwall Terrace; taking a direction due east, it passes York Terrace and Ulster Terrace, and, crossing the north side of Park Square, completes the circuit at St Andrew's Place.[17]

Peter Cunningham described the park in 1850 in his *Handbook of London*:

through the Park on a line with Portland-place to the east side of the Zoological Gardens, runs a fine broad avenue lined with trees and footpaths which ramify across the sward in all directions, interspersed with ornamental plantations; these were laid out in 1833, and opened in 1838, up to which time the public were entirely excluded from the inside of the park, except from the gardens opposite Cornwall and Sussex-terraces, which were free, up to the ornamental water, to the inhabitants of the park on payment of two guineas per annum for a key. Around it runs an outer road, forming an agreeable drive nearly two miles long. An inner drive, in the form of a circle, encloses the Botanic Gardens. Contiguous to the Inner Circle is St John's Lodge, seat of Baron Sir Isaac Lyon Goldsmid, overlooking a beautiful sheet of water, close to which is the garden of the Toxophilite Society. On the outer road is the villa of James Holford, Esq. St Dunstan's Villa, somewhat south of Mr Holford's, was erected by Decimus Burton for the late Marquis of Hertford. In the gardens of this villa are placed the identical clock and

automaton strikers which once adorned St Dunstan's Church in Fleet-street. When the marquis was a child, and a good child, his nurse, to reward him, would take him to see 'the giants' at St Dunstan's, and he used to say, that when he grew to be a man 'he would buy those giants'. It happened when old St Dunstan's was pulled down that the giants were put up to auction, and the marquis became their purchaser. They still do duty in striking the hours and quarters.[18]

A detailed description of the park in 1851 by Edward Kemp (landscape gardener of Birkenhead Park) provides a splendid tour of the park as surveyed by Sayer in 1847, and highlights the singularity of different parts of the landscape. While praising its virtues, Kemp's keen eye is not uncritical, and draws attention to details which confirm the rudimentary structure of parts of the park. Kemp's compass points are a little askew, but his references are clear.

The leading characteristics of this park are the long straight walk, the ornamental water with its bridges, the broad open space on the north-western side, and the villas and terraces ... There is a great air of finish and neatness, too, in the keeping of the whole, the lines of the walks being well defined and maintained, and the edgings kept good. This may in part be owing to the limited number of visitors which find their way here, as compared with the other parks; but it must also be due to the greater amount of attention which is given to it. The Long Walk is apparently about a mile

in length, and extends from the south end nearly to Primrose Hill. It is forty feet wide, on a rise most of the way, and attaining the top of a low hill near the end. On either side of it, there are four lines of trees, which are all elms towards the upper end; but, unfortunately, the character is changed at the lower part, by the use of a row of horse-chestnuts in front, with three rows of limes at the back [the back row on each side were actually elms as Clutton described]. The trees are now about twenty or twenty-five feet high, and rather stunted considering the diameter of their trunks. They are also becoming somewhat crowded. The public are permitted to walk amongst them, as well as on any part of the grass; and all the plantations have been thinned out, and the lower branches of the trees pruned off, so that persons, and cattle may roam about amongst them at pleasure. There is however, no kind of undergrowth to them, and low ornamental trees, shrubs, and bushes, have been quite excluded from the park, to the manifest injury of its character. That part of the park near the ornamental water is in all respects the most interesting. The water itself is of a good form, with its terminations well covered, and several fine islands, which are well clothed with trees. It lies also in the midst of some villas and terraces, from which it receives additional beauty. It is on the south side of the park. Some noble weeping willows are placed among its southern margin. Three light suspension bridges, two of which carry the walk across an island at the western end of the lake, are neat and elegant, but the close wire fence to their sides sadly interferes with the beauty of their form. These bridges are

made principally of strong wire rods. It is to be regretted that the material which came out of the lake at the time of its formation has been thrown into such an unmeaning and unartistic heap on the north side; although the trees which have been placed upon it in some measure relieve its heaviness. Here, perhaps, more than anywhere else, a good mass of shrubs, as undergrowth, would have been of the greatest assistance. Passing along the western road from Portland Place to the Inner Circle, there is a very *picturesque* and pleasing nook of water on the right, where the value of a tangled mass of shrubs for clothing the banks will be very conspicuously seen. Between the water and top of the long walk lies the broad open space we have before mentioned, which is on the slope of a hill facing the west. Perhaps, as this area is intersected with several walks, it may be a little too bare, and might possibly be improved by a few small groups of trees or thorns; but in parks of this description, such a breadth of grass glade, especially on the face of a hill that does not front any cold quarter, is of immense value, both for airiness and for effect. It will only want some scattered groups of trees along the edge of the slope, near the summit, to form a foreground to any view that may be attainable from the top of the hill, and also to get a broken horizontal line when looking up the slope of the hill from the bottom. The space we are speaking of is by no means favourably circumstanced in the latter respect as the hill is crowned by the fourfold avenue of the long walk, which presents an exceedingly flat and unbroken surface line. This consideration renders it very undesirable to carry avenues over any kind of eminence,

when they are at all likely to be viewed from the side, and particularly when they are seen from lower ground ... several fine villas, with ample pleasure grounds, besides a number of stately terraces, which are built so as to present two good fronts, the offices being kept in the basement, and concealed, adorn and improve the park rather than interfere with its effect. The handsome villa of the Marquis of Hertford, on the north-west side is, especially, a conspicuous ornament, but the plantations about it, chiefly composed of poplars, are of the commonest and most inferior character, and quite disfigure both the house and the park. Mr Bishop's mansion [South Villa] and observatory is an object also of science and beauty. The garden of Baron Goldsmid [The Holme] near the Inner Circle, rather enhances the beauty of the park, being so well seen from the opposite side of the lake. The Coliseum on the east side of the park, with its ample dome, contributes much to the effect from various points. The whole of this park is to be thoroughly drained; its clayey subsoil having long caused a damp unhealthy atmosphere to hang over the district during autumn and winter. The advantage of good drainage in such a locality cannot be over-estimated, whether as it respects the public health and comfort or the progress of the trees. But it can, at best, be only imperfectly done now, unless the whole of the surface be again broken up. The full extent of [the park], which is decidedly one of the finest of the London parks, is nowhere seen, in consequence of the public road crossing it towards the south end, and the Inner Circle being taken out of it.

The foresight of John Fordyce, the vision of John Nash, and the tenacity of James and Decimus Burton were all significant contributors to the development of the Regent's Park. Decimus went on to have a significantly successful career. At the age of twenty-five Burton was commissioned by the Office of Woods and Forests to carry out a series of works intended, in the words of John Summerson, 'to bring Hyde Park within the monumental orbit of the palace'. He laid out paths and driveways, and designed a series of lodges, and an Ionic screen and triumphal arch at Hyde Park corner. These last two originally formed a single composition, designed to provide a monumental transition between Hyde Park and Green Park, although the arch was later moved. His other work for the Office of Woods and Forests included the elaborate Parliamentary Stables at Westminster. In 1824 he was commissioned by the Athaeneum Club to build a clubhouse for them on the west side of Waterloo Place. The task was complicated by the Office of Woods and Forests' initial desire to have its façade matching that of the United Services Club opposite, on which Nash was working. This demand was eventually dropped and Burton's building was constructed in 1829–30, its exterior decorated with a full-size replica of the Panathenaic frieze. Burton later made alterations to the United Services Club. In 1828 Burton's father James bought up an estate at St Leonards, Sussex, to develop as a holiday resort. It had a frontage of about two-thirds of a mile. Burton was probably the architect of the central section, a hotel with giant Corinthian columns, flanked by terraces in the Tuscan

order. Burton laid out the landscape and designed the buildings at the Beulah Spa, a spa and pleasure gardens in Croydon, for the entrepreneur John Davidson Smith. It opened in 1831 and became a popular society venue attracting large crowds to its fêtes. Burton's buildings were in a 'rustic' style, with the ticket office in the form of a thatched cottage. The spa closed in 1856 soon after the opening nearby of the Crystal Palace. Burton also drew up designs for a grand crescent of terraced houses on the hill above the spa, which was, however, never built. Burton also had a thirty year association with the Royal Botanic Gardens, Kew, starting initially with the layout of gardens and paths before moving on to major buildings. With iron founder Richard Turner, he designed the glass and iron Palm House (1844–48); at the time, this greenhouse was the largest in the world at 363 feet long, 100 feet wide, and 66 feet high. He then designed the even larger Temperate House, but did not live to see the project completed: although a section opened in 1863, lack of funds meant it was not finally completed until 1898. Other projects at Kew included the Main Gate (1846) and the Water Lily House (1852). Another major concentration of Burton's work is at Fleetwood on the Lancashire coast. Burton's work with his father on the East Sussex town of St Leonards-on-Sea (1827–37) had impressed wealthy landowner and fellow Athenaeum Club member Sir Peter Hesketh Fleetwood, who commissioned Burton to lay out his new port and seaside resort. Burton's buildings include the North Euston Hotel, Pharos Lighthouse and Beach Lighthouse, Queen's Terrace, St Peter's church, the

Town Hall and his own house on Dock Street (where he lived until 1844). Decimus Burton retired in 1869, died in December 1881 and was buried in Kensal Green Cemetery.

Decimus Burton's contribution was hugely significant, but it is the work and designs of landscape architect William Andrews Nesfield that are often overlooked. Born in 1794, W. A. Nesfield was the eldest child of the Reverend William Nesfield and Elizabeth, daughter of John and Elizabeth Andrews of Shotley Hall, Northumberland. After his early days in Durham and university in Cambridge, he embarked on a military career, starting at the Royal Military Academy in Woolwich in 1809. By 1818 he had resigned from the Army and turned to what he had wanted to do for a long time – become a professional watercolour painter. Years of training while in the Army had developed Nesfield's natural talent for painting and drawing; at the Academy in Woolwich he had been taught the essentials of civil architecture and perspective by Thomas Paul Sandby. After sketching and painting in his native County Durham, in 1820 he undertook a sketching tour in Switzerland with his friend and fellow artist Newbey Lowson, the squire of Witton-le-Wear. On his return to England, Nesfield moved to London with Anthony Salvin, who then was just starting out on his architectural career and eventually became Nesfield's brother-in-law. Nesfield joined the Old Watercolour Society in 1823 and had many opportunities to exhibit his pictures. During the 1820s and 1830s Nesfield continued to paint and sketch in England, Wales and

Scotland. He married Emma Mills in 1833, and after a brief time in Bath where their eldest son, William Eden, was born two years later, the couple moved to Muswell Hill, London. After a brief move to Eton, the family returned to London to 3 York Terrace, Regent's Park, where Nesfield was to remain until his death in 1881.

Following his marriage in 1833, Nesfield turned to landscape gardening as a profession, working in collaboration with Salvin, who suggested that he design formal gardens to accompany the Gothic revival houses that he, Salvin, was then engaged in building. Nesfield's career lasted over thirty years and encompassed over 200 estates. He travelled the country with an album containing designs of parterres copied from seventeenth-century French gardens, illustrating the work of such 'Old Masters' as Le Nôtre, Mollet, Boyceau and Le Brun. Of British practitioners, he was familiar with the writings of Sir Thomas Hanmer and John Evelyn; the designs of George London and Henry Wise; and the bird's eye views of Leonard Knyff and Jan Kip. Authorities nearer his own day included George Mason, William Gilpin, Humphry Repton, J. C. Loudon and, most important of all, Uvedale Price, whose writings on the *picturesque* formed the backbone for much of Nesfield's thinking. However, he was always at pains to stress his skills as a painter and that landscape gardening was 'the Art of painting with Nature's materials'. It must not be thought, though, that Nesfield was solely a designer of parterres. His accomplishments were many and various: they extended to fashioning lakes, fountains and cascades; positioning new houses, lodges

and gateways; screening railway lines; planting trees and avenues; designing arboreta, heatheries and Rosaria; siting garden ornaments; advising on topiary; laying out terraces and balustrade walkways; thinning and felling trees; and of course, horticultural, in addition to geometrical, designs for parterres.[19]

By 1827 Regent's Park was largely complete and plans of the time show the Broad Walk avenues which consisted of four rows of trees on either side of a walk; horse chestnut on the inner row, then lime, horse chestnut and finally lime on the outer row. However, early on it was apparent that there were problems with the plantations: in 1826 in *The Gardener's Magazine* Loudon had raised certain aesthetic objections to the plantings in the park, claiming that the single trees dotted all over the open spaces had been planted without the slightest regard to effect, and he concluded acidly, 'to say that they are in bad taste, would be paying them a compliment – but they display no taste whatsoever; all that can be said is, that somebody has been ordered to plant a number of single trees, and that single trees have been planted accordingly'. In addition to these complaints it was also clear by the 1830s that a number of trees throughout the park were failing to grow properly. Of particular concern were the horse chestnuts, especially those in the Lower Avenue of the Broad Walk. In 1855 John Clutton, the eminent land surveyor, was asked to advise on the plantations, and the horse chestnuts, which were of very stunted growth. Clutton advised leaving the trees for a while, and three years later when he was consulted for a

second time he believed they had made good progress, and he counselled against thinning them. In the winter of 1859/60, Clutton's suggestions for trenching and manuring the ground were carried out, but by the summer of 1860 little improvement to the growth of the trees was visible. Later that year John Lindley was asked to advise on the trees: the limes and the elms were thriving, but the horse chestnuts in the first and third rows were still uneven. Some were prospering but most were described as 'cabbage-headed', and a number were hopelessly stunted, especially in the third row. Lindley suggested four alternatives, all centring on the removal of some or most of the horse chestnuts.

Within the month, in January 1861, William Andrews Nesfield was called in to advise on the avenues. He first proposed removing the entire first and third rows of horse chestnuts but, recognising that this would incur public displeasure, he proposed a selective removal of the stunted trees and the creation of a dress ground in a geometric arrangement. This area was to include sculpture supplied by Austin & Seeley, whose Artificial Stone Works was nearby in Euston Road. Initial letters and estimates during 1862 refer to twenty-four kerbed flower-beds with simple external mouldings; eight large tazzas, 5 feet in diameter, with pedestals; eight upright vases with pedestals; and four ornamental kerbs to circular beds, 13 feet in diameter. By January 1863 Nesfield had produced a plan for the flower garden laid out in an Italian style and located within the four existing rows of trees. At the same time a further selection of sculpture was supplied by Austin & Seeley,

including a tazza, 7 feet in diameter, supported by four griffins; more vases, tazzas, finials and pedestals; and a quantity of plain and moulded kerbs for the flower-beds.

In February and March the work was put out to tender by the Office of Works: Joseph Meston was contracted to lay out half of the proposed Avenue Gardens 'in accordance with the plans and specifications prepared by Mr Nesfield'. James Veitch submitted an estimate for planting a protecting belt to the garden which included privet, hornbeam, lilacs, standard thorns, *Berberis darwinii* and fine pyramid *Quercus fordii*; he also tendered for the planting of the west division for the Avenue Gardens, at a cost of £250.

In June 1863 Nesfield was asked to put forward a plan for a layout for the eastern side of the avenue. Austin & Seeley was approached for more sculpture and, although Nesfield had not finalised his design, they estimated that a further 600 feet of plain kerbing and 164 feet of moulded kerbing would be required. Three tazzas, four baskets with pedestals, and three Grecian vases with pedestals were also quoted for, and in July the estimate was accepted for the sum of £262. At the same time the Office of Works accepted Meston's tender for constructing the eastern walks for the sum of £480. Work began immediately, and in August Messrs Hill & Smith tendered for the supply of ornamental fencing to the Avenue Gardens. In the same month Nesfield was requested by the Office of Works to select plants and trees from Veitch's nursery to a maximum value of £300. An early editorial in *The Gardener's Chronicle* for 15 August 1863 lamented the removal of the original avenue of trees:

Once upon a time, a pedestrian, happening to find himself, some sultry summer's day, in the neighbourhood of the Regent's Park, and desirous of pleasant exercise while inhaling the cool and freshening breezes which he might hope to find sweeping down from Primrose Hill, could have strolled the whole length of the Park from south to north – a goodly promenade – under the shade of lines of trees of, we suppose, some 40 years' growth. On either side of a gravel walk of noble proportions, he would have found Horse Chestnuts, Limes, and Elms in quadruple rank, forming three umbrageous avenues, with seats at intervals, the trees always furnishing a most delicious sweetness. Nothing could possibly be more pleasant and enjoyable, as we know from experience; and nothing certainly more entirely in accordance with the proper furniture of a Park. Now, however, the evil genius of alteration seems to be in the ascendant, as we have ourselves with sorrow observed ... we by no means agree in the conclusion that the promenades in our parks ought to be converted into 'beautiful garden walks', certainly not at so great a sacrifice as has in this case been made.[20]

A year later, a second editorial on Regent's Park appeared in *The Gardener's Chronicle* but this time the author was fully reconciled to the loss of the original avenue by 'the clever and beautiful CLASSICAL GARDEN which has been laid out by MR MARKHAM NESFIELD'.[21] The complaints of a year earlier were replaced by a generous and detailed account of the garden, noting the eastern and western divisions, each divided into three sections with two ante gardens, north and south of a

central garden. The central garden on the western side contained the large tazza supported by griffins, standing in the centre of a kerbed bed which was flanked north and south by two long, sunk flower panels on grass. The ante gardens were of a different arrangement, with a broad central path planted on both sides with a line of Lombardy poplars, and side borders planted with trees and dwarf shrubs arranged in lines and masses. On the eastern side the two ante gardens were similar in style to those on the western side, planted with Lombardy poplars. The central compartment was altogether different, 'owing to the necessity of introducing angular walks to facilitate the dispersion of the crowds which occasionally congregate', and was distinguished by two geometrical tapering flower-beds laid out in a guilloche or cable frieze pattern, although some plans show a diagonal planting, which were claimed to be 'the most original and beautiful examples of colouring seen for a long time'. The gardening press repeatedly credited Markham Nesfield with the geometrical gardens in the avenue, but also mentioned the 'commodious red-brick gardener's cottage' near the south entrance of the Park designed by William Eden Nesfield.[22]

At some point during 1863 Markham Nesfield had taken over the project from his father, and by 1864 the Office of Works was instructing Joseph Meston to liaise with him on modifications to the verges, fences and walks. A year later, in August 1865, Markham Nesfield was asked to advise on the planting of flowers in the Avenue Gardens. Again in 1867 and in 1868 Nesfield was asked to advise on the summer bedding

schemes for both the west and east side of the Avenue Gardens, and an article in *The Gardener's Magazine* for June 1875 carried a complete list of the plantings in the eastern section, together with a plan of the two flower-beds in the central section. By 1872, a report in *The Gardener's Chronicle* observed that 'the Avenue Gardens, though not wanting in flowers, are not so well kept as formerly', although the author still found the arrangement 'brilliant and novel'.

The many illustrations reproduced at the time show

the centre of the new and beautiful flower garden recently completed in the Regent's Park, which is laid out in the French-Italian style. On each side of the garden a row of handsome trees forms a grateful shade from the heat of the sun and a pleasing background to the brilliant denizens of the parterre. The garden is in the form of an oblong, divided into three principal parts. Entering at the end nearest to Ulster-terrace, we have before us a most brilliant *coup-d'oeil*. A broad gravel walk here divides the garden into equal parts for about a fourth of its length; a continuous border forms the outer portions of this part of the ground, the extreme edge of which is bounded by a low hedge of hornbeam [a tree which greatly resembles the beech, and is often mistaken for it]; this border is planted with variegated laurels, hollies, and, at equal distances along its length, groups of standard almond, laburnum, and hawthorn trees. Beds are cut in the turf, alternating with elegant vases standing in raised beds surrounded by stonework; these are planted in ribbons of scarlet-geranium, *lobelia*,

calceolaria, variegated and ivy geraniums, &c. Two large square beds are particularly noticeable; planted with crimson geraniums, they form an extremely handsome mass of colour; but it is a pity that a few plants of a lighter shade of the same colour have been introduced amongst them, as they only look like faded flowers of their more brilliant companions. Near to the light iron railing which protects the turf from the feet of the passers-by are small round beds, situated at equal distances, and sown with *lobelia* and *mignonette* alternately, a young poplar tree rising from the centre of each bed; these trees produce anything but a pleasing effect, and, indeed, greatly detract from the beauty of the garden. The trees which border the outer edges of the ground will no doubt, in a short time, have to be thinned by cutting down every other one to give light and air to the garden, and there really seems to have been some want of thought and foresight in planting along the inner portions of the garden trees like poplars, which have not even the recommendation of being evergreen. The pretty spring-flowering azalea, and other flowering shrubs, would have been more suitable; or the graceful juniper-tree and handsome *auracaria*, placed alternately, would have had a much better effect; at any rate, all must acknowledge the poplars to be most unsightly. The broad walk terminates at about a fourth of the entire length of the garden, and, dividing, leaves the principal part of the garden in the centre. This portion is also laid out in borders of different shapes amongst which are very handsome vases also surrounded by raised beds. There is a greater variety of plants in these,

and we noticed as a good feature the introduction of evergreens forming a hedge through the centre of the borders, which not only presents a pleasing contrast to the bright flowers on each side of them, but will in the winter keep the garden from having a bare appearance. We think variety and strong contrast have scarcely been enough studied in the planting of these borders, as the vases and beds are almost a repetition of those already mentioned, with the exception of the forming of some of the ribbons with the beautiful purple king *verbena* and *cerastium*. Fuchsias, except in the great centre vase have been quite lost sight of, as also the handsome *perilla narkinensis*, the dark purple leaves of which form such a magnificent contrast when planted next a ribbon of bright scarlet or yellow. Along the left-hand side of this portion of the garden is a continuous indented border, hedged by hornbeam and planted with Persian lilacs, &c; an edging of dwarf nasturtiums gives colour to this portion of the ground. In the centre of the garden – which forms the subject of the Illustration – is a circular mound surmounted by a massive vase supported by four griffins. The vase is filled with fuchsias, and scarlet and ivy geraniums, and *lobelia*, and finished by a handsome stonework edge. The turf surrounding this centre vase has small circles planted with box trees, &c. After passing the centre, the next half of the garden is the same as the first, although there is a little variety in the planting of the borders. Some handsome double poppies are introduced among the shrubs with a good effect, their height making them suitable for such a situation, the very small annuals placed in the same position in

the first half of the garden having only the appearance of pretty straggling weeds. On the opposite side of the road a similar garden is being formed, but will be much diversified in the laying out. When this second garden is finished it will doubtless form one of the most delightful promenades in London. Already it must be a source of great delight to those living within easy access of it; and we have but to see the crowds who flock thither on a Sunday afternoon to know how fully such places are appreciated by the public.[23]

The Avenue Gardens were largely complete by the end of the 1860s.

Markham Nesfield continued to be associated with Regent's Park. The English Gardens were laid out between 1865 and 1867 in the area between the Avenue Gardens and the Outer Circle and to the south of Chester Road to his designs. These works were undertaken immediately after completion of the adjacent Avenue Gardens and were deliberately informal in style, later interpreted as English in contrast to the perceived Italianate style of the Avenue Gardens. Initially the gardens appear to have been referred to as the Colosseum Gardens, since the Colosseum was, until 1875, a dominant feature on the Outer Circle overlooking this area of the park.[24]

Prior to the laying out of this area by Markham Nesfield, the area between the Avenue Gardens and the Outer Circle had consisted simply of a wide, flat expanse of grass with mature trees. In the context of the newly created and much admired Avenue Gardens,

one contemporary account in 1864 describes how
'at present, it certainly bears a rather meaningless
character',[25] and another describes how 'owing to the
crowded state of the trees the area is in many places
destitute of grass'.[26] This part of the park had been
initially opened to the public at the same time as the
neighbouring Broad Walk Gardens in 1835. Markham
Nesfield had already assisted in the layout of the
bedding in the Avenue Gardens for his father William
Andrews Nesfield, who had by then become infirm. So
when the Board of Works turned its attention to the
adjacent area, to the east of the Avenue Gardens, it was
predictable that Markham should be asked to supply
plans for the laying out of new gardens. In September
of 1865 the Board of Works wrote to a contractor,
Mr Neston, requesting him 'to submit a tender for
the alteration of ... beds in the shrubbery east of the
Avenue in Regent's Park and for erecting mounds
and planting ... in accordance with a plan of Mr
Nesfield'. By November, contracts were signed and work
continued until October 1866. In May 1867, Neston
submitted a further tender document for additional
work which included 'the finishing of the groundwork;
formation and preparation of groups for ornamental
planting, and otherwise embellishing the ground'. The
gardens were known as the Colosseum Gardens until
at least 1875, but with the Colosseum in such poor
condition, it was ultimately demolished. Shortly after
the completion of the gardens in 1874 Markham
Nesfield died after a riding accident in Regent's Park.
Contemporary descriptions of the gardens between

1874 and 1878 clearly indicate that flowers played an important part in the overall effect and were used in the following ways: herbaceous perennials around the edges of shrubberies; and island beds, some containing a single species of hardy and half-hardy annuals, some containing semi-tropical planting. 'In the beds are castor-oil plants, *Dracaenas*, *Aralias*, *Arundas*, India Rubber plants and the old-fashioned hollyhock whose fine form is desirable for the sake of variety. Nothing very delicate or tender is introduced.'[27] *The Gardener's Magazine* wrote in 1875, 'The lawns are planted with dwarf trees and shrubs ... most of the shrubberies have borders of perennials ... such as *Campanula*, *Iberis*, *Dianthus*, *Aralia Sieboldi* and *papyrifera* ... in the large flower-beds we find *Ferdinanda eminens*, *Nicotiana tabacum* and *Ricinas* of several kinds.'[28] By 1874 the Colosseum Gardens formed an informal pleasant area which complemented the adjacent formal flower gardens. A description from *The Garden* that year described the established layout as being 'an open undulating space laid out after the manner of an English pleasure ground, with serpentine walks and different-shaped clumps, containing selections of the finer kinds of flowering shrubs and evergreens ... of these some of the most striking are also planted singly on the grass'.[29]

Towards the end of the nineteenth century, the park was still continuing to change and evolve. Nash and Nesfield had already made their mark and further additions were being made. With the admission of the public, gifts of sculpture were encouraged such as the wonderful drinking-fountain presented by the

benefactress of London, Baroness Burdett-Coutts, in 1871. Made of bronze, granite and marble, and adorned with reliefs and surmounted by a cluster of lamps, it stood at the northern end of the Broad Walk near the entrance to the Zoo. It is no longer there. But what happened to the Burdett-Coutts fountain? The architect was a Scot, Henry Astley Darbishire (1825–99), who worked closely with Burdett-Coutts, and was the principal architect for the Peabody estates buildings, the first of which was the one at Spitalfields built in 1865. He also designed the cottage community, Holly Lodge estate in Highgate. Concerned about neglect of animals as well as mankind, Burdett-Coutts funded a fountain and statue in Edinburgh in memory of Greyfriars Bobby, the dog who refused to leave his master's grave. Other fountains and drinking troughs followed, with perhaps her best-known fountain at Victoria Park, Hackney, which was unveiled in 1862. It cost £5,000 and is still in pride of place in the park. Richard Westmacott's Swan Fountain, which used to stand in the middle of the Broad Walk, was also a new introduction, again no longer in place after significant vandalism. Another fountain, designed by R. Kevile and presented by the Indian potentate, Sir Cowasji Jehangir Readymoney, in 1865, is still in position in the centre of the Broad Walk. Another fountain was installed in 1878 near to Gloucester Gate designed by Joseph Durham which consists of a bronze statue of a girl drawing water from a natural spring, the pedestal being made of boulders from the Cornish moors. Many of the monuments and structures added to the park are discussed later.

The social as well as physical characteristics of the park continued to change. It was no longer perceived as an aristocratic precinct, but more of a resort for all Londoners. Residents had started to alter their individual homes. Many were simple subtle changes, whereas others were more considered such as the additions of extra attic storeys and dormers which peered over the balustrades or parapets Nash had designed. These changes had started as early as the early 1830s and were reported to Nash who complained that it was 'most injurious to the whole neighbourhood ... the Commissioners should repress this by every means in their power'.[30] Pennethorne was asked to make a report on the area and reported that 'the opposite side of Little Albany Street is now unfortunately occupied by servants of the worst description, living in the Buildings originally built as stables and gradually converted into Houses and this has been done to so great an extent and has long existed that I fear it would be almost impossible entirely to get rid of nuisance'.[31] In 1845, proposals were mooted to convert Regent's Canal into a railway but after significant opposition, the proposals were rejected. The Diorama and Colosseum both did well for a number of years. The Diorama eventually closed after takings declined steadily and was sold for £3,000, eventually becoming a Baptist chapel which it remained until 1921. The Colosseum lasted longer as a place of entertainment, though it too eventually succumbed. It was purchased in 1831 by John Braham, the famous tenor singer whose voice had earned him a fortune. He paid £40,000 for the building and added two marine

caverns, an African glen full of stuffed animals, and a hall opening onto Albany Street which was panelled with looking-glass and decorated with painted birds. It was a popular attraction, with the queen visiting in 1835. It was not long, though, before it started to decline. Converted into a place of evening entertainment in 1838, Braham sold it in 1843 to David Montague who invited Parris to repaint the panorama, creating one of London by night. It continued with Queen Victoria visiting in 1845, but sadly the Colosseum could still not pay its way and it was put up for auction in 1855. The auctioneer declared that £200,000 had been spent on it but no bid came near the reserve price of £20,000 so it was withdrawn and stood smouldering in the park, its stucco flaking and the brickwork showing bare underneath. It re-opened briefly in 1857 and 1863 but then finally closed and was demolished in 1875. Sadly, Decimus Burton was still alive to see his work vanish. Cambridge Gate, a Victorian terrace, was built on the site and at least preserved the original building line.[32]

The park also witnessed a number of significant tragedies, two appalling ones in the nineteenth century. In January 1867 the ice of the lake gave way under the weight of skaters with over 150 people left struggling in the water. The depth of the water, presence of islands and underwater current from the Tyburn meant that a solid canopy of ice did not form. There were too few ropes available and too few lake attendants present and as a result over forty people died, either from drowning or from exposure. Fourteen of the victims were under the age of sixteen. Almost immediately, the

commissioners ordered the lowering of the lake depth and stringent precautions against skating.

The second serious accident occurred in the early morning of 2 October in 1874 when five barges, laden with gunpowder, were being towed along Regent's Canal. The third barge was the *Tilbury*, and as she reached Macclesfield Bridge, the northernmost of those spanning the canal, she suddenly exploded, damaging the bridge and the banks and blowing out all the windows of North Villa. All the crew were killed and it was assumed that one of them must have been smoking.

Regent's Park entered the twentieth century very much as Nash had left it. Described by Charles Dickens,

> Regent's Park is a large open space nearly three miles round, but a good deal taken up by the grounds of the Zoological and Botanical Societies, the Baptist College, and sundry private villas. It affords a pretty drive, and is surrounded by terraces of good but rather expensive houses. It is a great place for skating. A band plays near the broad walk on Sunday in the summer, and a vast amount of cricket of a homely class enlivens the north-eastern portion of the park on Saturday afternoons.[33]

Local popularity is evident from *The Illustrated London News* article 'Sunday Evening in Regent's Park' from 11 September 1880.

> The summer Sunday evenings in several of the London Parks are wont to afford healthful and pleasant recreation, of a befitting tranquil kind, to many thousands of

families, including both the middle and poorer classes of our townsfolk. The music of the band which is engaged to play in the stand erected not far from the south-eastern entrance to the Zoological Society's Gardens, about midway along the Broad Walk, is an unfailing attraction in fine weather. People are drawn within reach of its concord of sweet sounds and find themselves presently seated on the chairs placed there for hire, or perhaps on the cool greensward, to listen and to enjoy, while some keep strolling round and round, preferring freedom of movement, and surveying every part of the lively scene before them. The refreshment stall, which is at no great distance, furnishes many a bottle of lemonade, and many a cup of tea or coffee, with biscuits or sponge-cakes, to relieve the exhaustion felt by those who may have walked a long way from their homes to this Park; especially the women and children. Nowhere that we know of, can you see different classes of our London population quietly mingling in a common entertainment with so little fuss or mutual constraint. It may be a Continental custom but not, therefore, objectionable or unworthy of English gravity and propriety of manners.

By 1883, cricket and other sports were well established when the *Pall Mall Gazette* recorded that

the true glory, however, of Regent's Park as at present constituted is not its garden, but its playground. Every Saturday in summer eleven games of cricket, thus healthfully employing 250 persons, occupy every corner

of its cricket-ground. About thirty applications are refused every Saturday, the ballot being used to select the clubs that shall be accommodated on any given day. Football and volunteer drill are also encouraged, and it is a pleasure to see public ground so well employed.

However, huge social changes had been afoot, not only in London, but across the country, and the demand for parks and open spaces had been a major part of this new movement throughout the nineteenth century.

The Demand for Parks

The increased public use of the Royal Parks in London brought an awareness of the need for more areas like them. The most widely known examples of public parks in Britain were probably the Royal Parks. Hyde Park had been opened to the public since the 1630s; St James's Park and Green Park were formed by Charles II, and, as we know, Regent's Park gradually opened during the early years of the nineteenth century. Regent's Park, because of the influence of Nash and its location in London, became an important influence on the subsequent development of municipal parks. Its importance to later urban park design lay in the economic lessons to be learnt from the development of a park combined with housing, brought about by Nash, and in its successful adoption of some of Repton's principles of landscape gardening. Steps were therefore taken to create new Royal Parks explicitly for public use, situated in areas of London where none previously existed. Victoria Park and Battersea Park, both designated 'royal', were among the early fruits of this campaign, its great moment coming with the

perceived birth of the municipal park. However, these parks did not just appear as a matter of goodwill of local benefactors and philanthropists. Their need had been established in the early part of the nineteenth century but heavily influenced by what had been occurring at the long-disappeared Marylebone Park and newly born Regent's Park.

The municipal park is a public park and its advantage over all other forms of public parks is that complete control rests with the local authority and the unalienable right of access for recreation is secured. The term implies that it was an achievement of the municipal corporation and should be associated with the passing of the Municipal Corporations Act 1835, but municipal parks were developed in certain urban centres long before the nineteenth century. The first municipal park so far identified was formed in Exeter in the early seventeenth century, with others created in Shrewsbury and Leicester. In Shrewsbury, a public walk, known as The Quarry, was laid out along the banks of the Severn in 1719 and was open to the public at all times and maintained by the corporation. In Leicester the New Walk was formed by the corporation in 1785 as a promenade for the recreation of the inhabitants. These, however, were isolated examples.[1] It was not until 1833, with the Report of the Select Committee on Public Walks (SCPW), that there was an official recognition of the problem of open space for recreation. The aim of the report was to establish what open space was available for public use in the major towns and to recommend local and national action to ensure adequate

provision in the future. Although economic factors had provided the main impetus for the development of the early nineteenth-century park, such as Regent's Park, they were not stressed in the report. The report's main emphasis was on the physical need for open space and the problem of working-class recreation. The report was chaired by R. A. Slaney and its sole focus was on public walks. Slaney's influence was considerable. Not only did he bring it to the attention of Parliament in 1833, but he was also responsible for promoting the Recreation Grounds Act in 1859, an important piece of legislation aimed at stimulating the provision of parks. There had been little physical need to set aside open space specifically for recreation. Most towns had been small enough for adjacent spaces such as commons and wasteland to be accessible. However, by the beginning of the nineteenth century London was the largest city, with a population of over 1 million, and other urban centres were growing rapidly. Manchester, Liverpool, Birmingham and Bristol all had, by 1801, populations of over 60,000. Fifty years later the figures for Manchester and Liverpool had reached nearly 400,000, Birmingham was well over 200,000 and 1851 marks the point when the population became equally divided between town and country dwellers. By the time of the census of 1911 it had reached 36 million, with over 80 per cent of the population living in towns and cities. With such population expansion, the growth of the urban centres and the enclosure of commons, open space for recreation became less accessible. The Select Committee for Public Walks received evidence of

the open space available in London, in towns associated with the major manufacturing industries, and in smaller towns such as Shrewsbury and Norwich, so they were not concerned only with those towns where the factory system was most fully developed, or with the largest urban centres. From the evidence, they established that the greatest problems concerning access to open space for recreation occurred in the largest population centres. Only in the West End of London was there sufficient open space, due to the presence of the Royal Parks, although Regent's Park was still only gradually opened to the public.

Accessibility was a real concern and issue. Because the evidence to the Select Committee did not indicate who was allowed to use the available open spaces, the situation was in fact worse than that presented. The powerful nonconformist lobby had abolished many of the hitherto traditional amusements like wakes and fairs. With only holidays and Sunday as free days and a few hours in the evening, the working man of a large manufacturing town had little alternative but the ale house, there being no other place to amuse himself. In Manchester, which had a population of 187,000, there was nowhere for the working man to take his family for an outing or an airing. Even in London with its three large parks – St James's, Green Park and Hyde Park – there was the same problem, since only one, Hyde Park, was open to all the classes. These parks, said Slaney, 'did not afford sufficient space for the healthful exercise of the population'. On Sundays thousands flocked to Hyde Park with their families, many having to trudge

4 or 5 miles from the East End where none existed. But from Regent's Park in the north to Limehouse in the east, there was not a single place preserved as a park or public walk; and south of the river there was only one, near Lambeth Palace. In 1833, apart from the Temple Gardens, the terrace in front of Somerset House, and the Adelphi walk, there were no walks on the north bank. This was in marked contrast to cities on the Continent such as Paris, Florence and Lyons, which all had thoroughfares for the public beside the water.

Outside London, the situation was the same. Only Liverpool, Bristol, Norwich, Nottingham and Shrewsbury had preserved open spaces in their immediate vicinity, and these, said the Select Committee, 'are not enough'. The nearest open land to Birmingham was at Sutton Coldfield 6 miles away, available to the public thanks to the far-sightedness and philanthropy of Bishop Vesey. Hull had none, apart from the quays; nor did Leeds or Blackburn, and Manchester had only Salford lying to its west as open space.[2]

The Select Committee's recommendations for London included acquiring, before it was too late, 50 acres called Copenhagen Fields which were about to be sold for development. These duly became Hackney Downs. Also recommended was the extension and improvement of the embankment from Limehouse to Blackwall by the creation of a public terrace walk. On the south bank of the Thames the Select Committee found only Kennington Common still unenclosed; it was suggested that, if the commoners who had grazing rights there agreed, this could be laid out with a walk

and planted round its edge, reducing the grazing by very little. Although in the first instance only walks were being proposed, the Select Committee was aware that something much more in the way of space for exercise and recreation was needed. 'It was not gravel walks but public grounds which were really needed. The foot is freer and the spirits more buoyant when treading the turf than the harsh gravel; one game at cricket or football would do the young and active, be worth more than fifty solemn walks on a path beyond which they must not tread and beyond which they are therefore perpetually thirsting to go.'[3] Despite Loudon having publicly campaigned for public parks in the 1820s, the word park was not used in the terms of reference adopted by the Select Committee. But in practice the spaces created, ultimately, were parks. The provision of recreational places continued to be urged in the press. 'The sooner these places, together with public bathing, are provided, the better for the comfort, the health, the morals of the people and the credit of their rulers,' was the opinion of the *Westminster Review* in 1834. There were clear benefits, as Gally Knight MP told the House of Commons. On the Sabbath in the metropolis, he said, 'when the poor are released and catch a glimpse of the aristocracy in our parks it gives them pleasure as it does the aristocracy. It is to provide more frequent unions such as these that I desire public walks – also as a means to stop inebriety which lower orders of other countries which have had them for longer do not have'. As the *Manchester Courier* put it, such walks would be a 'means of throwing all classes together'.[4]

Five parks were consequently planned for Manchester, though by 1835 none had been put in hand: there was neither the economic nor the administrative means to implement them. Before the Public Health Act of 1848, in which municipal authorities could purchase and maintain land for parks, authorities had in the main no power to buy land to make a park except by a special Act of Parliament, which was cumbersome and costly. The Municipal Reform Act of 1835, which professed to give the inhabitants of towns the power of self-government, limited this financial to such an extent that the acquisition of land to create a park was still virtually impossible. The Act even prevented local authorities from contributing to the maintenance of a park if it was gifted land – as at the Royal Victoria Park – unless authorised by a private Act of Parliament. In 1839, Slaney was again addressing the House of Commons on 'its duty to take measures to provide Public Walks ... in the vicinity of large and populous towns'. Again the House expressed sympathy but could not agree on the means for paying for them, so the notion was withdrawn.[5] In such a laissez-faire climate it was not surprising that new parks continued to be made on the initiative of private benefactors. In the opening years of Queen Victoria's reign, Joseph Strutt of Derby acquired 11 acres on the city outskirts, for the purpose of providing 'Public Walks for the Recreation of the Inhabitants' and uniting 'Information with Amusement'. J. C. Loudon was the designer and creator of Derby Arboretum. He transformed what at first had been a very dull site by making the ground more uneven,

by laying out winding walks whose views continually changed, by concealing the boundary, and above all by planting trees and shrubs whose variety was unequalled outside any botanical garden. Strutt did not endow the Derby Arboretum with funds for maintenance, and on five days of the week admission charges were made. In the absence of public funds, levying charges and private subscriptions was unavoidable. Nonetheless that did only leave two days a week when poorer people had access, during which, as the reformer Edwin Chadwick pointed out, it might well rain. Thus despite a declaration by Strutt that the park was open to all classes it was still not fully available to the poor. Strutt's benevolence paved the way for other developments, including the Duke of Norfolk making 50 acres of land available in Sheffield for a public park. A new park and surrounding residential area was also laid out in Liverpool, as a speculative development where the middle classes could escape the miseries of the city. It was commissioned in 1842 by Richard Vaughan Yates, and named Prince's Park. Joseph Paxton, the Duke of Devonshire's head gardener at Chatsworth, designed it, on principles similar to those employed by Nash at Regent's Park. Maintenance costs at Prince's Park were met by rents from the surrounding villas, and the park itself was exclusively for the use of the villas' occupants. It remained private until 1918 when Liverpool Corporation took it over.

By contrast with these mainly private endeavours, little was achieved at first in the public domain. Slaney was exasperated by the inaction of Parliament in

relation to the Public Walks debate. In 1840 the Select Committee on the Health of Towns included in its findings a reference to the 1833 report, endorsing the fact that 'not much had been done ... in the meantime'. Problems of public health had become even more pressing as the population increased. Among the Select Committee's recommendations was a General Act to facilitate improvements, extending to all towns above a certain population. This was not fulfilled. Instead, however, £10,000 was voted to promote the opening of public parks, on the condition that bodies wishing to benefit from this fund should match such loans with at least an equal amount of their own money. Between 1841 and 1849, Dundee, Arbroath, Manchester, Portsmouth and Preston all made use of this scheme, with applications still pending in 1849 from Leicester, Harrogate, Stockport, Sunderland and Oldham. As early as 1841 it was claimed that throughout the country seventy-seven additional parks, public walks and places for the people were in the process of formation.[6]

In London at this period conditions were deteriorating fast. The 1840 report urgently recommended the creation of a park at the east end of the metropolis. It was suggested that this would probably diminish the local death rate, and spare thousands from years of sickness. Moreover it would be 'to everyone's interest as epidemics start in the East End and travel to the West'. Around Bethnal Green there were still open spaces; but they were unusable for recreation, being full of stagnant water and rotting waste, and a general source of disease. The Bishop of London even joined the debate

on living conditions and 'trusted that some parks, public walks, or other means of healthful recreation would be afforded to the miserable and neglected inhabitants of Bethnal Green and Spitalfields, and that neighbourhood, which was in a state none could conceive'.[7] Slowly, the government were waking up to the fact that if they did not move fast they would 'soon find it difficult to get any eligible spot'. It was Slaney once again who moved that a committee should be established to consider the creation of a new Royal Park in the East End near Spitalfields. This would offer the beneficial effects of 'exercise in the open air on the population', numbering 400,000 in the area.

Support for these proposals came from the people themselves. In 1840 a petition to the queen, and pleas to Parliament, were signed in Bermondsey and its environs by 30,000 people; by 1842 the means of establishing a park were being seriously considered. The government should raise the money, it was suggested, by 'exchange of Crown property in one place to procure appropriate sites in another'.[8] By 1843 the ground, already named Victoria Park, had been reserved, but no progress had been made towards laying it out. Yet another report, in 1844, noted that it was still only being talked about. Finally the government responded. York House, in Westminster, was sold with the intention of helping to establish the new Victoria Park, on about 244 acres to be purchased in Hackney, Bethnal Green and Bow. Following the precedent set by Regent's Park, 32 acres on the perimeter were to be appropriated for new villas, whose leases would be sold to defray the

overall cost. It had been recognised that the value of the land adjacent to a new park would always increase. Consequently it became government policy, wherever such a development was proposed in the metropolis, to acquire an extra strip of land that could be let out as building plots. At last the inhabitants of areas such as Tower Hamlets were to have a park, provided at public expense. More than ten years passed before the government's deliberations became reality. The park was designed by James Pennethorne, who had worked under Nash at Regent's Park, with planting by Samuel Curtis. Pennethorne's plan of 1841 was modified several times before work started in 1842. The park was opened to the public in 1845. In the 1850s the horticultural control of the park was directed by John Gibson who had worked with Pennethorne on the design and laying out of Battersea Park. The initial park area of 77 hectares was increased to 87 hectares in 1872, incorporating ground which had previously been brick fields, market gardens and farmland. In 1887 the management of the park was transferred to the Metropolitan Board of Works, which was succeeded by the London County Council in 1889. At the time of its creation Victoria Park was uniquely 'public', being the first Royal Park made for use by the people as opposed to the Crown. Other metropolitan schemes followed. Kennington Common was by definition already a public open space; in 1848 it had been the scene of a Chartist demonstration at which 200,000 people had been expected to muster before marching on Parliament to present a petition – in the event, they were dispelled by police and soldiers. In

1852, largely through subscriptions organised by a small number of local gentry, the Common was enclosed as a park. In 1887 it was transferred to the Metropolitan Board of Works, and ultimately by the London County Council. Meanwhile, on the city's northern outskirts, Primrose Hill, adjacent to Regent's Park, which had been saved from development, had been purchased by the government and likewise enclosed for the public. From 1848 it also included the country's first children's playground to be funded by government money.

South of the River Thames there was also urgent need for a new park, according to the Fifth Report of the Commissioners for the Improvement of the Metropolis in 1846, which repeated a recommendation made three years before. The report urged the immediate purchase of at least 150–200 acres of Battersea Fields, 'otherwise they will be swallowed up by building'. Thomas Cubitt, giving evidence, declared that such a site 'would be without parallel as there would be no other such open space by a large river and constant steamboat travel in the whole country for use of common people'. He reminded the government that by appropriating part of the land for building, it would reimburse itself and perhaps even make a profit. This time the authorities acted promptly. At last it was appreciated that as London continued to expand, the value of land within its limits would rise, making such projects more expensive with every year of delay. In 1846 an Act of Parliament duly empowered the Commissioners of Her Majesty's Woods and Forests to form a park in Battersea Fields. £2,000 was voted to cover laying out, enclosure, planting, and constructing

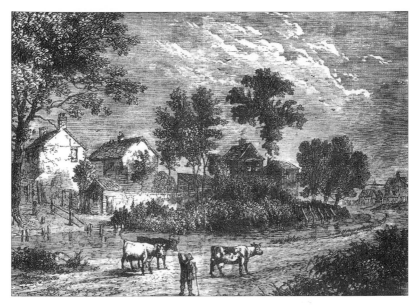

1 Farm in Marylebone Park in 1750. (Webster, 1911)

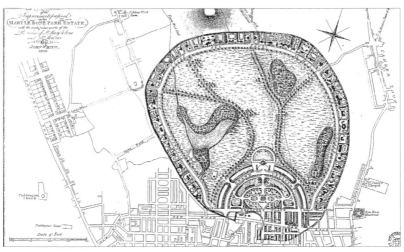

2 Plan of Improvements proposed for Marylebone Park in 1809 by John White. His plan showed housing round its perimeter. White, who lived in the park, wished to preserve the rural characteristics and to allow it to remain a place of recreation open to the public. White's design certainly influenced Nash's own ideas, although White was never acknowledged. (The Royal Parks)

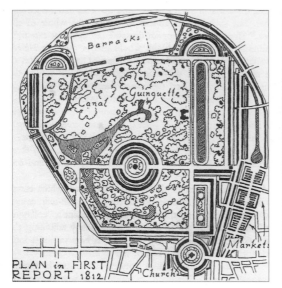

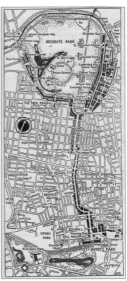

Above left: 3 Engraving plan of Marylebone Park appended to the Commissioners' First Report to Parliament on 4 June 1812 and ordered to be printed by the House of Commons on 13 June 1812 by John Nash. In this revised plan, the barracks are still to the north of the park, the canal has moved and the interior of the park is dotted with villas, including one for the Prince Regent, facing an ornamental body of water. (Summerson, 1935)

Above right: 4 Streets, squares and parks laid out by John Nash, 1811–35. (Summerson, 1945)

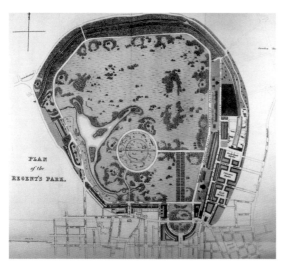

Left: 5 A later plan of Nash's amended in 1826, where the barracks has moved to Albany Street and the entrance to the park is no longer a circus, and there are now fewer villas in the park. (CRES 60/3)

6 Thomas Lawrence's *Portrait of John Nash* (1827) at the age of seventy-two. (Courtesy of the Principal, Fellows and Scholars of Jesus College, Oxford)

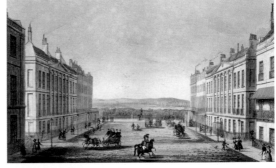

7 'Panoramic View round the Regent's Park', 1831. Hand-coloured aquatint on engravings by S. H. Hughes from drawings by Richard Morris, published by R. Akermann – Park View from Portland Place. (Guildhall Library)

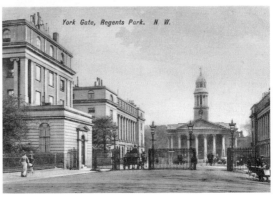

York Gate, Regents Park. N. W.

8 York Gate, the grandest entrance to the park, with Ionic façades on either side of St Mary's church. During the development of the park, the parish of St Marylebone finally came to a decision about where to build its new parish church, built by Thomas Hardwick (1813–17).

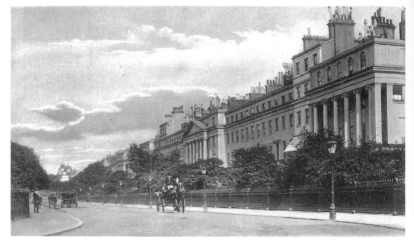

9 Cornwall Terrace (1821), the first terrace in the park to be built and designed by Decimus Burton. Corinthian, with a central portico with free-standing giant columns.

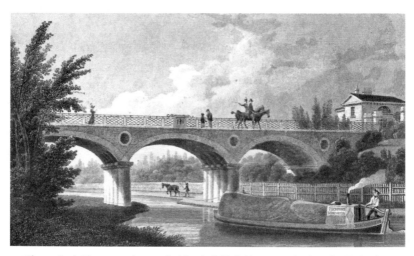

10 The main bridge over the canal, Macclesfield Bridge, named after the Earl of Macclesfield. This was the scene of the most dramatic incident in the nineteenth century, when in October 1874 the *Tilbury*, a barge carrying gunpowder, exploded, killing the three members of her crew, badly damaging the bridge as well as frightening the animals in the nearby Zoological Gardens. It also destroyed the park superintendent's house, which was rebuilt on the Inner Circle.

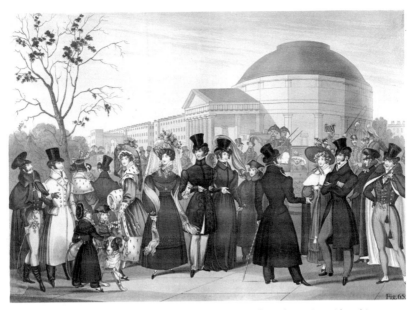

11 Fashion plate showing the Colosseum in 1830. Coloured aquatint with etching by B. Read and Co. (Guildhall Library)

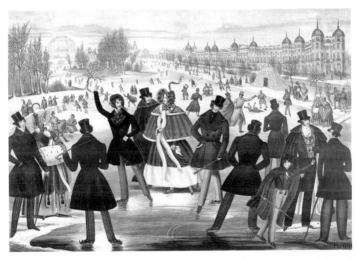

12 Fashion plate showing Sussex Place across the Lake in 1838–39. Coloured aquatint with etching by B. Read and Co. (Guildhall Library)

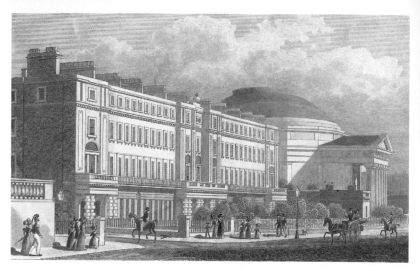

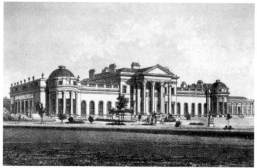

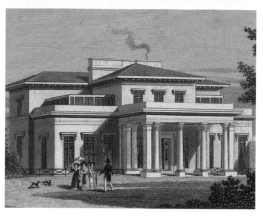

Above: 13 Cambridge Terrace and the Colosseum. Cambridge Terrace was originally built in 1825 by Richard Mott, who also built Chester Gate and Gloucester Terrace.

Left: 14 Holford House *c.* 1835. Tinted lithograph from a drawing by Wyatt Papworth. The last and most expensive of the villas to be built in the park. Designed by Decimus Burton for the wine merchant James Holford. Badly bombed during the Second World War, it was subsequently demolished.

Bottom left: 15 Hertford House, named after the 3rd Marquess of Hertford, which he renamed St Dunstan's Villa. Another Decimus Burton design, it was in use by 1829 but eventually demolished in 1936.

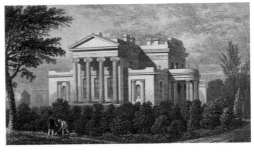

16 Grove House, steel engraving by T. H. Shepherd. Designed by Decimus Burton and built by James Burton in 1823. Sigismund Goetze was its most notable resident.

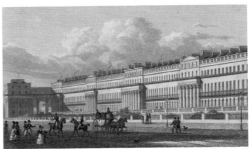

17 Chester Terrace, built in 1825, with three porticoes with projecting Corinthian columns. The magnificent arches at either end were put in by builder James Burton, against Nash's wishes. Likewise, the sculpted figures by J. G. Bubb were taken down at Nash's insistence.

18 South Villa (1816–17), from an engraving by T. H. Shepherd, with the Ionic portico central to this impressive villa. Probably designed by Decimus Burton, its most interesting tenant was the astronomer George Bishop, who built an observatory in the grounds. The observatory closed when Bishop died in 1861, and the instruments and dome were moved to Meadowbank, Twickenham, in 1863. Twickenham Observatory closed in 1877 and the instruments were given to the Royal Observatory of Naples (Osservatorio Astronomico di Capodimonte). The South Villa is now replaced by Regent's College, now one of the two largest groups of buildings in the park alongside London Zoo.

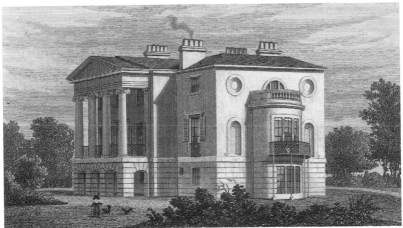

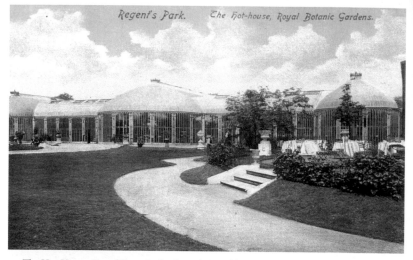

19 The Hot-House, Royal Botanic Gardens, designed by Decimus Burton in 1845. Built by Turner of Dublin, who was also responsible for the Palm House at Kew.

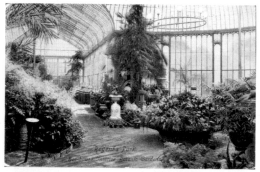

20 Interior of the Hot-House in the Royal Botanic Gardens. It held a range of tropical flowers, including the Victoria Regis lily, on which the Secretary of the Society could sit in a chair.

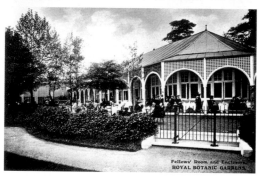

21 Fellow's Room and Enclosure at the Royal Botanic Gardens. The Society held annual flower shows in giant marquees, regularly attended by Queen Victoria, bringing the royal children. Another regular visitor was Elizabeth Barrett, from nearby Wimpole Street, who picked flowers in the garden to give to Robert Browning.

22 Royal Botanic Gardens Rock Garden. The layout of the gardens changed considerably over the ninety years, with many additions, including the Rock Garden. The Society proved to be excellent at running social events but less so with regards to innovative horticulture and was poorly managed, folding in 1930 and opened as a public garden in 1932. Burton's conservatory was past repair and was pulled down and the gardens renamed the Queen Mary's Gardens in 1935.

23 The Avenue Gardens and Broad Walk. Also known as the Italian and Flower Gardens, they replaced Nash's original avenue of trees between Park Square and Chester Road, which by the 1860s was in poor condition. Nesfield kept two of the four lines of trees, with elms outside horse chestnuts. Inside these, he set a series of highly ornate display beds, punctuated by tazzas and urns, to both sides of a plain central avenue. (Courtesy of the Parks Agency)

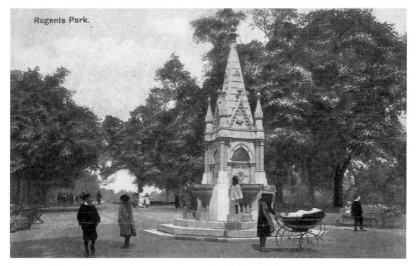

Regents Park.

24 The Readymoney Fountain (1869) was the gift of a wealthy Parsee, Sir Cowasjee Jehangir, who, in gratitude to the British Raj for its protection of the Parsees, in 1865 sent £1,200 from India to pay for a fountain 'in the Regent's Park or Kensington where a large number of nobility or gentry frequent'. Reaching 22 feet high and recently restored, it is made of Sicilian marble and Aberdeen granite. On its sides are reliefs of Victoria, Albert and Sir Cowasjee, as well as a lion and a Brahmin bull. 'Readymoney' refers to the donor's profession as a moneylender.

25 Flower planting in parks became the subject of vigorous debate at various times during the course of the century, and when flowers began to be introduced into the royal parks, where there had only been grass, trees and water, there was an outcry. The introduction of flowers to the royal parks was an innovation of the Commissioner of the Board of Works in the late 1850s and was commended by some on the grounds that it gave the vast majority of people who were without gardens the opportunity to see flowers. However, many professional landscape gardeners opposed the principle, saying that an attempt 'to convert our parks into tropical gardens ... cannot be too strongly condemned'.

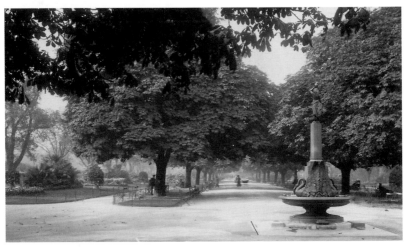

26 Richard Westmacott's Swan Fountain, which used to stand in the middle of the Broad Walk, was also a new introduction, no longer in place after significant vandalism.

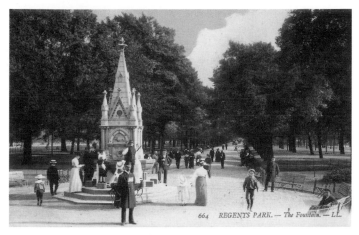

664 REGENTS PARK. — The Fountain. — LL.

27 The Broad Walk with the Readymoney Fountain. The Broad Walk, the avenue forming the main axis of the park, was originally intended to lead to the Prince Regent's villa. It extended Nash's route from Westminster beyond Portland Place.

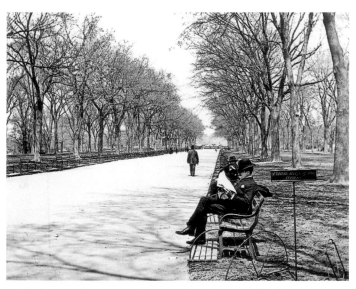

28 The location of seating vexed many, with Loudon giving detailed instructions in his parks on how they should be placed, so that the extent of the park was not made obvious. In particular they should be placed by the side of walks where passers-by would provide interest and all fixed seats 'should have footboards for the comfort of invalids and the aged'. Such attention to detail in the positioning of seats was not the rule, and when Kemp reported on the number and position of seats in Birkenhead Park in 1857 he only gave the most general indication as to where and how they were placed.

29 Elephant rides in the Zoological Gardens were popular, as well as along the length of the Broad Walk.

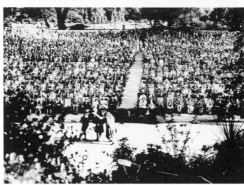

30 An Open Air Theatre performance, Regent's Park, 1935. (GLRO X71/187)

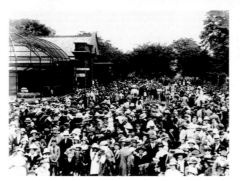

Above left: 31 Zoo scene, August bank holiday crowds, 1924. (The Royal Parks)

Above right: 32 Bomb-damaged terraces in the Second World War. The terraces suffered terrible bomb damage and, with lack of funds for maintenance, further deterioration was inevitable. This left them in such a dilapidated state that by the end of the war there was 'not a single terrace, with the partial exception of Hanover Terrace ... which does not give the impression of hopeless destruction'. (NMR C44/511)

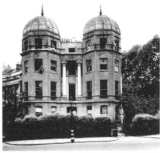

Above left: 33 Primrose Hill, gun emplacements, early 1940s. (Imperial War Museum H868)

Above right: 34 Sussex Place end towers, bomb damaged in 1944, thankfully retained as a result of the Gorell Commission, which reported in 1947, recommending full restoration, a conclusion accepted in Cabinet on the casting vote of the Prime Minister, Clement Attlee. (NMR C44/511)

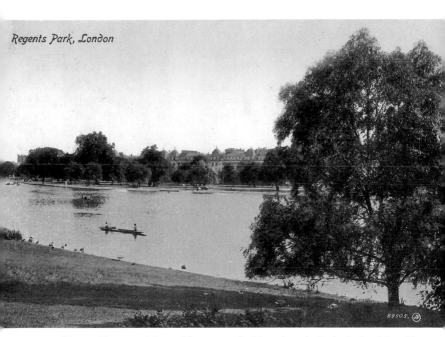

Regents Park, London

35 Clarence Terrace and Sussex Place across the lake, where the ice broke in 1867, with the loss of forty lives after 150 plunged into its waters.

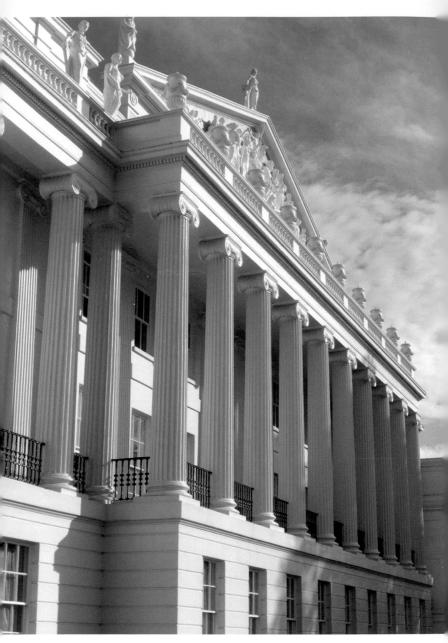

36 Cumberland Terrace in 2012, now maintained by the Crown Estate Paving Commission.

37 Sussex Place, topped with its pointed hexagonal domes. No longer divided into individual houses, and rebuilt, retaining the original façade, after serious damage in the Second World War, Sussex Place now houses the London School of Business Studies.

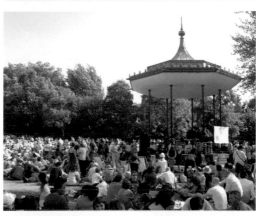

38 Klezmer in the Park 2012. The original bandstand in the park was near the Readymoney Fountain. A twin of the Kensington Gardens bandstand, this was originally erected in Richmond Park in 1931 but after 1951 fell out of favour and was dismantled and moved to Regent's Park in 1975, where it is now a popular feature.

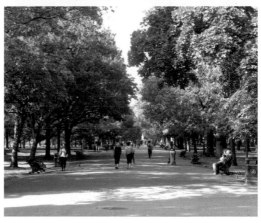

39 The Broad Walk is now popular with walkers, joggers and those who still wish to sit and watch passers-by.

40 The Queen Mary's Gardens with over 30,000 roses and 400 varieties on show. With national collections of delphiniums and 9,000 begonias, the main attraction today is still the wonderful display of roses, with many quiet areas to escape to and relax.

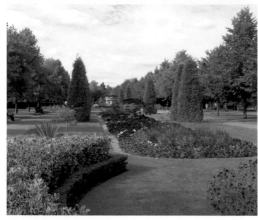

41 The newly restored Avenue Gardens, with urns and tazzas replaced and restored.

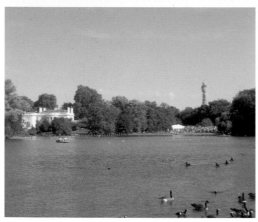

42 The lake with Post Office Tower dominating the skyline, but The Holme standing in a superb position, built for and by James Burton and designed by Decimus Burton as the family home between 1818 and 1831.

lodges, museums or other ornamental buildings; and another 'royal' public park was in the making. The ideal of surrounding London with a belt of parks was taking physical shape, if in piecemeal fashion.

The creation of parks was now a matter for public and legislative debate. Those already formed had come about by a variety of means ranging from private gifts, subscriptions or speculative development, to special Acts of Parliament and funding by central government. By the late 1840s the provision of open spaces, walks, parks or other recreational areas had clearly become a concern of the public health movement. Gaining momentum, by 1848 this movement had led to the first Public Health Act, enabling local authorities to purchase and maintain land for the purpose of recreation: 'The Local Board of Health with the approval of the said General Board, may provide, maintain, lay out, plant and improve Premises for the Purpose of being used as public walks or Pleasure Grounds, and support or contribute towards any premises provided for such Purposes by any means whatsoever.'[9]

Such legislation did not apply to London. To make up for this, in 1855 the Metropolitan Local Management Act was passed, enabling the Metropolitan Board of Works to apply to Parliament 'for the means of providing parks, pleasure grounds, places of recreation and open spaces for the improvement of the Metropolis and the benefit of the inhabitants'.[10] Three parks were to be planned, the first being Finsbury, the second and third in Hampstead. Back in 1842, almost all the inhabitants of Bermondsey had also signed a petition,

which they had presented to Parliament, 'praying' for a public space similar to Victoria Park: it had been desired too that Hampstead Heath be secured for public use. However, these two projects had been postponed after the government declared that there had not been sufficient notice given. It was not until 1871 that Hampstead Heath was obtained for the public, after the Metropolitan Board purchased rights over it from the then lord of the manor of Hampstead, Sir John Maryon Wilson.

Finsbury Park, situated on what used to be Brownswood, a sub-manor of the 3,000-acre manor of Hornsey and part of the ancient Forest of Middlesex, was largely owned by the Bishops of London who hunted there. By 1548 Brownswood lands consisted of 122 acres, and in the seventeenth century, a manor house, Copt Hall, was built on a site to the south of the present lake. By the mid-eighteenth century, this building was replaced by a house known as Hornsey Wood House, a popular tea house with pleasure gardens and woods for sport and recreation, including a bowling green and shooting range. It was also known as a centre for duelling. In 1786 the house was enlarged and the wood reduced to provide larger pleasure grounds and a lake for fishing and boating. In 1866 Hornsey Wood House was demolished when the house and grounds eventually became part of the new Finsbury Park, which also took in farmland to the south, west and east. As mentioned earlier, the park was created under the auspices of the Metropolitan Board of Works following the Finsbury Park Act of Parliament of 1857 in order

to provide a much-needed municipal park for Finsbury residents, and became London's second municipal park after Victoria Park. Although the Act had specified that 250 acres of parkland should be retained free of development, when work finally began in 1866 it was reduced to an area of 115 acres, purchased at £472 per acre. Discussions around creating a park here had actually already arisen prior to the Act when a plan for what was proposed as Albert Park had been drawn up in the early 1850s by James Pennethorne, the designer of Victoria Park in Hackney and Battersea Park. The structure of the park, including its five entrance gates and the Lodge at Manor Gate, the perimeter carriage-drive and main paths, was designed by Frederick Manable, Superintending Architect to the Metropolitan Board of Works. Various areas of formal planting were set within open parkland; this 'ornamental portion of the park', which included the American Gardens and network of curving paths within the perimeter drive, was designed by Alexander Mackenzie, the Metropolitan Board of Works landscape designer. The park was originally laid out in zones but these later became no longer distinct. There were horticultural features to the south-east and east of the lake and in the north-west corner; recreational features, the lake and refreshment room in the centre; and sporting features around the edge. Finsbury Park opened to the public in August 1869. The London County Council also took responsibility of this park in 1889 on its formation.

One dilemma still impeded the public authorities. Should parks be funded locally or by central government?

Though provincial towns were as much entitled to grants as the metropolis, there was a strong lobby against central government aid for local purposes. The inherent English dislike of centralised government finally resolved that issue with the Public Health Act of 1875. Under Clause 157 of the Act, headed 'Public Pleasure Grounds', it was declared that 'any urban authority may acquire, lay out, plant, improve and maintain lands for the purpose of being used as public walks or pleasure grounds, and may support or contribute to the support of public walks or pleasure grounds provided by any person whatsoever. In addition any local authority may for the purposes of the Act purchase or take on lease, sell or exchange any lands or any rights in, over, or on lands, whether situated within or without the district.'

This legislation did not apply to Scotland or Ireland 'save as by this Act is expressly provided'; nor to London, which continued to be governed by the Metropolitan Board until the creation of the London County Council in 1889. In effect the 1875 Public Health Act enabled local government both to raise loans through Parliament and to levy its own rate. This was the signal that had been fought for all along. Councils like Manchester had resisted using ratepayers' money for the formation of parks; now they did so willingly. By the end of the century between 150 and 200 parks had been created or purchased in the name of the people. Municipal park-making had become a mania.

Inevitably a new problem arose with urban parks. As land values around them shot up, so the poorer classes were driven out, once again finding themselves without

the proximity of a public recreational space. Slaney, like Loudon, had recognised that if parks were to serve the poor they needed to be near at hand. He accordingly had urged the acquisition of land, small areas included, to serve their neighbourhoods as recreation grounds.[11] As London and other towns expanded, many owners of private parks that had once been in rural settings sold or donated their properties to town councils, hence the number of smaller open spaces such as Ravenscourt Park, Hammersmith, and Waterlow Park, Highgate, both in London. The formation of the first public parks was a long and arduous effort. Under the leadership of a few public-spirited individuals moreover, it was, as J. C. Loudon said, a movement from the people rather than the government.

The most comprehensive description of London's parks at the turn of end of the nineteenth century was by the Honourable Mrs Evelyn Cecil, who described in detail in 1907, London's parks and gardens.

> The parks and gardens of London have a past full of historical associations, and at the present time their full importance is slowly being realised. Much has been done to improve and beautify them, but much remains to be achieved in that direction before their capabilities will have been thoroughly developed. The opportunity is great, and if only the best use can be made of it London Parks could be the most beautiful as well as the most useful in the world. It is impossible to praise or criticise them collectively, as they have different origins, are administered by separate bodies, and have distinct

functions to perform. It cannot be denied that the laying out in some and the planting in other cases could be improved. Plans could be carried out with more taste than is sometimes shown, and new ideas be encouraged, but on the whole there is so much that is excellent and well done that there is a great deal to be proud of.[12]

She goes on to describe many of these parks in much further detail. Beginning on the extreme north there is Golder's Hill, then to the east of Hampstead lies Waterlow, the next going eastwards is Finsbury, then Clissold and Springfield, and down towards the east Victoria. In South London, between Woolwich and Greenwich, lies Maryon Park; then, west of Greenwich, Deptford and Southwark; then a densely built-over district before Kennington, Vauxhall, and Battersea are reached; while away to the south lie Camberwell, Ruskin, Brockwell, and Dulwich; right away into the country, on the south-east, Avery Hill and Eltham; and back again west, across the river again, in Hammersmith, is Ravenscourt. These parks of varying sizes, and smaller recreation grounds between, made up the actual parks, although some of the commons, with playgrounds, artificial water, and bandstands, can hardly be distinguished from the true park.[13]

These parks were enjoyed at the turn of the twentieth century by hundreds of thousands annually. There was much variety in these parks as there was in the Royal Parks and in particular Regent's Park since the introductions by Nesfield. The London County Council was instrumental for the greater number and in many

cases they deemed certain things essential, for instance, the bandstand, many of which were ordinary in design, others more rustic, and others much more ornate in character. Every park seemed to have cricket pitches by the dozen, although Waterlow was too hilly! Numerous goal posts were provided for in each and all the larger parks. Gymnasiums were included, with swings for smaller children, bars, ropes, and higher swings for older boys and girls. Bathing pools were often added, the one in Victoria Park being especially large and crowded. The larger parks had green-houses, with a succession of plants on view all the year round. Iron railings and paths are the inevitable beginnings in the creation of a park, and more or less ambitious gates. It was only in the larger ones, such as Finsbury, Victoria, Dulwich, and Battersea, that carriages were anticipated. Fancy ducks and geese attracted small children on all the ponds, and some parks had enclosures for deer or other animals.[14] However, Mrs Cecil also comments on many of the problems and difficulties faced by creators and managers of these new parks. In particular, the numbers of people who enjoyed these parks caused significant problems. The grass suffered to such an extent that areas had to be closed off to allow recovery. Children had to be kept a certain distance from the flowers or feel the wrath of the park-keeper. The trials of the climate of London and its 'hurtful' fogs were an issue, especially intensified towards the end of the nineteenth century. Trees suffered terribly from smoke emitted as well as healthy young shrubs and bushes such as laurels which became completely dried up,

brown and shrivelled. Despite these difficulties, every park appeared to be thoroughly appreciated by the inhabitants, and no one

> can underestimate the health-giving properties of these lungs of the city. It would be vain repetition to point out the fact in each case, or to picture the crowds who enjoy them on Sundays – who walk about, or lounge, or listen to the bands, or to what appears still more stimulating, to the impassioned harangue of some would-be reformer or earnest preacher. The densely packed audiences, the gesticulations and heated and declamatory arguments, are not confined to Hyde Park. Victoria Park gathers just such assemblies, and every park could make more or less the same boast. The seats are equally full in each and all, and the grass as thickly strewn with prostrate forms. Perambulators are as numerous and children as conspicuous in the north, south, and eastern parks as in those of the west.[15]

Mrs Cecil is equally descriptive of Regent's Park, describing the 'flower-beds as one of the most attractive features in the Park ... the fogs are the greatest enemies of the London gardener, and more especially on the heavier soil of Regent's Park. Not even the most hardy of the bedding-out plants will survive the winter, unless in frames. Even wall-flowers and forget-me-nots will perish with a single bad night of fog, unless under glass.'[16] She goes on to describe the considerable alterations made in the arrangement of the beds in the flower-garden of the park, chiefly with a view to reducing the bedding and

to obtain a better effect. The railings had always been timber and Cecil 'hoped the old traditional style of fence of this delightful Park may be continued'.

Although Regent's Park entered the twentieth century very much as Nash had left it, the park was now nearly fully accessible to all and was intensively used. With 'park mania' under way across much of London and the rest of the country, Regent's Park had evolved further, especially the buildings on the park, and would face new challenges in the twentieth century which would include two world wars and a significant threat of demolition and a further tragedy within its confines.

The Avenue Gardens – or 'The Flower Garden' as former park superintendent Webster had described it in 1911 – remained popular. However, changes had been made. By the 1880s and 1890s this type of formal garden was already going out of fashion. A gradual decline started around this time and continued until the early twentieth century. By 1911, Superintendent Webster had already started to simplify the design. The structure of outer lines of trees and path layouts remained but the features such as the poplar avenue, shrub planting and carpet bedding 'was done away with, and the present more natural style adopted'.[17] As with any landscape, change and evolution were inevitable as it was indeed with Regent's Park.

The Twentieth Century: A Park for the People

The most significant changes to the park were not so much the parkland itself, but the buildings on the estate, which underwent considerable changes in use. In 1908 the lease of South Villa was acquired by Bedford College, the oldest establishment for the higher education of women. The college had grown and was flourishing and needed newer and larger premises. When the lease of South Villa came on the market, the college bought the remaining sixteen years with permission to replace the villa with a fully equipped academic building, which was designed by Basil Champneys and completed in 1913. The residents were unhappy with these proposals and the new tenants within the park and protested vociferously. As a result, part of the grounds of South Villa were reserved by the Crown and were made into a public walk along the edge of the lake but residents were still unhappy, feeling that an encroachment was being made on their claim to open air and space for recreation. Despite the opposition, the college moved in, with the buildings opened by Queen Mary in July 1913.

There were some changes to the parkland too. A. D. Webster was the long-time superintendent of Regent's Park and wrote at length in 1911, describing the landscape in detail. His account of the park is the most detailed account of Regent's Park at the end of the nineteenth century and the turn of the twentieth century.

The Broad Walk, which runs through the Park in an almost straight line from north to south, commences in the flower garden by Park Square, and terminates at the Outer Circle Road by St Mark's Bridge. It is a noble avenue, thirty- three feet wide throughout, and flanked on either side by a wide belt of trees except at the highest point by the fountain, where a well-arranged shrubbery backs up the nearly circular promenade at the junction of several of the Park roads and footpaths. In the flower garden, too, the avenue is bordered by lines of well-developed horse-chestnut trees, which, when in full flower, add greatly to the charm of these grounds. On the right or eastern side of the Broad Walk from Avenue Lodge is Cumberland Green, a portion of which is reserved as a hockey and cricket ground for ladies, not far distant and hidden from view in one of the shrubberies being a dressing-room for the players ... the Broad Walk is a favourite promenade of residents and visitors, the shade and shelter being much appreciated, as are the numerous chairs and seats that are conveniently placed in recesses by the roadway, while it is traversed in every direction to all parts of the Park by well-kept paths and roads.[1]

Clearly the improvements carried out by Nesfield to the trees on the Broad Walk had been effective, as Webster describes the view towards Highgate and Hampstead 'becoming more difficult owing to the rapid growth of the trees'.

Webster describes a 'handsome drinking fountain ... presented by Lady Burdett-Coutts ... of noble proportions, being built of granite, marble and bronze, with statuary, and surmounted by a cluster of lamps, with several jets of water springing from the basins. It is to be regretted that this handsome fountain was not erected in a position where it could be better preserved from harm, as several of the figures and other portions have been damaged and broken off from time to time.' As the superintendent of the park, Webster recognised the difficulties in establishing and maintaining the planting in the park due to the 'stiff, unctuous clay that retains a great amount of moisture in winter and readily cracks during dry and hot weather in summer', along with the 'hurtful fogs'. He goes on to describe the need for soils to 'be largely replaced by that of a more suitable quality for the growth of trees and shrubs ... with top dressing the surface soil has much improved, while tree planting and the formation of shrubberies have greatly altered the cold and dreary aspect of the landscape.'

Mrs Evelyn Cecil had described how popular London parks were. Similarly in Regent's Park, its popularity was heightened due to its many attractions that were now available. Webster goes on to describe 'the Van Horse Parade held in the park on Easter Monday and the Cart Horse Parade at Whitsuntide, both attracting

large numbers of visitors'. A band played every Sunday afternoon during the summer months, the bandstand being situated near the fountain on the Broad Walk. There were three refreshment kiosks in Regent's Park.

> That on the western side of the Broad Walk is a spacious and well-arranged building with adjoining shady grounds where refreshments are served in the summer. The cricket pavilion is near the centre of the park, and conveniently situated for the cricketers and footballers, for whom it principally caters. Not only are refreshments served here, but all implements in connection with the above games can be stored in the building, and there are likewise washing and dressing rooms for the use of the members of the various clubs who make use of the adjoin grounds.[2]

A 'small neat building, at the entrance to the Broad Walk' was selling cakes, sweets and mineral waters. The park was surrounded by 7 miles of 'a stout oaken fence of neat and rustic design, but quite unsuited for a boundary ... on each post of the fence was inserted a brass plate on which was recorded the name of the maker and his address. These plates were all removed and sold as old brass by a gang of thieves from St Giles.' The fence was in a poor condition and was now gradually being replaced by a 'neat and more efficient structure of iron'. Plant houses occupied a secluded spot by Chester Road and close to the Broad Walk and took up a large area, producing thousands of plants that were required in the way of spring and

summer bedding. Plants were grown here not just for Regent's Park but for other parts of London, including the Law Courts, Tate Gallery and the Record Office. Within the same area were workshops, including a 'well-appointed carpenter's room, blacksmith's forge, paint room, stables and capacious store-room for tools and other appliances used in the Park'.

Provision of sports facilities was well catered for, with over 100 acres of the park mainly devoted to cricket, football and hockey with also five grounds set apart for children from London County Council schools, who played a variety of games on them. Cricket was incredibly popular within the park and the ground set aside, extending from the cricket pavilion to the zoo boundary, could accommodate twenty matches at the same time. In 1910, there were 1,313 games of cricket played along with 1,035 games of football. Bizarrely, hockey was only allowed to be played by ladies, on a specially prepared ground provided on Cumberland Green. 'So popular has hockey become of late years that at the present time five games take place on several days of the week. Cricket for ladies is allowed on the hockey-ground during the season.'[3] The majority of the display beds remained in the same locations as Nesfield's plan except for the western edge, which was planted up as a herbaceous border, 12 feet wide, south and north of the central compartment. Although there were losses within the elm and chestnut avenues, the majority of the trees remained. The tazzas and vases were retained but some were relocated from the south and north to the centre. By the early part of the twentieth century

the layout had evolved, still displaying the beds, edges and paths of Nesfield's layout and with more vases and tazzas in the centre compartments. From photographs and postcards of this time, these gardens appeared to have been immaculately maintained. The trees were flourishing and Webster writes, 'Of elms, both English and Scotch, there are several majestic specimens, the far-reaching branches of which sweep greensward and extend to fully 90 feet in diameter of spread ... the Chestnut Avenue is quite a feature of the gardens, especially during the flowering season.' The gardens had a vast array of flowering shrubs and plants throughout including bulbs, the majority which flowered during the first three months of the year. Shrubs included Witchhazel, Forsythias, Mezereons, Cornelian Cherry, early flowering Rhododendrons, Christmas Rose and a host of Anemones, Chionodoxa, Woody Lilies and Narcissus. The herbaceous border is described as extending 400 long 'and contains nearly every procurable species and variety of herbaceous plants'. In fact, Webster states, 'exclusive of bulbs, the number of bedding plants annually dealt with in Regent's Park is 154,500, the total area of the flower-beds being just over an acre, while the borders extend to about a like area. The herbaceous borders cover a space of fully one and three-quarter acres and contain upwards of 17,000 plants.'[4]

Sadly, only three years later, the First World War had broken out. The park suffered no direct damage as a result of the war but as a consequence repairs to houses and terraces were neglected. Otto Kahn, the owner of St Dunstan's Villa, surrendered the lease in 1917 so

that the house could be used as a training centre for blind and disabled soldiers and sailors. This centre had been established by Sir Arthur Pearson and the villa, as we know, was renamed St Dunstan's Institute for the Blind. St John's Lodge was taken over as a hospital for disabled officers. When in 1921 it was no longer needed as a hospital, St Dunstan's moved to the other villa and made its headquarters there until 1937. The Royal Hospital of St Katherine's, which had been disbanded in 1914 since it no longer served a useful purpose, was used throughout the war as a hospital for British and American officers. After the war it became the West London Hospital for Nervous Diseases.[5]

Between the end of the First World War and Second World War the park flourished, with social conditions making the comparatively small terrace houses desirable to those who would formerly have kept a larger establishment in Mayfair. The increasing commercialisation of the West End made the park seem even more attractive, for the clause in the Crown leases that each dwelling should be used by no more than one family was strictly enforced. Notable figures from London society made their homes here and included Hugh Walpole in York Terrace, H. G. Wells and Edmund Gosse in Hanover Terrace and Mrs Wallis Simpson at 7 Hanover Terrace. By the 1920s, the original ninety-nine-year leases began to fall in and the Crown policy was to renew them for a further twenty-one years at a higher rental. As a consequence, the Baptist College moved out of Holford House in 1927 and built a new college at Oxford while the villa was let out in

apartments. St Dunstan's stood empty through the 1920s and then from 1935 to 1936 was the home of Lord Rothermere, the newspaper magnate, who as we have already noted restored the clock, after which the villa had been named, to the church of St Dunstan's in Fleet Street. After his tenancy the villa was demolished and Winfield House was built on the site for Barbara Hutton, the daughter of the founder of Woolworths, and is now the home of the United States Ambassador.[6]

The economic situation at the end of the 1920s was felt across Europe and America and impacted on the park. After the First World War leases had sold readily, but by 1931 'For Sale' boards became common and remained there, with houses standing unoccupied, which meant a decline and reduction in maintenance and condition. The Toxophilite Society numbers declined significantly and it ultimately disbanded in 1922 when the lease came up for renewal. The grounds were taken over by the commissioners and, after the buildings had been pulled down, were opened to the public. An unwelcome and unattractive alteration and addition was the children's paddling and canoeing pool which was opened on the western boundary in 1930. Residents protested vociferously, but were ignored, and it soon became a popular feature with many small and excitable children.

One addition to the park, and still present in Regent's Park to this day, is the Open Air Theatre. From the Middle Ages, 'pastoral playing' in Britain has had a rich ancestral line. Medieval 'mysteries' or 'miracle' plays were acted out of doors by the amateur guildsmen, who

would perform on wheeled platforms or two-decker 'pageants'. As the centuries passed by, players would act from their carts, or from a trestle stage in the inn yards. From these would derive the theatres, such as the Globe in London's Bankside. Shakespeare himself would have been used to open-air theatre as an actor and playwright. Four of his comedies – *Love's Labour Lost*, *As You Like It*, *A Midsummer Night's Dream* and *Twelfth Night* – are the staple of pastoral playing, professional and amateur. There has long been a history of open-air playing in the gardens of great houses, 'inns of court', public parks, and universities. The latter part of the nineteenth century and the Edwardian period were fruitful for the pastoralists and there were many open-air amateur theatre groups. The Woodland Players were one of the most consistent outdoor performers who toured the country in 1887, including Garrick's Villa at Hampton; Wilton House; Clopton House at Stratford; Bristol Zoological Gardens; Alexandra Palace and also the Botanical Gardens in Regent's Park. Performances were originally given by the lake in Edwardian times in the form of charity matinees. Shaw's *Passion, Poison and Petrification of the Fatal Gazogene* had its first performance in 1905. Earlier, there had been a full season in 1901 in the Royal Botanic Gardens, playing in 'a lovely woodland glade'. Evening performances were lit by limelight. The present theatre, which opened in 1932 in a very different shape from today's, was derived from a meeting earlier that year between Sydney Carroll, an Australian-born impresario whose real name was George Frederick Carl Whiteman, and

Robert Atkins. In April 1932, this new partnership presented in the West End *Napoleon: The Hundred Days*, a historical drama by the Italian dictator Benito Mussolini. The day after opening, Hannen Swaffer, the celebrated columnist, wrote, 'Diners out last night had a raw deal as every Italian waiter in London was at the New Theatre to see El Duce's play.' The production was a disaster. A replacement show had to be found quickly. The answer was the famous 'black-and-white' *Twelfth Night* which Carroll and Atkins transferred, after its successful run at the New, to Regent's Park on 12 July 1932 for four performances, with grudging permission from the Ministry of Works, but with help and enthusiasm from the then park superintendent. The area was previously called the Grotto Garden, which included a tennis court exactly where the stage is located. The players performed in wet and dry conditions as well as in Decimus Burton's magnificent glass and metal conservatory in the Botanical Gardens. The Regent's Park superintendent in 1931 was Duncan Campbell, a man not only interested in horticulture but also theatre, who as a result gave strong support to the Open Air project.

In 1932 the land within the Inner Circle, which had until that date been leased by the Royal Botanic Society, reverted to the Ministry of Works. Duncan Campbell was largely responsible for redesigning the gardens. The offices of the Botanic Society were converted into a tea house and the museum closed. The Open Air Theatre was given premises on the north side of the garden. By 1935 this area within the Inner Circle was renamed the

Queen Mary's Garden. However, it was in 1933 that the theatre opened its first full season, the stage and auditorium established then as they would be through the next thirty years with an immense semi-circular sweep of seating, deck chairs in front, slatted park chairs behind, facing an 80-foot lawn stage backed by a screen of poplars, sycamore and hazel. It was an exhilarating season of large audiences but despite such attendances, it lost nearly £3,000. It was Carroll who had to pay for shaping the stage, digging and transplanting trees, a marquee for inclement weather and the need to ensure his greensward was kept well-drained and springy. He was exceptionally proud of his new stage, covered in turf by a firm from Surrey. On the opening night of the season, surrounded by his cast, his especially long speech ended with the words, 'And I wish you all to know that every sod on this stage comes from Richmond.' Between 1934 and the declaration of war in early autumn 1939, the Open Air Theatre put on eight valuable productions as well as the popular familiar choices of *Henry VIII*, *Julius Caesar*, *Romeo and Juliet*, *The Merry Wives of Windsor* and *Pericles* as well as the operas *Cosi Fan Tutte* and *The Marriage of Figaro*.[7]

By 1934, the Zoological Society too was flourishing. Having come into existence in 1828, they had received no aid from any public funds with income from only two sources – gate-money paid by the public and the subscriptions of Fellows. The recent improvements in the gardens had generated extra income from gate-money, but this was still insufficient to meet expenses and to make improvements in buildings and

appliances for the care of the animals 'and to carry out the scientific work imposed on the Society by the terms of its Royal Charter'. The Fellows of the Society, by their annual subscriptions and by the work of their voluntary council and committees, were responsible for the creation, maintenance and on-going success of what at the time was the most important zoological institution in the world.[8] The Society consisted of just nearly 8,000 Fellows, and twenty-five foreign and 200 corresponding Members. Along with the curators and superintendents, the Zoological Society employed five overseers, a head gardener, clerk of the works, electrician, storekeeper and nearly 200 keepers, gardeners and labourers. In 1933, over 155,624 persons were admitted without payment on Sundays through Fellows' tickets. The 1934 guide to the Zoological Gardens offers curious insights to its management and some of the rules and regulations are certainly amusing. 'Visitors are earnestly requested to co-operate with the Staff in preventing any teasing or irritating of the animals. The Keepers should be communicated with at once if visitors wish to call attention to interference with any of the animals ... They are earnestly requested to use common sense and care. Tobacco in no form should be given to any animal.' In the same guide,

> The Broad Walk between the two great lawns is used for the Elephants to carry children every afternoon when the weather permits. Riding tickets can be obtained at the office at the west end of the Lion House. Visitors are warned that the Elephants are accustomed to be fed

by the public, and, although they are quite gentle, will snatch paper bags or handbags with their trunks, in the belief that they contain buns. Visitors who are nervous should not go close to the Elephants, and should keep a sharp look-out on any bags or parcels they may be carrying.[9]

It was the Second World War which took a heavy toll on the park, significantly more so than the First World War had done. The Zoological Gardens remained open, but the park was dramatically affected. Barrage balloons were moored in the Inner Circle, with villas and terraces standing empty and forlorn, and many were badly damaged. Holford House, the Master's House at St Katharine's and part of the western sector of Park Crescent were destroyed by bombs. However, the real harm set in due to inevitable neglect and by building restrictions which made all but absolutely essential repairs illegal. By 1945, there was scarcely 'a single Terrace ... which does not give the impression of hopeless dereliction; there are in fact, few more lugubrious experiences in London than that to be obtained from a general survey of the Nash Terraces in Regent's Park'.[10] Two-thirds of the houses were empty; few remained undamaged from blast or bombing; many were no longer weatherproof. A committee under the chairmanship of Lord Gorell was set up by the government to consider what should be done for the best with the decaying terraces. Their terms of reference on appointment by the Prime Minister on 12 January 1946 were to 'consider the future of the Terraces adjoining

Regent's Park from all aspects, architectural, town planning and financial, and to make recommendations as to their future adaptation or replacement to meet modern requirements'. Nash's legacy and the Regent's Park were at an important crossroads with the committee seriously considering possible 'replacement to meet modern requirement'. The scope of the enquiry was to consider Hanover Terrace, Kent Terrace, Sussex Place, Clarence Terrace, Cornwall Terrace, York Terrace, York Gate, Ulster Terrace, Ulster Place, Park Square West, Park Crescent, Albany Terrace, Park Square East, St Andrew's Place, Someries House, Cambridge Gate, Cambridge Terrace, Chester Gate, Chester Terrace, Chester Place, Cumberland Terrace, Cumberland Place and finally Gloucester Gate. In total, these terraces contained 374 houses. The Committee were to be thorough and consulted a wide range of public bodies, professional institutions and experts and held over seventeen meetings and inspected the terrace buildings and the area as a whole. They fully acknowledged that Nash's concept remained and the importance of his contribution, as well as that of Decimus Burton, and especially the contribution of sculptor J. G. Bubb, who was employed to design and execute sculpture in the pediments of Hanover Terrace and Cumberland Terrace.

However, prior to the appointment of the Committee, three steps were taken, which were to instruct architect Louis de Soissons to prepare plans, together with estimates of cost, for converting a typical terrace block into flats and maisonettes, while preserving the façades.

They then consulted the Royal Fine Art Commission, who made a number of recommendations, as well as, lastly, agreeing that the Ministry of Works should take over more than half of the terrace houses, and convert them for temporary use as government offices.[11]

The new government under Attlee set up the committee with six members – headed up by Gorell – who were Mrs I. M. Bolton, Sir Edward Forber, J. H. Forshaw, Sir Eric Maclagan, Sir Drummond Shiels, and John A. F. Watson. However, the views they received were wide and varied and often conflicted and reaching a conclusion was difficult. The London County Council stated that all the terraces should be preserved, so great was their architectural importance, and that 'nothing less than the restoration of the buildings to their former state can be contemplated' but St Marylebone Borough Council thought that everything should be demolished and 'blocks of multi-storey flats of a mixed character' should be erected, while St Marylebone Labour Party said that Nash's architecture was not worth preserving and that the whole area should be redeveloped for the working classes. As a result, the committee appointed their own expert, Dr Oscar Faber, to examine the structural condition of the terraces, which unsurprisingly, he found to be very bad; apart from bombing, blast, subsidence and neglect, dry rot had attacked almost every house. The remaining residents were standing steadfast and included the novelist Miss Elizabeth Bowen, who declared that the houses were far more solidly constructed than any modern dwelling. There were even disagreements and conflicting costs

related to rehabilitation and patching up. Estimates ranged from £1,350,000 for rehabilitation to £6 million if the buildings were to be demolished and rebuilt with façades identical to those designed by Nash but with interiors suitable for modern living, and faced with Portland stone. It was Mr de Soissons who considered that the terraces, if converted and modernised, could be guaranteed a life of no longer than fifty years, which would scarcely have justified so great an expenditure; Faber considered a hundred years was equally possible. Gorell's committee made up its own mind. On 21 January 1947, Gorell submitted the report to Attlee, acknowledging that the inquiry had been 'prolonged and of some complexity'. The statement read, 'The main conclusion of the Report is that the Nash Terraces are of national interest and importance, and that, subject to certain reservations, they should be preserved, so far as that is practicable. With this conclusion the Government are in sympathy. The Government also agree that the long-term use of these buildings should be for residences and not for offices; they will give consideration to the proposals for new building.' The committee also recommended

that the preservation should be carried out without strict regard to the economics of prudent estate management and that due regard should be paid, in fixing any rents, to the desirability that occupation of these magnificent sites should not be the privilege of any particular income group; they clearly contemplate that the capital expenditure ... would amount to several million pounds

– should fall, in the main, on the taxpayer, and that the tenants should occupy on a subsidised basis.[12]

In more detail, Park Crescent, York Gate, Sussex Place, Hanover, Cornwall, Chester and Cumberland Terraces were to be preserved at all costs, and York Terrace if possible. They advised that the terraces should be reconditioned as they stood or converted behind the original façades on plans such as those devised by Mr de Soissons. They emphasised that the park should remain for residential use only but agreed that Someries House, Cambridge Gate and Cambridge Terrace could be pulled down and replaced by a hostel for students at London University, and a music centre. They also insisted that 'the present building line should be adhered to in perpetuity' and added that 'we would greatly deprecate any further building within the Park itself'. They were also critical of the way the commissioners had managed the park over the years, saying they could not understand why additions such as attic storeys and other additions had been allowed and why, since the war years, damaged buildings had not at least been made weatherproof. The criticism was undeserved. There had after all been a major world war only just recently and they would have been criticised for diverting men and materials for the repair of the half-empty terraces. At least the terraces were still standing at the end of the war, and Nash's concept of the park still remained.[13]

Despite the recommendations of the Gorell committee, little happened for nearly ten years. There were however, significant changes in the Albany Street

area. The Crown Commissioners had purchased from the Regent's Canal Company the remainder of the wharf leases, and in 1942 and 1943 had had the easternmost arm of the canal filled in since it was no longer used for transport and was nothing but an unhealthy expanse of stagnant water. Heavily bombed and standing forlorn and desolate, St Pancras Borough Council developed the area in 1951, redeveloping the area for 1,700 families with architect Sir Frederick Gibberd at the helm. By 1956, the Commissioners of Crown Lands were reorganised and became the Crown Estate Commissioners, who under the chairmanship of Sir Malcolm Trustram Eve, considered the future of the terraces and in November 1957 they issued a statement announcing 'that a number of Nash terraces will definitely be preserved for effective use for many years to come. That an attempt will be made to secure the same result for all the other Terraces designed by Nash or his contemporary Decimus Burton, if this can be achieved without undue capital cost. That, while an assured future cannot yet be forseen for all the Nash and Decimus Burton Terraces, present plans do not provide for the demolition of any such Terrace, or for the elevation of any such Terrace to be altered'. The cost of restoration had risen from £6 million to £8–10 million. The commissioners remained unperturbed and, as a first step, decided to preserve and, where needed, to rebuild Park Crescent, Park Square and York Gate 'comprising sixty-one houses ... the main southern entrance to the Park and are ... its most important features'. Residents in Hanover and Kent Terraces were

given new long-term leases provided they undertook necessary repairs. Cumberland Terrace was to be converted into flats. Mr de Soissons was appointed as architect. Both Cambridge Gate and Someries House were demolished, but Cambridge Terrace was reprieved. Sussex Lodge was so badly damaged it was pulled down and made way for a new building for the Royal College of Obstetricians and Gynaecologists. As Nash had done, the commissioners were keen to work with experienced property developers in the hope that it might be possible to save all the terraces by converting them into modern accommodation. By 1965, the appearance of the park had changed with the restoration of Park Crescent, York Gate and Cumberland Terrace all well under way and heading for completion. No longer skeletal terraces, there were now painted façades, remodelled statues and capitals and flats and small houses suited to the scale of modern living equipped with lifts and modern heating.

But what of the parkland and the effect of the Second World War and post-war years on the landscape of Regent's Park? During the war years, military camps were set up in both Regent's Park and Primrose Hill. Huts and gun turrets were built and their concrete foundations remained on Primrose Hill until 1955. Paths were widened and trees removed to allow for the passage of heavy vehicles. Contingency plans for further removal of trees in an emergency were also set up. In the parkland itself, the cricket field was used for hay to provide fodder for zoo animals, and large areas of grassland were cultivated as allotments by local residents. Barrage balloons were anchored in the

park, air-raid shelters were built around the edges of the park and those on Cumberland Green still cause subsidence problems in the park. The perimeter iron railings were taken down and donated to the national collection of iron as part of the war effort. The park and its surroundings, as we know, sustained considerable bomb damage. Rubble was collected in the northern part of the park and during 1942 and 1943 was used to fill in the easternmost arm of the canal and basin. The canal, having been bought by the commissioners from the Regent's Canal Company, was filled with clay from the Underground workings and the area north of Gloucester Green was subsequently laid out as a car-park for the Zoological Gardens. The bomb damage rubble was spread over the northern area of the park between The Holme, the north of the lake and the Zoological Gardens to a maximum of 10 feet depth. Within the park, the last private villa residence in the park, The Holme, was leased to London University for student accommodation in 1947. St Katharine's Lodge and Holford House were taken over by the Ministry of Works and demolished. These new 'sites' offered opportunities for development and, as a result, a range of proposals were put forward. Plans for laying out the Holford House site as bowling greens and playing-fields were drawn up between 1950 and 1954, and also plans for developing St Katharine's site as a playground. Eventually, the Holford House site was laid out for tennis courts, a golf school and an archery ground, and within the wooded area a maintenance ground for the Parks Department was built called Leaf Yard. The

woodland plantation and shrubbery which had been the grounds of the old house was identified as a bird sanctuary and fenced off in the early 1960s. The St Katharine's site was left vacant.[14]

Although most of the major changes in the park at this time were developed from damage caused during the war, many incidental changes were made to the park during the 1950s and early 1960s continuing the trend set by the 1930s. Slight alterations were made to the shrub beds along the Broad Walk and in the Inner Circle, with such decisions made by the park superintendent at the time. Other changes included the building of jetties at the edge of the lake and the filling in of the small reservoirs in the Inner Circle. Decisions like these would have been referred to the Royal Parks Bailiff, with major decisions demanding the attention of the Minister. Other changes included the filling in of the small lake in the Broad Walk Gardens, the removal of the tea room on Primrose Hill and realignment of paths and the donation of the 'Triton' Fountain in the Inner Circle to the memory of Sigismund Goetze in 1951. Shakespeare's Oak, which had died in 1963, was replaced by another oak in 1964 by the Society of Theatre Research. Primrose Hill had suffered from a loss of trees during the war and as well as a programme of replacement, the Parks Department undertook in the early 1950s a major operation of re-siting the existing avenue trees into informal groups. Funding appeared not to be a problem and public facilities were extended within the park. Additional depot and nursery space was added to the Parks Department buildings in the

Inner Circle after 1952. The tea rooms in the Inner Circle based on the old offices of the Royal Botanic Society were demolished in 1962 and the new Rose Garden restaurant was built. Also in 1962 the Bernard Baron Sports Pavilion, which had been bombed in the war, was rebuilt as a redesigned and larger building.

In 1954 two committees were formed by the government to give advice on particular decisions taken within the park. These were the Bird Sanctuaries Committee and the Tree Committee. Each committee was made up of specialists in the subject, was run on a voluntary basis and did not aim to give advice on the development of the park as a whole. The committees met once or twice a year and decisions were referred to the park bailiff or the minister. They were clearly effective as Regent's Park and Primrose Hill are now subsequently rich in both birdlife as well as containing a wide diversity of specimen trees with considerable arboricultural interest.

The destruction caused during the Second World War led to further changes to the form of the park, which had already altered in character from Nash's design. Despite the continuing seemingly random additions of public facilities, the intense interest shown in the future of the Nash terraces in the 1950s and the setting up of the Tree and Bird Sanctuary Committees reflected a changing attitude to the park and a more positive approach to its future by the mid-1960s.[15]

Regent's Park was now very much a 'city park'. By 1970, almost 300 of the 363 acres of the park were open to the public and managed by the Ministry of Works

together with 60 acres of Primrose Hill. The remainder of the park was under the control of the Crown Estates Commission with 17 acres leased to Bedford College, and 12 acres leased to the United States Embassy. The Zoological Society managed 38 acres. The seventies was a period in particular where there was no formal management policy for the development of the park and this was partly due to reduced resources of finance and labour. The day-to-day management was still the responsibility of the park superintendent. Further incidental changes occurred and included in the 1970s a bandstand which was brought in from Richmond Park and positioned south-west of the lake near the main pedestrian route from Clarence Gate Bridge to the Open Air Theatre and Queen Mary's Gardens. This replaced a bandstand which had been positioned south of the entrance to the Zoological Gardens in the Broad Walk. Since 1971, the Winter Garden near Chalbert Street Gate was laid out, and a new plantation north-east of the lake. Within the Inner Circle the nursery buildings were rebuilt and on the eastern arm of the lake the boat storage facilities, kiosk and jetty were redesigned. In 1977 essential drainage works were carried out on Cumberland Green because of the waterlogged ground conditions.

Growth in tourism in London was a major reason for significant increased usage of the park, which ultimately resulted in additional seating and improvement of recreational and refreshment facilities. Despite the daily locking of the park, vandalism was an issue and especially so on Primrose Hill where it was particularly

severe. Tree planting had been significant but largely as scattered groups of specimen trees in grass, with the exception of an ornamental maple avenue across Gloucester Green and a hornbeam avenue across Cumberland Green. The aged cherry tree avenue along Chester Road which had been donated in 1932 by Sigismund Goetze was replaced by *Prunus Kanzan* in 1976. In 1974 it was recommended by the Tree Committee that the old chestnut avenue along the southern part of the Broad Walk should be replaced. It was decided to phase the replacement tree planting over three years, thus giving only a slightly uneven age in the avenue. Between 1975 and 1979 many trees were killed by the outbreak of Dutch elm disease. An attempt was made to save some of the elms by an injection method, but with only a small degree of success, with most of them failing. The biggest loss was sustained in the Elm Avenue of the northern part of the Broad Walk. These trees were replaced with Norway maple, silver maple, Caucasian ash, oak and lime.

The biggest and most significant changes were to Nesfield's Avenue Gardens. These had been much simplified over the last 100 years and by the late seventies, only the park structure and the ornamental vases remained. Among the shrubberies and lawns of the Broad Walk were now placed a number of modern sculptures. By 1979 the Tree Committee and Bird Sanctuary Committee were both disbanded by the new Conservative government. A new body, the Royal Parks Policy Committee, with wider responsibilities for the development of all the Royal Parks was set up in

1980. By 1981 Regent's Park was completely different in character and function to that envisaged at its laying out in 1812, now containing many different features from different periods of its history which reflected its development from a private estate to a public open space and city park.[16]

Decline and Revival

The fortunes of parks have fluctuated throughout their long history, and the twentieth century was no exception. The Victorians' great burst of civic park-making continued into the early years of the century, encouraged by the Public Health Acts Amendment Act of 1907, which gave greater powers to local authorities, strengthening the parks lobby. During the same period the Institute of Park Administration was formed, with the result that by the 1920s a city such as Manchester could boast some fifty-seven public parks. By the first quarter of the twentieth century visits to the local park were a regular part of most urban childhoods. For urban dwellers generally, parks were the social centre of outdoor and recreational activity, and an expression of civic pride. The nineteenth-century Victorian writer John Ruskin had already made the observation that 'the measure of any great civilisation is its cities; and the measure of a city's greatness is to be found in the quality of its public spaces – its parkland and squares'.

Nonetheless two world wars, each followed by depression or austerity, took their toll on this legacy,

particularly in many inner-city areas. Underfunded and undervalued, many parks became litter-strewn, dog-fouled wildernesses. No national authority or policy was in place to regulate their management. In London, inadequate resources led to a cycle of decline. Poor maintenance and underplanting resulted in under-use, in turn prompting vandalism and other anti-social behaviour. This was not unique to London. Even Birkenhead Park did not escape neglect, despite its unique place in history, and its pre-eminence as Paxton's masterpiece. The fine classical boathouse had become roofless, its walls scored with graffiti. Vandalised footbridges had to be closed, and the islands to which they led, left untended, becoming impenetrable jungles. The lake had turned green with algae; belts of trees and shrubs had been decimated by Dutch elm disease or over-maturity; and the conservatory demolished. The picture of depredation was completed by the surrounding phalanx of formerly proud villas, the sale of whose plots had once financed the park – the houses now dilapidated, the ornamental railings of their gardens replaced, as often as not, by broken sheets of corrugated iron.

This catalogue of neglect was typical enough to have brought into question the entire role of the park. Municipal parks were conceived mainly for passive use; for gentle exercise in fresh air, combined with listening to music, learning about plants and animals, or visiting an art gallery or museum. Above all they offered the chance to enjoy nature in the company of others. As Olmsted said, 'A rural retreat is an essential recreational

need in the heart of the city.' Playgrounds and in particular areas for sport were carefully integrated and did not dominate the overall concept. In the words of W. W. Pettigrew, superintendent of Manchester's public parks for twenty years, 'fair balance' was the key issue. Since the 1920s the increasing demand for more sports facilities has sometimes led to the complete exclusion of ornamental features, as 'unwanted extravagances'. Sites such as Crystal Palace, purely aesthetic features, continued to be displaced by playing fields, tennis courts, running tracks and so forth. The ornamental horticulture characteristic of Victorian parks also went into decline. Critics of the fashion objected to the garishness of its effects and in the eyes of the authorities flowers and sports were seen to be mutually incompatible. The retreat from horticulture also led to reductions in park staff, whose presence would give a reassuring sense of safety to the public. Loudon had recognised the problem in 1837 when he remonstrated with those who tore up the ancient and overgrown yews and hollies in Kensington Gardens in the name of public decency, saying that 'a few additional policemen would have effectually prevented the commission of these offences than the means resorted to'. Buildings once both useful and ornamental often became totally inappropriate to the character and use of the park. At one stage, the increasing number of artefacts and buildings in London's parks became a real concern – at one stage, there were 600 in St James's Park alone. In 1990, a friends group came together and formed the Regent's Park Protection Campaign and successfully

fought plans by London Zoo to develop 10 acres as a commercial theme park.

In the United Kingdom, the Garden History Society and the Victorian Society produced a joint report in 1993 highlighting the state of urban parks in the country. National agencies responsible for identifying landscapes of historic importance such as English Heritage, Cadw and Historic Scotland began to focus more on them. Research by Comedia in association with Demos was published on social aspects of urban parks, providing justification for reinvigoration. In 2001, the Urban Parks Forum published the Public Park Assessment, a survey of local authority-owned parks focusing on parks of historic interest. It concluded that urban parks in the United Kingdom were in serious decline, some 27,000 parks, with historic parks faring worse than recreational open spaces with significant loss of features and a disproportionate reduction in revenue expenditure. The devastating decline highlighted the loss of ice-houses, glasshouses, bandstands, paddling pools and fountains. Features such as boathouses, aviaries/pets corners, grottos, shelters, ornamental gates and monuments and follies were rapidly disappearing. However, as described, public parks were intended for all members of society, with the earliest uses for informal promenading, followed by sports, such as cricket and football, and then children's play. Despite the continuing validity of such uses, visitor numbers declined considerably in the second half of the twentieth century, a fact that can be attributed to factors such as car-borne recreation, a lack of modern attractions,

vandalism, poor security and indifferent standards of maintenance.

During the latter half of the twentieth century, as we have already stated, many well-designed parks deteriorated significantly due to lack of maintenance, vandalism, poor quality repairs, poor new design, poor location of new features, ill-informed planting and the removal of existing features, including planting and bedding. In many instances these decisions were taken in an ad hoc manner without considering the way this might affect the overall design of the park. An amalgamation of such changes would adversely affect the appearance and usage of any park. The Royal Parks and Regent's Park in particular were not immune to such dramatic changes and decline. Laid out with turf, water and hard surfaces within a framework of planting, the composition of these various elements are what determines any park's character, though it may alter subtly over time with growth of vegetation. Where any period of long, slow decline has been extended, nothing short of a thorough, ongoing repair is desirable, making an assessment of the extent of past changes, charting the historical development of the park. Slow and sensitive upgrading is needed to recognise the value of distinctiveness and the importance of memory in parks, and is generally preferable in older parks to redesign. In sites of historic importance there is generally a requirement for accurate restoration work and there should always be scope for reconstruction of former features.[1]

Webster in 1911 had already described changes that he had made to Regent's Park, and in particular, the

Avenue Gardens, which had moved away considerably from Nesfield's original plans of the gardens. By the early eighties, little remained of these gardens and the park had suffered from a clear lack of strategic direction and as a consequence, the original historic landscape was now significantly compromised. As a result, in 1981, the Directorate of Ancient Monuments and Historic Buildings of the Department of the Environment commissioned William Gillespie and Partners, Landscape Architects based in London, to 'carry out a survey to record the history, development and current state of the park to provide a stock taking document from which future policy could be prepared'.[2] They concluded that

> change is the basis of historical evolution and central to the park's development have been the changes brought about by public access to the park. The particular purpose for which Nash designed the park is no longer valid in its original form. The basic framework remains in the perimeter road layout, the canal and the Broad Walk Avenue and the surrounding terraces. It is an indication of the strength, and suitability of Nash's overall design, that the park has continued through the years and been able to absorb so many changes ... In addition to alterations in the layout, changes in the character of the planting have occurred. The planting no longer provides a strong framework of dense plantations as shown in Nash's plan. The plantations have not been replanted in the original form. New tree planting has been scattered groupings often of ornamental species rather

than Nash's original choice of indigenous and exotic forest trees. Many shrub beds have been introduced and this type of planting was expressly excluded from the parkland by Nash ... The landscape and built features reflect the history of the parkland. The analysis shows that some of these are of a positive contribution whilst others conflict due to their siting or design. A number of features which are in many ways typical of the periods in which they were provided, are often un-harmonious in their present setting, conflicting with the visual or historical character of the park ... It is evident from the historical research and the survey that the park cannot continue to absorb further piecemeal development. A defined policy for the management and continuity of the park should be prepared which will co-ordinate future new development and restoration. This policy is essential to the future of the park which is not only of historic importance in London, but is part of our national heritage.[3]

The conclusions were based on a detailed analysis of the park carried out by the consultants which was comprehensive and described in detail the changes to the parkland and its condition in the early eighties. In particular, there was an emphasis on the changes to planting, changes in trends in planting patterns and distribution. Nash's choice of tree species for Regent's Park was a range of indigenous and exotic forest trees which included birch, plane, sycamore, oak, larch, lime, horse chestnut, elm, Spanish chestnut, ash and beech, with a few flowering trees such as hawthorn. By 1850,

we already know that certain trees were unsuitable for the soil conditions in the park, in particular lime and horse chestnut. Exotic trees were planted as specimens in the more ornamental areas of the park, particularly in the Avenue Gardens and the private enclosures. This trend reflected the Victorian fashion for collecting newly discovered plant varieties. During this period the trees suffered not only from the poor soils and drainage but also atmospheric pollution. This may have been a further reason for the introduction of a greater variety of tree species to the park. Little is known about tree planting since the beginning of the twentieth century as few records exist. Tree planting was generally confined to the south of the park, and in particular to the garden areas of the Inner Circle Gardens and the southern Broad Walk, which was the Avenue Gardens. After the last war, tree planting occurred, primarily of ornamental species such as flowering cherries, as well as the avenue of tree planting north of Chester Road, which was originally elm and comprised of Norway maple, silver maple, lime, Caucasian ash and various oaks, with two new ornamental avenues planted across the north-east of the park, across Cumberland and Gloucester Greens, of variegated sycamore with red Norway maple and fastigiate hornbeam.

The oldest trees, of 100 years or more, are scattered across the park and are likely to be remnants of Nash's original design. There are a wide range of ages across the park but in many instances, even-aged planting existed and is likely to be of historical significance. The Queen Mary's Gardens in the Inner Circle were

considerably altered in layout in the 1930s and much of the planting in this area dates from the period 1930 to the early seventies. Nash's plan for the Regent's Park Estate as realised in 1827 shows dense tree plantations and closely planted clumps of trees in open grass lawn. There is a broad avenue of planting in the position of the existing Broad Walk gardens and an open area to the north-west of the park. Nash consciously avoided the scattering of individual trees in grassland and used dense tree planting to provide structure to the parkland. The Broad Walk planting was thinned in 1864 with the construction of Nesfield's intricate Avenue Gardens. The Victorian period saw a gradual change in the pattern of planting. Trees were planted in open groups or singly as specimens, and Nash's plantations became thinner as they aged. From 1930 tree planting was carried out in a range of forms including scattered in grass and latterly in densely planted groups. By 1981, the planting structure of the parkland was significantly different from Nash's design, particularly due to the amount of specimen trees scattered in grass, further diluting the strength of Nash's tree plantations.

As far as shrub planting was concerned, Nash intentionally generally excluded it from his design and organised the tree planting in such a way that any shrub planting in private villa gardens would not be seen when passing through the parkland. The only shrubs specified for the park were those sown by seed on the canal banks for the purpose of soil stabilisation. After 1850 the Victorian fashion for gardening and the use of ornamental shrubs in planting became favoured in the

park. The Inner Circle developed independently from the rest of the park as the gardens of the Royal Botanic Society, but the major contribution to Regent's Park from the Victorian period was the construction of the Nesfield Avenue Gardens in 1864, with their complexity and intricacy contrasting completely to Nash's plans for the park. As we have already mentioned, these gardens were much simplified by the beginning of the twentieth century, and by 1981, only a basic layout remained in footpath plans and general form of the shrubbery to the east of the Broad Walk. Nesfield's design in essence no longer existed.

What of the landform and built structures within the park? The landform actually remained substantially unchanged since 1827. The alterations which were made to ground levels in the park were carried out during the 1940s and 1950s. Nash's design shows grass walks, with the exception of one hard-surfaced walk, and this reflects the degree of anticipated pedestrian use. By the mid-nineteenth century there is reference to hoggin surfaces for footpaths, and the Inner Circle road is gravelled. Much of the footpath network to the north of the park dates from the period 1829–50. By 1870 further additions had been made to the network. Between 1871 and 1895, much of the existing footpath network west and north-east of the ornamental lake was formed, together with a link across the lake to the Inner Circle. The bridge over the lake from Clarence Gate dates from this period as well as the bridge by The Holme. York Bridge was rebuilt together with Macclesfield Bridge over the

canal, and the footbridge west of Macclesfield Bridge was constructed.

Recreational facilities within the park have existed since 1847 with the 'gymnasium' constructed at the foot of Primrose Hill as well as a number of play areas. Tennis courts were established in the old grounds of the Toxophilite Society, south of the Inner Circle, in 1922 as well as a poorly located tennis and golf school to the north of the park in the grounds of the demolished Holford House site. To the west of the ornamental lake near Hanover Gate is the small boating and paddling pond which dates from 1930. A running track on the southern canal bank was opened in 1930 and is still in place alongside the busy Outer Circle Road.

As previously indicated, none of the original villas remain intact in the park. The villas of St John's Lodge and The Holme, formerly used by Bedford College, had a considerable impact on the park and are still part of significant views across the park. However, the oldest building in the park is the lodge at the junction of the Broad Walk and Chester Road, dating from the period 1850–70. The refreshment lodge in the tennis courts by York Bridge was built during the period 1871–95 as the pavilion for the Toxophilite Society and is still an asset to the park. The Broad Walk refreshment lodge dates from 1913 on the site of a previous refreshment lodge of 1879 and in its position has extensive views across the open north-western area of the park. Close by is one of the few shelters in the park, dating from approximately 1895.

Sadly, as was often the case in public parks, buildings

that were introduced latterly were generally associated with public facilities such as toilets and shelters associated with children's play areas. Most in Regent's Park, however, were unobtrusive as they were hidden by shrubberies. Depot facilities were increased but generally well screened. Gillespies were critical of the boating pond kiosk and the box office associated with the Open Air Theatre as well as significantly the sports pavilion that was prominent in the north-west of the park. This was built in 1962 on the site of the previous pavilions since 1887 to serve the vast array of pitches that Webster so ably described in 1911. The analysis quotes, 'The opportunity for a building on this site to make a valuable contribution to the park has been wasted.' The Rose Garden restaurant, central to the Queen Mary's Gardens, was built in 1965 and sits in a garden setting but by 1981 was looking poorly maintained and badly weathered. Finally, three buildings that were later introductions to the park included the boating lake admission kiosk and landing stage, a gardener's store to the west of the Broad Walk south of Chester Road and the toilet block by York Bridge tennis courts, all with mixed reviews by the landscape architects.

It was, however, the Avenue Gardens that were most significantly altered and as the 1981 report had concluded, 'the present pattern of grass and a few herbaceous beds is far removed from the character of Nesfield's gardens'. The report concluded, however, that 'the restoration today of the intricate gardens of Nesfield's design would be extremely costly and perhaps of little interest to the everyday park user. Without such restoration the gardens

would benefit from a more positive and impressive planting scheme to enhance the strong lines of the Broad Walk, the avenue planting and the symmetrical form of the layout.' It was another eleven years before any further action was taken in relation to the Avenue Gardens. Land Use Consultants this time were engaged in 1992 with a purpose to review the extent to which full restoration could be achieved, possibly with limited compromises for specific items, possibly in a phased manner, and preferably with works undertaken as early as winter 1992. However, as previously described, little remained of the original gardens with the exception of the footpath network, the Broad Walk, and a small number of tazzas. Modern paths had been introduced, with gravel replaced by tarmacadam. Flower-beds had been re-cut to modest rectangular and circular shapes of varied sizes and varied colour displays. Despite being popular and much admired, they were deemed without clear design, purpose or proportion.

Incremental changes which had been made in the past now posed some problems to a full restoration. A good example was the central avenue of horse chestnuts (replaced between 1975 and 1982) had not been planted to the original pattern. Spacing was also somewhat irregular. Similarly the line of gingko on the eastern side (planted in 1976) was just off the line of the original elms and again had different spacing. It was not matched by a line of trees along the western boundary either. This was not necessarily critical in terms of starting the process of restoration, but did suggest that both the chestnuts could be felled in the

long term and replaced to the appropriate pattern and spacing. Land Use Consultants identified a range of restoration options ranging from 'full restoration ... compromised restoration ... partial restoration ... to adjusted layout'. Full restoration was simply not feasible because this would have meant dismantling almost everything in the gardens as they stood, including the horse chestnut avenue, the herbaceous gardens and the dolphin fountain. As a consequence, a phased approach was undertaken and, between 1993 and 1996, a major restoration was carried out. Only a few of the Victorian tazzas and urns survived to be incorporated into the new gardens. Replacements, copied from the original firm's catalogue, were made out of the same artificial limestone used in the nineteenth century. Eight fountains, from the catalogue, were added, even though the original gardens had had no fountains, and, as planned, the elms and horse chestnuts flanking the garden were replaced by limes.[4]

The restoration principles continued and in 1995, Land Use Consultants were once again engaged to come up with options for the restoration and renewal of Markham Nesfield's English Gardens. These gardens were now in a state of 'drift'. The main components of Nesfield's scheme were still recognisable but the character had evolved beyond that originally laid out by Nesfield. Described as pleasant, informal and well used, there were a number of management and renewal issues which deserved attention. One effect of restoring the Avenue Gardens was the increased prominence of this area. Shrubberies had become outgrown, tree

planting had been added into the more open grass areas and as a result the more subtle and interesting effects of the original landform were no longer presented to their best effect. Again, the fabric of Markham Nesfield's design remained, including path layout, landform and some of the shrubberies. The restoration proposed and ultimately undertaken from 1996 recognised the features and spirit of the original design and sought to consolidate the layout without taking on a complete and wholly authentic restoration. Accordingly the restoration strengthened the 'English' character of Nesfield's scheme, with some replanting of existing shrub-beds and planting of additional beds. Some tree clearance was undertaken as well as new tree planting. In many areas, such as the mound, thinning was carried out and restored the scale of the landform, an important part of the Nesfield design. Although many of the details of the Nesfield layout were missing, the spirit of the scheme remained, with the informal English Gardens once again contrasting clearly with the restored 'Italianate' Avenue Gardens to the west.[5]

Hidden within Regent's Park is also St John's Lodge Garden. St John's Lodge was completed in 1819. The grounds had an informal layout until the 3rd Marquess of Bute purchased the lease in 1888. Lord Bute commissioned Robert Weir Schultz to carry out works to the villa and grounds including making 'a garden fit for meditation'. Weir Schultz arranged distinctly shaped spaces on the axis of the villa. Formed by hedges, these enclosures remain the framework for the garden. He extended the villa forecourt into a sunken lawn, with large rusticated stone

piers at the corners (boys on each support Bute family coats of arms) and scalloped hedges along the edges. This lawn led up steps to a circular garden of mixed borders and a central statue of St John the Baptist. An oval tennis lawn beyond was reached through a large stone loggia of classical design. The axis terminated at a nymphaeum, a semi-domed temple within a tight circle of lime trees. Garden features reflected both Arts and Crafts ideas and the late nineteenth-century revival of classical art. To the south were kitchen and rose gardens, paddocks, and to the north side a gravel walk. These and the stone loggia and nymphaeum were lost during a decline between the wars. The central statue was replaced by *Hylas and the Nymph* and the *Shepherdess* statue was introduced. The villa and outbuildings were used as a hospital for disabled officers, and became St Dunstan's Institute for the Blind, and eventually the garden became public in 1928. Despite changes, the garden core retains the quiet, reflective mood intended by Lord Bute. In 1994, the Royal Parks undertook works to strengthen and enhance the character of the garden and accommodate a new access walk brought about by a change of use for St John's Lodge. Elements of the original concept have been re-introduced; there is a new gravel walk with a circle of lime trees around a stone urn at one end and the *Shepherdess* at the other. New planting throughout has increased seasonal interest and variety, and clipped yew hedges replace old privet. A pergola with climbers takes the place of the lost loggia, and a covered seat forms the focal point to the axis where the nymphaeum once stood.

Restoration continued with many other buildings,

monuments and features restored and repaired. On the site of a Victorian gardener's cottage, the hexagonal roofed café in the Inner Circle was built in 1964 in an effort to modernise restaurant facilities in the Royal Parks on behalf of the Ministry of Works. At a cost of £50,000 and designed by Piet and Partners, the brief was to create a building that was sympathetic to its park surroundings. The use of a geometric style popular in contemporary design at that time produced a naturally organic form which sat comfortably in its surrounds. The caterers at that time were Peter Merchant Ltd, who were asked to 'create a medium-priced restaurant with waitress service where all types of people would feel at home'. Forty years later, this unique building was rescued, with its hidden features reclaimed and rejuvenated. In 1964, it was called the Little Chef and today is known as the Garden Café.

As we know, John Nash built a large number of houses along Regent's Canal. More than half of these have disappeared. The largest estate of Nash-built houses was located at what was called the North Bank and the South Bank, sited between Lisson Grove and Park Road. Nash originally envisaged that fifty-six classical houses would be built alongside Regent's Canal within Regent's Park. In the event only eight were built. Of the original eight, only Nuffield and Hanover Lodge still stand. Further houses were built by Nash alongside the Regent's Canal extension to the Cumberland Market area. These houses are sited to the east of Regent's Park by Gloucester Gate bridge. These are known as Park Village East and Park Village West. They still exist but

no longer have a canal running through. Some of the east side villas were demolished to make way for the widening of the railway lines out of Euston. However, in 1987, the Crown Commissioners tendered for new villas to be built to enhance the park setting. They were to be built alongside Regent's Canal.

The classicist architect Quinlan Terry designed the 'new' Nash houses, which were ultimately built from 1987 onwards, the last being completed in 2008. The themes for their design were taken from Nash himself. Controversial at the time, newspaper coverage was mixed, with criticisms that the City of Westminster should 'stop this capricious over-development' while the *Sunday Times* reported that the villas 'would have made Nash smile with satisfaction'. Nevertheless, Quinlan Terry was quoted as saying, 'I find Nash's free form of classicism particularly applicable to the late twentieth century. I have chosen to work on variations on the theme of Nash's earlier work. These villas are not mansions, they are medium-sized twentieth-century classical houses in the *picturesque* tradition.'

As mentioned previously, one of the most important structures within the park is the current bandstand. A twin of the Kensington Gardens bandstand, this was originally erected in Richmond Park in 1931 but after 1951 fell out of favour and was dismantled and moved to Regent's Park in 1975. Regent's Park has suffered a number of tragedies, including the 1867 skating incident and the 1874 Regent's Canal explosion. Sadly, the bandstand is probably best known for the appalling atrocity that occurred in the park on 20 July 1982. Just

two hours after a remote-controlled car bomb exploded in Hyde Park as a mounted detachment of Blues and Royals passed along South Carriage Road, a bomb with a timing device exploded beneath the Regent's Park bandstand, detonated by the IRA. The *Daily Telegraph* reported 'up to 200 people, including children and pensioners, [were sitting] in the sunshine listening to the Royal Green Jackets Band playing a selection from the musical *Oliver*'. According to the *Telegraph*, 'between twenty-six and thirty bandsmen were on the Bandstand' at the time, of whom seven were killed and most of the remainder injured. A little over a year later, on 5 October 1983, the Band of the Royal Green Jackets, consisting of thirty-four players, of whom nineteen were survivors from the attack, returned to play in Regent's Park in an act of remembrance to the men who, in the words of the Prime Minister, Margaret Thatcher, as she unveiled a memorial stone, 'brutally and tragically died'. The stone, inscribed with the names of those lost, stands by the restored bandstand which is now regularly used every summer.

However, in March 1995, the *Independent* reported that 'London's Royal Parks are being short-changed by the government and allowed to slide quietly into shabbiness and decay, according to a panel of experts appointed by ministers'. As a result, the Royal Parks Review Group was established and had been tasked with examining each of the Royal Parks in detail. Eminent architect Terry Farrell was a member of the Review Group which was chaired by Dame Jennifer Jenkins.

During the last four years I have been a member of the Royal Parks Review Group. Initially we looked at Hyde Park and Kensington Gardens, with a report on our findings for these parks being published, and also a conference being held at the Queen Elizabeth 2nd Conference Centre. We then looked at the remaining inner parks – St James's, Green Park and Regent's Park, the work on these being completed in May 1993 with a conference at Regent's College, Regent's Park. Finally, during the last year or so we have been looking at the outer Royal Parks – the riverside parks of Greenwich the east and Richmond and Bushy to the west.

Each member of the group looked at a specialist subject area – horticulture, sports and leisure, tourism and so on. Park managers and local politicians attended a range of meetings with widespread consultation. Terry Farrell summarised his experience, stating, 'I learnt a lot about a particularly fascinating aspect of London; after all, our green parks set London apart from most world cities by their generosity, scale and their special character, [all are uniquely based on the idea of the rural idyll contained within the urban scene]'.

His particular remit was to look at the large-scale design of landscape and buildings together, and the role of what was royal (and private) and was now in the public realm and how to make the best of this changed situation.

There is no doubt that royal privilege and royal heritage created very special places of exceptional value; that

they are now largely in the public domain enriches London immeasurably, but these qualities should not be debased, should not be municipalised. What is the essence of these qualities and what is the real way forward today now that we do not have an all powerful monarchy, yet the parks are not fully in the public domain? One serious shortcoming today is that the parks can sometimes seem a physical manifestation of a national identity crisis, i.e. the royals do not enjoy them as they used to, but then neither does the populace use them as their designers intended.

Farrell's views could indeed echo the use of many of the parks up and down the country in the early nineties. Were parks still relevant and indeed still of any real value?

Farrell continued,

All of the Royal Parks suffer from a similar lack of vision of how society today could use the parks in an inspiring way ... At Regent's Park, pedestrian routes from the vantage point of Primrose Hill down into London's centre are blocked by age-old concepts of private interest that are not relevant today, whilst the public pays for the upkeep of the central spaces. I believe some routes through Park Square and the Zoo need to be released to the public realm in order to allow Nash's vision to be reinterpreted for modern times. The wonderful view from Primrose Hill and the Broad Walk should be linked directly with a pedestrian avenue through the Zoo; and then further south, the

Broad Walk should continue through Park Square and Park Crescent gardens (taking up very little land to do so) and thus link Regent's Park, the tube station and Portland Place, in one great accessible and direct vista ... The Royal Parks need a socio/cultural vision. This is not an anti-royalist argument, I do not want to turn them into less 'designed', less Royal Parks like Battersea or Hampstead Heath, but nor should Royal Parks be too backward looking like sterile husks which sustain the appearance of usages that no longer exist ... Parks and pedestrians go together. Action should be taken at Park Lane, Hyde Park Corner, Marble Arch, Regent's Park and its connections, and Greenwich, so that they could all, quite simply, be experienced as fully accessible, fully enjoyable, wonderful public places of world stature ... When it comes to the future of the Royal Parks, we must not tinker round the edges. They are among the most original and sublime man-made environments in the world. At present they are neither the royal wonders of yesterday, nor the fully accessible and public treasures of today. The Royal Parks Review Group's work should be a real beginning to make London's green 'trapped countryside' work even better for all of us – for royalty and the people; we should, on all sides, combine to keep faith with the original inspired design achievements, even though society and the political order has evolved and changed.[6]

The report was well received by the government, and National Heritage Minister Iain Sproat in March 1996 stated the government recognised the crucial value

of the Royal Parks to visitors and local residents and 'would ensure that their unique character as areas of quiet enjoyment will continue to be protected – whatever pressures they face'.

However, over the last thirty years, the Royal Parks have continued to enjoy a renaissance. Since the formation of the Royal Parks Agency in 1993 as an executive agency of national government, they have continued to manage and develop their parks with a coherent and strategic direction, despite continued funding pressures. Fully accountable to Parliament through the Secretary of State, they have managed a range of restoration projects with not only continued improvements in Regent's Park, but also in Bushy Park, with a £7.2 million restoration project from 2000 to 2009 with significant funding from the Heritage Lottery Fund. Nationally, since 1996, the National Lottery has funded over £640 million worth of improvements to some of our most significant and important historic parks, including Victoria Park, London; Birkenhead Park and Sefton Park, Liverpool; Lister Park, Bradford; Heaton Park, Manchester; The Arboretum, Lincoln; Albert Park, Middlesbrough; Leazes Park, Newcastle upon Tyne and many others, in total over 700 historic public spaces. They continue to do so into the twenty-first century.

The Management of a Twenty-First-Century Royal Park: The Park Today

The Royal Parks share a rich history, and Regent's Park in particular, the vision of one man, John Nash, has contributed to London's identity as a great metropolis but also to the nation's cultural, scientific and political heritage. However, the park is many things to many people. It is still the home, place of work or study for a few but also a place for many to visit occasionally or regularly, not only for local people, but for people from all over Britain, Europe and the rest of the world. For all, it provides physical and spiritual relief from the pressures of modern living, and from the traffic and hubbub of modern urban life.[1]

But what of Regent's Park in the twenty-first century? Despite continued financial and political pressures, the Royal Parks Agency have managed Regent's Park since 1993 and despite being criticised for a lack of vision by Terry Farrell and facing the claim that all the Royal Parks should be used in a much more inspiring way, this park retains its unique qualities and identities. The Royal Parks Agency responded admirably to criticism

that they were not managing their responsibilities in a strategic way. The unplanned changes and ultimate decline of Regent's Park and loss of so many important features, such as the Avenue Gardens and English Gardens, were partly down to ad hoc and unplanned management without a general recognition of its place in history. The management of the park is now strategic, planned and carefully considered and throughout the core of this strategic approach is John Nash. The Regent's Park Management Plan confirms the Royal Parks' aims of conserving and enhancing the park's heritage value and essential and varied character whilst continuing to provide and improve facilities and activities for the local community and wider visiting public, engaging them in the process. The review also highlights current developments in the park such as community engagement and a prioritised programme for action'.[2] The Management Plan continues,

The Regent's Park is significant at the national level on account of its connections with John Nash and as an important historic landscape in its own right. This is reflected by the Grade One listing of Regent's Park on the English Heritage Register of Parks and Gardens of Historic Interest. Indeed, many would argue that it is significant at the international level and possibly worthy of World Heritage Site status. Primrose Hill, as a later addition, is not on the English Heritage Register. However, the magnificent view of the London skyline over Regent's Park from Primrose Hill is recognised as being of such importance that it is protected by statute

for specific vistas to the Palace of Westminster and to St Paul's Cathedral. Regent's Park and Primrose Hill fulfil a strategic and important role as green space, providing an oasis of peace and 'fresh air' within the bustling city valued by locals and international tourists alike and with significant facilities and wildlife habitat. The parks also provide important opportunities for formal sports and sightseeing including London Zoo, which is within the purlieus of Regent's Park. In summary, the essential character and strong *genus loci* of Regent's Park is created by a sense of grand internal spaciousness and the strong formal relationship to the city setting with the architectural splendour of Nash's Regency terraces.[3]

The park now has wider strategic significance. Regent's Park's ecological importance in the context of Greater London is recognised by its designation as a Site of Metropolitan Importance for Nature Conservation, the bird fauna and mosaic of parkland habitats being particularly notable. There are over 7,000 individual tree specimens, 104 hectares of grassland, 6,300 metres of hedgerows, 20,000 rose bushes, and 184,300 bulbs planted every year. It is home to a range of events such as the Frieze Art Fair, the Camden Green Fair, small-scale cultural, musical and arts events, puppet shows, children's entertainment, and the ongoing summer programme in the Open Air Theatre. Regent's Park is now the largest open space for sports in Central London. The addition of the 'Hub' community sports facility and café in 2005 vastly improved the sports

provision for local people, eventually replacing the Bernard Baron Pavilion.

The park, terraces and villas now also form part of the Regent's Park conservation area and cover the eastern segment of John Nash's early nineteenth-century Regent's Park development. It is a small part of a greater scheme that extends to the west into the City of Westminster, and recognises the unique planned composition of landscape and buildings, at once classical and *picturesque*. The Regent's Park Conservation Area Appraisal and Management Strategy highlights the significance of the Regent's Park area as of national and international importance. The comprehensive masterplanning of the park, terraces, villas and the (largely redeveloped, but still appreciable in plan form) working market and service area served by canal to the east was on an unprecedented scale of urban design in London. The integration of all elements of a living area, from aristocrat to worker, from decorative to utilitarian, in a single coherent scheme was exhibited here. On approaching the conservation area from the park the terraces emerge over the trees; here is the city in the country. On approaching from the south Regent's Park is the culmination of Regent's Street, Portland Place and the wineglass shape of Park Square. Park Village East and Park Village West are *picturesque* precedents for the small suburban villa, closely set in a variety of styles that were to become so popular with the Victorians. The service area, while largely redeveloped in the twentieth century, is preserved in the layout of later development, and the physical remains of the canal

and basin to the east of Albany Street. Control over development has been in place from the start when the concept of Regent's Park development was established after the nineteenth-century design competition; after which John Nash sold his building leases for approved designs. Today, the majority of the buildings are listed and the area is a conservation area within either the London Borough of Camden or the City of Westminster. Added protection is afforded by the management of the estate by the Crown, the Royal Parks Agency, and the Crown Estates Paving Commission through the control that they exercise on the upkeep of the buildings, the park, shared private gardens, roads and paving.

Since the writing of the last Conservation Statement in 2002, a number of concerns have started to arise which, ironically, Nash was raising nearly 200 years ago. Despite buildings being maintained and altered with exemplary restoration of original features, some unsympathetic alterations were beginning to occur with loss of details. However, many mature trees are now adding greatly to the character of the area. The trees are now protected by conservation area designation. Many are now in private gardens and incremental careful replacement is being encouraged as these trees continue to add greatly to the quality of the street scene and the sense of the country in the city, exactly as Nash had planned it. Tall buildings at the perimeter of the Park have introduced an overbearing effect behind the trees and the terraces, particularly at the southern end of the park. Basement extensions have been built under gardens resulting in changes to the

landscape and setting of the buildings. Some alterations have been made to rear elevation windows, changing window types, and adding small roof terraces – which Nash despised. Privacy screens have also been added behind railings rather than hedging or shrubs.[4] This is a unique area of national and international importance, managed and controlled by several disparate bodies, including the Crown Estate, the Crown Estate Paving Commission and Westminster City Council.

It was in 1811, when the lease of Marylebone Park to the Duke of Portland expired, that an Act was passed establishing this new park and authorising houses to be built and let by the Commissioners of Woods and Forests. As we know, John Nash drew up the design for the park, and James Morgan laid it out. By 1824 the west and south terraces had been built, all designed by Nash, except for Cornwall Terrace which was designed by Decimus Burton.

The government then promoted a Bill in 1824 for transferring from the existing local authorities the care and maintenance of the roads and sewers on the Crown Estate – from Whitehall to Regent's Park – to a new commission to be called the Crown Estate Paving Commission. Its commissioners were given wide authority to make roads and footways, to provide street lighting, water supply, sewerage, refuse collection, and to lay out and maintain ornamental gardens adjacent to the terraces. To pay for all these activities the commissioners were empowered to levy certain types of rates on the neighbouring properties. These rates had set upper limits, or rate-caps, and charges were to be calculated from the rateable value of

each property. The commissioners were also given the statutory powers to decide the necessary rateable values.

In 1825 a second Act extended the commissioners' powers to cover New Palace Yard, Old Palace Yard and other Crown property in Westminster. An Act in 1828 added the property covering the site of Carlton Palace, Richmond Terrace and other Crown properties, to the commissioners' jurisdiction. Again in 1832 an Act added Cockspur Street, Great George Street, and more Westminster properties belonging to the Crown. The Acts also added various powers to the commissioners, the intention being to secure efficiency and uniformity of treatment for all the Crown Estate properties. For example, Section 29 of the William IV Act authorised the commissioners to undertake the cleaning and painting (known as colouring), in a regular and uniform manner, of all the outside stucco and stonework of the houses abutting the streets and terraces, because 'such an arrangement would greatly contribute to the beauty of the line of street and of the houses and buildings, and would also tend to the ease and convenience of the inhabitants'. After a short time it was found necessary to allow Park Square and Crescent Gardens to be used by residents who agreed to pay a subscription for a key. This was probably because the garden rates from the adjacent householders, charged at the maximum of 6 old pence in the pound allowed by statute, were insufficient to maintain the gardens.

The Commission's minute books show that at the first meeting of the commissioners on 2 August 1824, Viscount Lowther, Lord of the Treasury, was in the

chair and the three ex-officio commissioners appointed
nineteen new commissioners, including the Earl of
Macclesfield, Viscount Duncannon, John Wilson Croker
MP, Secretary of the Admiralty, and John Nash himself.
Many of these were Members of Parliament and most
were resident on the estate. Lord Lowther generally
took the chair until 1835, but Lord Duncannon and at
least eight of the non-official commissioners did so from
time to time.

After twenty-three years the government decided to
withdraw control of Regent Street, Cockspur Street,
Whitehall, Parliament Street, Old Palace Yard, and
other Westminster properties from the commissioners.
A new Act repealing the former Acts and reappointing
the Commission with modified powers was passed, but
there were no subsequent changes to the legislation
affecting the Commission after that.

The various Acts set out the original functions of the
Commission and included

to collect and dispose of all house refuse from the houses
on the Crown Estate at Regent's Park; to maintain all
roads, footways and mews roadways on the Estate;
to provide and maintain street lighting on the Outer
Circle and terrace and mews roadways; to scavenge
and clean all roads, footways and mews roadways on
the Estate; to provide and maintain day and night gate
keepers at certain entrances into the Regent's Park to
control traffic; to maintain the gardens attached to the
terraces on the Estate; to maintain the surface of the
terraces fronting the Mall at Carlton House Terrace [the

podium] and also maintain the adjacent gardens; and to maintain a Lodge Keeper and Night Gate Keeper, and maintain the garden at Richmond Terrace, Whitehall.

These statutory duties have, for the most part, been carried out consistently since their inception, although with various necessary modifications over time. The Second World War resulted in considerable financial difficulties for the Commission because of the extent of the wartime bomb damage. Rising costs and the effects of the rate caps imposed by its statutes meant that the Commission was unable to carry out its full role in maintaining the estate.

The Commission remains today a fully effective and working organisation, a relic of former times, but still maintaining John Nash's unique Georgian exercise in urban planning. It still employs a Clerk and Treasurer, now combined into the role of Director, who also acts as the rate collector. An appointed Surveyor is responsible, with the Inspector of Pavements, for the condition of the roadways and pavements. Other members of the Commission's staff team are the Head Gardener and his gardening team, traffic controllers, craftsmen and an office manager. However, the old office of Sergeant of the Night has long fallen into abeyance.

However, it is the Royal Parks Agency who continues to give so much to the park and their millions of visitors. The most frequently visited park is Hyde Park where there are over 7 million visitors with St James's Park the second most visited with over 6 million. With over 4 million visits to Regent's Park, the intensity of

use impacts directly on the park. Yet the most common activity in Regent's Park is still simply walking. Cars are still allowed on the Outer and Inner Circle but not elsewhere. The early morning commuters passing over Primrose Hill and striding down the Broad Walk are numerous with later users taking in the other areas of the park or sitting in one of the many cafés. Families, dog walkers, couples and those wanting exercise, sunbathers and those wanting to experience countryside in the city all congregate in Regent's Park. Children enjoy the many play areas, the boating lake and ball games in many of the more open areas of the park. In some areas, although limited, cyclists race through the park, especially down the Broad Walk. Private horse-riding is forbidden inside the park, but despite this, Regent's Park has a long association with horses. The Cart Horse Parade, attracting thousands at its peak, was held on the Inner and Outer Circles on Whit Monday from 1888. This was complemented from 1904 by the Van Horse Parade on Easter Monday. In 1966 the two amalgamated to form the London Harness Horse Parade, which was held in Regent's Park until 1994. The horses of the Royal Horse Artillery, based in St John's Wood, are also a familiar sight out exercising round the roads of the park in the early morning.[5]

Regent's Park is the largest sports area in Central London, but the first sport in the park was archery. The Royal Toxophilite Society's grounds, on what is now the site of the York Bridge tennis courts, were established in 1832 and lasted until 1922, with the society's distinctive Archer's Lodge on the edge of the

boating lake. In winter the grounds were flooded to provide a skating arena that was certainly safer than the boating lake. Since 1922 they have been used as tennis courts open to the public. Boating on the lake, from 1861, at one time included sailing as well as rowing; more recently pedalos have been introduced and are immensely popular. Primrose Hill is popular for boules as well as kite-flying and in winter is a sledging mecca. No sports or games are allowed in the formal gardens of the park. Pitch improvements have been significant, and in particular drainage problems which had persisted in being a problem since the Second World War. A more controversial scheme to build floodlit, hard-surface, five-a-side football pitches on the site of Holford House, replacing the ninety-year-old tennis and golf school there, was defeated in 2008 after a widespread protest.[6]

The wildlife of the park continues to attract birdwatchers out looking for the incredible number of species recorded in the park each year. Regent's Park, situated in the heart of London and away from the river, does not seem ideally positioned to attract birds other than those that are typical of urban parkland. Nothing could be further from the truth. For many years this park has attracted the attention of birdwatchers who, like the birds, are drawn to the park's varying habitats. Their dedication and observations have produced an annual tally exceeding 110 species and the overall park list now stands at 192. Birds that are flying over London tend to follow rivers or canals as they can then stop off and feed to replenish their body fat. Reservoirs are another habitat that birds are attracted to. A high percentage

of bird movement over the park consists of birds flying either north-east in the spring or south-west in the autumn. Twenty-one species of butterfly and more than 230 species of moth have been recorded in the park. Some unusual butterfly records for the area include the Marbled White and the White Letter Hairstreak. Many wildlife conservation projects continue to be carried out in the park. These included the creation of loggeries and 'dead hedges' within woodland areas, the planting and management of reed-bed areas, the creation of a wetland and wildflower area in the Silt Pen, the planting of native trees such as English oak and birch, the coppicing of elm on the canal banks, and the planting of native-species hedgerows along fence-lines. There are continued changes to the grassland management. In several areas, but particularly around the new sports pitches, the grass is being allowed to grow longer and wildflowers are being encouraged. In carefully selected areas, a total of 10,000 native wildflowers had been planted, including Field Scabious, Knapweed, Meadow Cranesbill, Red Campion, Lady's Bedstraw, Devil's-bit Scabious, Meadow Vetchling and Lady's Smock.

Formal entertainment in the park is still regularly held. The Zoo is still an ever-present, and has been since 1828. The Open Air Theatre continues to be a major draw to the Queen Mary's Gardens. Despite the loss of the Colosseum in 1875 and the closure of the Diorama in 1848, the park has been the host to many events and festivals including the bandstand marathon Klezmer in the Park, which 'shows the exuberance of the Jewish people in what has become the greatest free annual

Jewish cultural event in London'. The largest event is now the Frieze Art Fair, which is an international contemporary art fair that takes place every October in the park. However for many visitors, it is the sculpture, arts, buildings and monuments, an ever-present in the park since the time of Nash, whether free-standing or incorporated into many of the surrounding buildings that are the attraction for many visitors to Regent's Park.

From the Outer Circle, ornamental gates lead straight into the restored Nesfield Avenue Gardens. The strongly geometric layout of 1863 included extravagant bedding schemes and imposing tazzas and is now complemented by magnificent, flowing fountains, copied from nineteenth-century catalogues. The Griffin tazza in the centre is still the original. The adjoining English Garden is more informal in style and now contains the Chester Gate at one end, with one of the few modern sculptures to be found in the Royal Parks. The intriguing block of granite, *Prism* by John Maine, is the only piece left from the open-air exhibition of the late 1970s which included work by Barbara Hepworth and Henry Moore. The length of the Broad Walk contains many features including the intriguing Gothic refreshment kiosk with its brick façade and pierced bargeboards and dates from about 1850. The black-and-white Broad Walk Café further up the Walk was built in 1913, as was the nearby wooden shelter. The view from here is one of the most magnificent in Regent's Park as it faces Cumberland Terrace, the most palatial of all, with its grandiose Corinthian columns, yet behind these

triumphal arches are rows of identical terrace houses. At the end of the Broad Walk, visitors can still enjoy the Readymoney fountain from 1869, a ponderous Gothic edifice donated by 'Sir Cowasjee Jehangir ... a wealthy Parsee gentleman of Bombay as a token of gratitude to the people of England for the protection enjoyed by him and his Parsee fellow countrymen under the British rule in India'. It is still used by many of the joggers in the park to quench their thirst as they jog on by. At the northern end of the Broad Walk is Gloucester Gate, the subject of one of Nash's most famous remarks that 'the parts looked larger than he expected'. Not surprising as the designs were worked up by draughtsmen from the briefest of sketches and carried out, with considerable license, by speculating builders. Close by is the Gothic church of St Katherine's, designed by Ambrose Poynter as a chapel to the adjoining hospital. The Zoo contains the work of many fine architects and is still visible and includes the cliff-like Mappin Terraces by Belcher and Joass (1913) and the bulky grey cylinders of the Elephant House by Casson, Conder and Partners (1964). The new Sports Hub is visible and suitably imposing, having replaced the 1962 Bernhard Baron Pavilion.

The Macclesfield Bridge, rebuilt in 1876 after the explosion on the canal, has an interesting history, with some of the materials salvaged from the explosion and used in rebuilding the bridge. In the process the cast iron columns were turned round, so the old rope-worn grooves from barge-hauling now show on the 'wrong' side of the columns. New grooves, worn since 1876, show on the

waterside. Many of the bridges in the park are significant and worthy structures themselves. Five of them were originally suspension bridges, built – rather too cheaply – in 1841–42. From the 1860s they were gradually repaired or replaced. They must have been heavily used, for the park constables were ordered to prevent perambulators and bath chairs from remaining stationary on the bridges and so blocking the pedestrian traffic.

Nash's ornamental water, now the boating lake, has an adjacent boat-hire ticket office near Hanover Island and opposite a modern but popular Wildlife and Waterfowl Centre. The eastern reaches of the lake are crossed by Longbridge, an early replacement for the 1842 suspension bridge. The south side of the park offers many glimpses of Nash who is never far away. The Holme is just visible to the right of the bridge and is one of only two surviving villas, with its ostentatious design and Corinthian portico and bay frontage. Opposite, the tall white domes of Sussex Place, built in 1823, peep through the trees; Sussex Place is contemporary with Nash's Brighton Pavilion and shares a little of its oriental fantasy. The nearby glowing copper dome belongs to the London Central Mosque, which was designed by Sir Frederick Gibberd in 1978 and was built with the aid of funds raised in the 1920s by the Nizam of Hyderabad and stands in the grounds of North Villa, built around 1827 by C. R. Cockerell and Decimus Burton. Greatly altered, it is now the Islamic Cultural Centre. Hunter Davies visited the Mosque in 1983 as part of his travels around London's parks.

[I] returned to the Park, wondering what John Nash would have thought of this shining new addition to his master plan. He might well have approved. Sussex Place, which is very near the mosque, is not quite in the same Neo-classical style of Cumberland Terrace and the other Nash terraces, but is distinguished by the fact that it has ten pointed domes, grouped in pairs. The domes were disliked by several architectural experts of the time, dismissed as being eccentric and too experimental. Now, they rather complement the dome of the mosque, as if, 150 years earlier, John Nash knew what the future might bring.

The Clarence Gate corner of the park, where South Villa once stood, is now entirely occupied by Regent's College. York Bridge, which was built in the late nineteenth century to replace the 1816 original, links the Outer Circle with the Inner Circle.

The Queen Mary's Gardens are entered by the black-and-gold Jubilee Gates, donated by Sigismund Goetze, who lived in Grove House, now Nuffield House. Goetze had his studio in the grounds and painted the walls of the music room with scenes from Ovid's *Metamorphoses*. At the end of the central walk is the Triton fountain where the Royal Botanic Society conservatory stood. Besides the Triton fountain, there are also in the garden the *Boy and Frog*, pensive and contained, by Sir William Reid Dick (1936), the *Mighty Hunter* (1913) and the *Lost Bow* (1915), both decorative pieces by A. H. Hodges, and a nineteenth-century Japanese bronze eagle in the middle of the water garden. The stone lantern nearby is

another of Goetze's gifts. The fossilised tree stumps by the cascade come from Lower Purbeck Becks in Dorset and were placed here in 1845.

The other remaining villa in the park is St John's Lodge, just outside the Inner Circle to the north. The secret garden, recently restored, has a series of compartments ornamented with sculpture and stonework. Its centrepiece was originally *St John the Baptist*, but this has been replaced by *Hylas and the Nymph* by Henry Pegram, donated by the Royal Academy of Arts in 1933. The other fine sculpture is the *Goatherd's Daughter* (1932) by C. L. Hartwell, inscribed, 'To all the Protectors of the Defenceless.' In front of the Lodge six stone piers support *putti* holding shields with Bute arms. In a park so full of historic interest and present-day activity, this garden is a wonderful place to pause.

Although the original framework of Nash's Regent's Park survives, many of its finer details have been lost. Yet despite this, the park has developed its own momentum and contains a whole range of activities, more varied and extensive than those in any of the other Royal Parks. With its educational establishments, sporting activities, wildfowl and zoo, flower displays and fine trees it epitomises the worthy tradition of the nineteenth-century municipal park movement, yet as always, Nash is never far away. But where does Nash's reputation stand today? Professor Mordaunt Crook summarises saying he died in public disgrace, pilloried for 'inexcusable irregularity' and 'great negligence'. He was called 'a jobber' or at the very least

'a great speculator ... a most suspicious character'. Nash responded to his accusers, simply replying: 'I am not a public accountant.' It was his pragmatic vision which triumphed over the trivialities of finance. As one contemporary MP put it, 'if Mr Nash had not been speculator as well as surveyor, [Regent's Park and] Regent Street would never have been finished ... at great risk and hazard [he] carried that noble project into complete execution'.[7]

As a neoclassical architect, Nash was neither an archaeologist nor a rationalist, but a self- confessed eclectic and not so much a designer 'as a collector of designs ... he has taken them from all schools, more for their variety than for their beauty'. An Ionic is an Ionic, he once told James Elmes, and he seemed not to care which one of his draughtsmen he used. Such a cavalier approach in matters of detail was all part of the *picturesque* mentality. Nash's Regent's Park terraces certainly epitomise the precarious balance between neoclassical archaeology and *picturesque* theory, according to Mordaunt Crook. The architecture of Regent's Park, as classicist C. R. Cockerell noted in 1825, 'may be compared to the poetry of an *improvisatore* – one is surprised and then captivated at first sight with the profusion of splendid images, the variety of the scenery and the readiness of the fiction'. It is worth remembering that Cockerell, in old age, lived happily enough in Chester Terrace. 'Nash,' he grudgingly admitted, 'always has original ideas.' Despite all, one has to admit that if nothing else, the scale of the whole

operation is prodigious: the lateral span of Chester Terrace alone is little short of 1,000 feet.[8]

Regent's Park was formulated, unfinished, decayed, rebuilt; vandalised, bombed and redeveloped and what actually survives of Nash's scheme is but a fragment of what he planned and a shadow of what might have been. And let's not forget that what he actually did – and did not – build was forced upon him by political and economic pressure. Even so, there is no mistaking the imprint of his assimilative vision. Mordaunt Crook summarises his impact:

> The glorious panorama of Regent's Park survives as testimony to a master pragmatist, a virtuoso of scenographic art. In Puckler-Muskau's phrase, art has here solved the problem of concealing her questions under the appearance unrestrained nature, and the result is worthy of the capital of the world. Defying the swings and roundabouts of taste, Nash continues to rank with Wren as a maker of modern London. But his genius was essentially opportunism writ large.[9]

Primrose Hill

North of Regent's Park, before the land begins its main ascent to Hampstead and Highgate, stands the nearest hill to the centre of London. Reaching only 206 feet high at its summit, elsewhere Primrose Hill would be unremarkable. It is its commanding position, overlooking the Zoo, Regent's Park and then the whole sweep of London that makes it memorable.[1] After the variety and picturesqueness of Regent's Park, Primrose Hill may appear comparatively desolate. Its name suggests what it must have been like in the distant past, when it was a southern-sloping elevation overlooking farmland and the distant prospect of pre-industrial London. But Primrose Hill has a much longer and more distant history and is described at length by Webster in 1911.

Originally there were two mounds or hills, on which the reservoir of the West Middlesex waterworks had been erected. At various periods the hill was known under three distinct names, Barrow Hill, Primrose Hill and Greenberry Hill. The name Barrow Hill and its origins are unclear but it is likely that it relates to it

being the burial place of some great chieftain, the word
barrow meaning 'cover' or 'shelter'. It is also supposed
to have some military significance and the name Battle
Hill also appears around 1814. Unfortunately, little
or no traces of the Barrow Hill now exist, the mound
having been partially levelled when a reservoir was
made, and still more unfortunate is that all relics of the
early British burial place were lost or destroyed. The
name Primrose Hill arose from the growth of primroses
there. Park superintendent Webster remembers a letter
from a lady, eighty years old, who remembers filling
a basket with primroses, gathered between Primrose
Hill and the adjoining Zoo boundary, prior to 1838.
The reservoir was an important addition as both Nash
and Fordyce had foreseen the need for a substantial
water supply for the villas and terraces of Regent's
Park. In 1828 it was decided to build the reservoir for
this purpose on Barrow Hill, and in its construction
the height of the hill was considerably reduced. This
left Primrose Hill as the sole summit rising north of
Regent's Park.

The dense forest of Middlesex was composed
principally of oaks and extended all over the hill and
the old park of Marylebone. As far as Primrose Hill is
concerned, probably the last remnants of the old forest
disappeared in 1882, when five large, hollow oak trees,
each a couple of spans and upwards in girth, were
removed, and in one of which a wallet of guineas was
said to have been discovered. At what date a general
clearance of the trees took place in order that farming
operations might be engaged in is not quite certain, but

we do know that towards the end of Elizabeth's reign 'the slopes of Primrose Hill were used as meadowland'. In 1778, cattle are recorded as grazing on the hill and were taken away by deep and dirty lanes and in 1708, Primrose Hill was tenanted by a Mr Thomas Baker, the extent of ground – which consisted of five fields, some under the cultivation of wheat – extending to 63 acres.

Geologically the formation of Primrose Hill is the London clay, but described as of a 'particularly unctuous, obstinate nature', which accounted for the retention of the two mounds after the surrounding parts were washed away. In 1842, soon after the succession of Queen Victoria, an exchange was made between the Crown and the authorities of Eton College, by which Primrose Hill became Crown property. Since 1822, Eton College had been attempting to take advantage of the large, prestigious development arising to the south of the hill by planning to divide the hill into plots for building leases, as part of the larger Chalcotts Estate. Various plans exist showing alternative strategies but none of these schemes were ever put into practice.

In consequence of the great resort to the Regent's Park since the Eastern portion was opened to general admission, and of Proceedings in Parliament during the present Session for further opening that park, arrangements are now in progress for the purpose, to as great an extent as on very full consideration as deemed to be compatible with the protection and enjoyment of the Property of Individuals who have largely embarked capital in erecting Houses upon that part of the Crown

Estate ... And we have great satisfaction in being able to add, that the means of public recreation and exercise will be further extended in this quarter, by the acquisition of that portion of Primrose Hill delineated ... And we are now considering the best means of making direct communication between the Property and the Regent's Park, to which, as will be seen by the Plan, it immediately adjoins.[2]

Soon after this, alterations and improvements were carried out in rapid succession, and the neglected hill, with its water-worn courses, was soon converted into a place of pleasure and recreation. The oak fence was erected in 1842, the gymnasium in 1847, while in 1852 a large and somewhat dangerous hollow on the northern side of the hill, which was used for rifle practice, was filled in with 2,000 cubic yards of soil, and shortly afterwards lamps were placed by the path sides all over the hill. In 1902 the last remains of the old pond on the north-western side of the hill – a relic of one of the branches of the Tyburn – disappeared by being filled up with soil, while a little later about 20 acres of the ground on the same side, where cavalry exercised and rough games were engaged in, were reclaimed and laid out as a recognised ground for cricket and football. As the natural drainage of the hill accumulated in the pond and along an adjoining hollow where a branch of the Tyburn formerly flowed, this lower side was hardly accessible, and was subject to numerous complaints from the general public. However, subsequent drainage, tree planting and laying out of paths ensured the area

was transformed 'into one of the most desirable resorts on the hill'. By 1904, an indexed dial was erected here distinctly pointing out the various places of interest that were visible from the hill-top '206 feet above Trinity high-water mark of the Thames'. At the beginning of the twentieth century, shrubberies were planted and fences erected, and further new footpaths and the placing of chairs all contributed to make the hill a place of public recreation and enjoyment. Webster describes 'the public appreciation of these improvements, it may be stated that whereas a few years ago private chairs were not required on the hill, today [1911] these number several hundreds'.

Primrose Hill is also notorious in history for the murder of Sir Edmund Godfrey, or, perhaps more accurately, for his body having been found there in October 1678, after he was murdered elsewhere. Sir Edmund was a wealthy timber merchant, a justice of the peace, and received a knighthood for his conduct during the Plague. His body was found 'in a ditch on the south side of Primrose Hill, surrounded with divers closes fenced in with high mounds and ditches, no road near, only some deep, dirty lanes made for convenience of driving cows and such like cattle in and out of the grounds and those very lanes not coming within 500 yards of the place'. Three men, Green, Hill and Berry, were tried and convicted of the murder, all three being executed the following year.

The North Western Railway tunnel passes under Primrose Hill from Chalk Farm to St John's Wood and Kilburn through the most treacherous and unmanageable

of London clay. At one time and for several years the hill was a place of meeting for popular demonstrations, before Hyde Park was chosen. On 29 May 1856, fireworks were displayed in celebration of the peace for the end of the Crimean War, and a public meeting was held here to protest against the supposed expulsion of Garibaldi from England. In 1864, an oak tree was planted by Mr Phelps, the tragedian, to commemorate the tercentenary of Shakespeare. Webster was written to by a Mr Truelove:

> I am writing to you because I thought you would be interested in the subject of the Oak tree which was planted at the foot of Primrose Hill, on the 23 April 1864, by Samuel Phelps. Mr Henry Marston started a committee in the year 1864, which held its meetings at St John's Gate, Clerkenwell. I was a member of the committee. The object of the committee was to obtain permission of the Regent's Park authorities to plant an Oak tree at the foot of Primrose Hill. Permission was granted, and then Miss Eliza Cook was asked to plant the tree. She consented. On the 23 April 1864 a large fence was put up and a young Oak was planted by Mr Phelps. Mr Marston recited an ode by Miss Cook, who was prevented by serious illness from being present. Mrs L. Banks sprinkled the tree with water from the River Avon. Mrs Banks then spoke and the proceedings terminated.

Primrose Hill and the adjoining Chalk Farm have been scenes of several bloody duels, as in April 1803,

when Colonel Montgomery and Captain Macnamara fought with pistols, Montgomery being killed, and in 1818 Lieutenant Bailey was fatally injured, while later in February 1821 an encounter took place between Scott, the editor of the *London Magazine*, and a friend of John Lockhart's named Christie, a contributor to *Blackwood's Magazine*. Scott was severely wounded, and died a fortnight later at Chalk Farm. Previous to its purchase by the Crown, and for some years afterwards, Primrose Hill was the resort on Sundays and holidays of a very rough and rowdy class of visitor, the behaviour of which was frequently reported in the press. This was probably due to the proximity of the hill to Chalk Farm Tavern with its tea garden and adjoining fields, where affairs of honour were frequently discussed and settled, and where balls, promenades, wrestling matches and prize-fights were freely engaged in. The old tavern was pulled down in 1853, with newer buildings replacing it and the duelling fields.

Webster describes Primrose Hill in 1911 as being 61 acres, 3 roods and 31 poles, and standing in the parishes of St Pancras and Marylebone. Despite stiff clay soils, trees and shrubs were growing well as exemplified by the lines of black Italian poplars which were a real feature of the landscape. The pink and white flowering May trees were doing well, with fine specimens of the cut-leaved pyrus or beam tree, while a row of the far-from-common walnut-leaved ash are flourishing by the fence side of the reservoir. Some of the guidebooks on London of the time referred to Mother Shipton's prophecy that 'Primrose Hill must

one day be the centre of London'. The prophecy has been somewhat distorted over the years. The memorial to Queen Victoria at Buckingham Palace was prepared on Primrose Hill, the large temporary wooden erection by the side of the gymnasium having been put up for that purpose. Primrose Hill also narrowly escaped being laid out as a public cemetery, a Bill having been introduced to Parliament in 1842 for acquiring and converting the whole of the ground for that purpose. Thanks to opposition of the Vestry of St Pancras at a meeting on 24 May, the members one and all opposed the scheme when the Bill was registered.[3]

Further tree planting occurred during Webster's time and plans of 1916 show further tree planting, especially on Primrose Hill where the western boundaries were planted with a double row of trees and fenced shrubbery. Along the footpaths the avenue planting was extended and groups of widely spaced trees were placed at park junctions and by the hill summit. Like Regent's Park itself, changes to Primrose Hill appear to respond to the increased public use of the park and incidental requirements for facilities. During the First World War Primrose Hill was divided into plots for allotments which were cleared in 1919. Maintenance of Primrose Hill, as well as Regent's Park, was reduced to a minimum during the war. By the Second World War, further changes were made, with huts and gun turrets built on Primrose Hill, with their concrete foundations remaining until 1955. It was once again turned over to allotments, with many trees felled to make room for the gun turrets. A large part of the north-western area was

made into a radar net. A barrage balloon was tethered near the playground and an air-raid shelter built at the hill's south-east corner. Primrose Hill was also hit by the only V2 to fall on either park. This landed near the reservoir in March 1945 and destroyed the refreshment lodge. By the end of the twentieth century, Primrose Hill was still extremely popular but was somewhat changed from Webster's time as parks superintendent. Planting now included a number of planes, single-leaved ash, lime, oak, Norway maple and elm. The poplars had gone, but the thorns and whitebeam remained a feature of the Hill. The Gillespie report of 1981 emphasised the need to conserve the open character for historical reasons as well as for the fine views afforded of the city from this high point. The small stature of the trees remaining served to exaggerate the impression of height when looking towards the summit from below.[4]

Today, Primrose Hill is a park very much favoured by dog walkers, picnickers and those enjoying one of the best views in London. It is less used than adjacent Regent's Park but very popular for filming and has inspired writers, poets and musicians throughout its history. It remains open at all times, unlike Regent's Park, despite attempts to close it at night in 1975. It is, however, a superb viewing platform from where can be seen a panorama of modern London, from Canary Wharf in the east to Westminster in the west and as far as Crystal Palace. In 2012, the Royal Parks were once again looking at the pressures on this historic parkland and had noted issues with drainage, desire lines, erosion and compaction as well as limited seating.

Improvements to the summit were subsequently made in 2012 and included a William Blake inscription, which links the contemporary and historical appeal of the summit. 'I have conversed with the spiritual sun. I saw him on Primrose Hill.' Nick Biddle, Regent's Park Manager, said, 'The Blake inscription is appropriate for many reasons, but I love it because it sums up so well the experience of standing on Primrose Hill in the early morning light. It is always a wonderful experience.'

Regent's Park: A Literary Park

Regent's Park has generated significant output and literary contributions from a range of poets, authors, song lyricists and writers throughout its history and continues to do so – from Dickens to Du Maurier, Woolf to Wells, Samuel Johnson to P. D. James and the Beatles to Blur. They have all been inspired in some way to write about Regent's Park, whether describing it, just reflecting on its beauty, passing a comment or simply telling a story within its bounds. However, no writer has evoked Regent's Park more frequently, more perceptively, or more lovingly than Elizabeth Bowen. Her two best-known novels both open with a chapter set entirely within the Outer Circle, and it provides the background for several short stories. 'I had always placed this park among the most civilized scenes on earth,' she wrote in an essay, *London 1940*. She was an air-raid warden at the time and living at 2 Clarence Terrace, near the Baker Street corner of the park, her home for sixteen years. 'The Nash terraces look as brittle as sugar – actually, which is wonderful, they have not cracked; though several of the terraces are gutted.'

But successive bomb blasts were to weaken Clarence Terrace beyond restoration, and the building we see now is a 1960s replica of the original Decimus Burton façade.

The Death of the Heart (1938) begins with two people walking around the boating lake.

> That morning's ice, no more than a brittle film, had now cracked and was floating in segments ... On a footbridge between an island and the mainland a man and woman stood talking ... Beside the criss-cross diagonal iron bridge, three poplars stood up like frozen brooms ... The swans, the rims of ice, the pallid withdrawn Regency terraces had an unnatural burnish, as though cold were light ... St Quentin threw a homesick glance up at Anna's drawing room window.

The three poplars have gone, but otherwise it seems to be much the same today. Anna's house figures extensively throughout the book. It's given a fictional address but is generally agreed to be an exact description of the author's own house. She seems to have been fond of the poplars. They appear again in a short story about a weepy small boy and his awful mother, *Tears, Idle Tears* (1941), but now it is May and they have become 'delicate green brooms' instead of frozen ones. Another short story gives a clue to their demise. *I Hear You Say So* concerns the unsettling effects of the first nightingale in the week after the war in Europe ended. 'Just inside the park three poplars, blasted the summer before by a flying bomb, stretched the uncertain leaves they had put out this year towards those of the unhurt trees.'

The Queen Mary Gardens provides the title for a poem that Sylvia Plath wrote about 'this wonderland/ hedged in and evidently inviolate', in 1960, when she was living in Chalcot Square, Primrose Hill. She must have been a frequent visitor to the park, particularly after her first child was born in April.

In this day before the day nobody is about.
A sea of dreams washes the edge of my green island,
In the centre of the garden named after Queen Mary'.

She goes on to describe 'the great roses, many of them scentless,' which 'rule their beds like beheaded and resurrected'.

The Broad Walk is also the setting for several scenes in Virginia Woolf's novel *Mrs Dalloway* (1925).

The long slope of the park dipped like a length of green stuff with a ceiling cloth of blue and pink smoke high above, and there was a rampart of far, irregular houses, hazed in smoke, the traffic hummed in a circle, and on the right, dun-coloured animals stretched long necks over the Zoo palings, barking, howling. There they sat down under a tree.

The couple who sit down and survey this scene are a shell-shocked ex-soldier and his Italian wife. The doctor has assured her that Septimus 'had nothing whatever seriously the matter with him but was a little out of sorts'. The man later commits suicide, as his author was to do, and in these pages Virginia Woolf

expresses the anger she felt at the way her own bouts of insanity were treated. The wife, Rezia, is in despair: 'I am alone: I am alone! she cried by the fountain in Regent's Park (staring at the Indian and his cross), as perhaps at midnight, when all boundaries are lost, the country reverts to its ancient shape ... such was her darkness.'

At the end of the Broad Walk we cross the Outer Circle to a canal bridge, scene of a tragic and disturbing incident described by Charles Dickens in *The Uncommercial Traveller*. It's not far from the main entrance to the Zoo, depicted in a contemporary engraving. One afternoon in the winter of 1861, 'I was walking in from the country on the northern side of the Regent's Park – hard frozen and deserted – when I saw an empty Hansom cab drive up to the lodge at Gloucester-gate, and the driver with great agitation call to the man there'. Dickens runs after the cab, which stops at a bridge 'near the cross-path to Chalk Farm'. The body of a drowned woman is on the towpath, broken ice and puddles of water

dabbled all about her ... The dark hair streamed over the ground ... A barge came up, breaking the floating ice and the silence, and a woman steered it. The man with the horse that towed it, cared so little for the body, that the stumbling hoofs had been among the hair, and the tow-rope had caught and turned the head, before our cry of horror took him to the bridle. At which sound the steering woman looked up at us on the bridge, with contempt unutterable, and then looking down at

the body with a similar expression – as if it were made in another likeness from herself ... steered a spurning streak of mud at it, and passed on.

The bargees' behaviour suggests that canal drownings were not a rarity in those days. Another unpleasant feature of the park, 'ruffianism', had upset Dickens some twenty years earlier. Recalling this in *The Uncommercial Traveller*, he says, 'The blaring use of the very worst language possible, in our public thoroughfares – especially in those set apart for recreation – is another disgrace to us ... Years ago, when I had a near interest in certain children who were sent with their nurses, for air and exercise, into the Regent's Park, I found this evil to be so abhorrent and horrible there, that I called public attention to it.'

At that time he was living at 1 Devonshire Terrace (now the corner of Marylebone High Street and Marylebone Road), and according to another writer the 'near interest' refers to Dickens's own family: 'his nurse and children were insulted and molested by tramping women and girls'. Nowadays one is unlikely to encounter anything worse than the occasional alcoholic dosser.

H. G. Wells lived at 13 Hanover Terrace from 1937 until his death in 1946 and frequently referred to the park in his writings. *Select Conversations With an Uncle: John Lane, 1895 (A collection of humorous articles written for the Pall Mall Gazette)*'s 'The Man With a Nose' recounts a conversation between two men 'sitting, one at either end, on that seat on the stony summit of Primrose Hill which looks towards

Regent's Park. The paths on the slope below were dotted out by yellow lamps; the Albert Road was a line of faintly luminous pale green – the tint of gaslight seen among trees; beyond, the park lay black and mysterious, and still further, a yellow mist beneath and a coppery hue in the sky above marked the blaze of the Marylebone thoroughfares.' 'The Great Change' recounts a conversation about marriage as uncle and nephew walk through the zoo: 'He gave the bachelor wart hog a parting dig, and we walked slowly and silently through the zebra-house towards the elephants.' 'Under the Knife' (1896), reprinted in *The Complete Short Stories of H. G. Wells*:

> I was suddenly brought back to reality by an imminent collision with the butcher-boy's tray. I found that I was crossing the bridge over the Regent's Park Canal, which runs parallel with that in the Zoological Gardens. The boy in blue had been looking over his shoulder at a black barge advancing slowly, towed by a gaunt white horse. In the Gardens a nurse was leading three happy little children over the bridge. The trees were bright green; the spring hopefulness was still unstained by the dusts of summer; the sky in the water was bright and clear, but broken by long waves, by quivering bands of black, as the barge drove through. The breeze was stirring; but it did not stir me as the spring breeze used to do.

Obsessed by a presentiment of death regarding his forthcoming operation, the narrator feels

isolated from the life and existence about me. The children playing in the sun and gathering strength and experience for the business of life, the park-keeper gossiping with a nursemaid, the nursing mother, the young couple intent upon each other as they passed me, the trees by the wayside spreading new pleading leaves to the sunlight, the stir in their branches – I had been part of it all, but I had nearly done with it now.

The Invisible Man (1897): 'At last I found myself sitting in the sunshine and feeling very ill and strange, on the summit of Primrose Hill ... All I could think clearly was that the thing had to be carried through; the fixed idea still ruled me.' After a successful experiment on a neighbour's cat, Griffin has walked from his lodgings near Great Portland Street to meditate on his next steps. 'I looked about me at the hillside, with children playing and girls watching them, and tried to think of all the fantastic advantages an invisible man would have in the world.' *The War of the Worlds* (1898): 'As I emerged from the top of Baker Street, I saw far away over the trees in the clearness of the sunset the hood of the Martian giant from which the howling proceeded.' This unwelcome visitor – 'a walking engine of glittering metal' – was to make Regent's Park famous around the world (the book has been translated into more than twenty languages). It seems to be immobilised, but the narrator, who has witnessed the destruction it can cause, gives it a wide berth and heads up Park Road. 'Far away, through a gap in the trees, I saw a second Martian, motionless as the first, standing in the park

towards the Zoological Gardens, and silent ... I came upon the Red Weed again, and found Regent's Canal a spongy mass of dark red vegetation.' Primrose Hill has been made into a 'huge redoubt' by the Martians, and is now full of their corpses. They have succumbed to bacteria that humans have long been immune to.

In *Ann Veronica* (1909), the heroine is a student at the Central Imperial College near Great Portland Street and there are several visits to the park to sit and think and walk across on her way home walk around the Zoo with a biologist she is in love with and finally to break off her engagement to a civil servant over strawberries and cream at a pavilion.

Robert Browning and Elizabeth Barrett's *The Courtship Correspondence 1845-1846* features Regent's Park heavily. The Barrett family lived in Wimpole Street near the park, and a visit accompanied by her sister Arabel was a welcome treat for the semi-invalid Elizabeth. Her father's disapproval meant that the courtship had to be conducted in secret. In a letter of 29 May 1846 she wrote to Robert,

> Dearest, I committed a felony for your sake today – so never doubt that I love you. We went to the Botanical Gardens, where it is unlawful to gather flowers, and I was determined to gather this for you, and the gardeners were here and there ... they seemed everywhere ... but I stooped down and gathered it – Is it felony, or burglary on green leaves – or what is the name of the crime? Would the people give me up to the police I wonder? *Transie de peur* [overcome with fear], I was ... listening

258

to Arabel's declaration that all gathering of flowers in those gardens is highly improper, and I made her finish her discourse, standing between me and the gardeners ... to prove that I was the better for it. How pretty those gardens are, by the way! We went to the summerhouse and sat there, and then on, to the empty seats where the band sit on your high days. What I enjoy most to see, is the green under the green ... where the grass stretches under trees. That is something unspeakable to me, in the beauty of it. And to stand under a tree and feel the green shadow of the tree! I never knew before the difference of the sensation of a green shadow and brown one – I seemed to feel that green shadow through and through me, till it went out at the soles of my feet and mixed with the other green below.

Earlier, on 11 May, she had written,

Look what is inside of this letter – look! I gathered it for you today while I was walking in the Regent's Park. Are you surprised? Arabel and Flush [her dog] and I were in the carriage – and the sun was shining with that green light through the trees, as if he carried down with him the very essence of the leaves, to the ground ... and I wished so much to walk through a half-open gate along a shaded path, that we stopped the carriage and got out and walked, and I put both my feet on the grass ... which was the strangest feeling! ... and gathered this laburnum for you. It hung quite high up on the tree, the little blossom did, and Arabel said that certainly I could not reach it – but you see! It is a too generous return

for all your flowers: or, to speak seriously, a proof that I thought of you and wished for you – which was natural to do, for I never enjoyed any of my excursions as I did today's – the standing under the trees and on the grass, was so delightful. It was like a bit of that Dreamland which is your special dominion ... And all those strange people [flitting] moving about like phantoms of life – how wonderful it looked to me!

Fortunately for other visitors these acts of vandalism ceased a few months later when the couple married and fled to Italy.

The park has continued to inspire literary enthusiasts. Regent's Park has also inspired singers and songwriters throughout its history, capturing tragedies such as the 1867 accident on the lake with the loss of forty lives. Henry Disley wrote in 1867 'Two hundred then fell in, oh what a sad fate, all struggled for their lives in the water ... They clung to the ice, until benumbed with cold'. His writings conclude with the sad description of 'a poor faithful dog, saw his master disappear, and never left the park since that evening'.

More contemporary artists have included the Beatles, Madness and Blur. 'The Fool on the Hill' by Paul McCartney from the album *Magical Mystery Tour* in 1967 has the lines 'Day after day, alone on a hill,' concluding with 'the fool on the hill sees the sun going down and the eyes in his head see the world spinning round.'

Alistair Taylor, in *Yesterday: The Beatles Remembered*, describes the genesis of this song.

Ascending Primrose Hill at dawn with Paul McCartney and his Old English Sheepdog, Martha, they stood and admired the spectacular sunrise, then 'turned around to go and suddenly there he was standing behind us. He was a middle-aged gentleman, very respectably dressed in a belted raincoat ... Paul and I were sure he hadn't been there only seconds before. Hadn't we been looking for Martha in that very direction?' Brief greetings are exchanged, the man walks away, and then vanishes as mysteriously as he had appeared. Shaken, 'we both felt that we had been through some mystical religious experience'. Hunter Davies, in *The Beatles: the Authorized Biography* says that the Lennon/McCartney song 'It's Getting Better' was inspired by another walk on Primrose Hill, 'on the first afternoon of spring', 1967. 'Martha ran around and the sun came out. Paul thought it really was spring at last. "It's getting better," he said to himself ... That day at two o'clock, when John came round to write a new song, Paul suggested, "Let's do a song called It's Getting Better."' It went into the *Sergeant Pepper's Lonely Hearts Club Band* album.

Blur likewise took inspiration from visits to Primrose Hill. In 'For Tomorrow – Visit to Primrose Hill', extended by Damon Albarn and taken from the album *Modern Life is Rubbish*, 1993, naughty girl Susan 'says let's take a drive to Primrose Hill, it's windy there and the view's so nice'.

Ska band Madness clearly had an intense love of Primrose Hill and wrote 'Primrose Hill' from the album *The Rise and Fall* in 1982 in which 'A man opened his

window and stared up Primrose Hill' where he sighted people sitting and enjoying themselves as 'I stare out of this window [and] see the world go past'.

Recorded in the 1980s when the North London ska/pop band was at its peak, the album had a photo of Primrose Hill on the cover. In an interview in *Q Magazine* in April 2001, singer and frontman Suggs (Graham McPherson) said, 'Primrose Hill was somewhere that had featured in most of the band's lives. We all came from the surrounding area so we'd always had good memories of the place. Primrose Hill was somewhere you could play football or, in the winter, go tobogganing, so it'd always been a place of fun and frolics.'

The Nash Legacy:
The Liberality of the Genius

The legacy of Nash remains but throughout history, Nash has either been regaled as a genius or maligned 'as a better layer out of grounds than architect'. Described by Summerson as 'the Prince of Architects', Nash himself wrote mockingly of his 'thick, squat, dwarf figure, with round head, snub nose, and little eyes'.[1] Nash was a robust old man and had lived a healthy life, going to bed early, rising early, and walking and riding much for exercise. Nash was an extrovert, was easily crossed and throughout his life he made many friendships, although how many of these were close or long-lasting is hard to define. It was easy to be friendly with him, but easy enough to fall out, and he did not always care to make an effort to cover up disputes. As a businessman he could be hard, even to the point of oppression. However, Nash had few friends among men of his own profession and this was partly due to circumstances and partly to temperament. He quarrelled with Cockerell and Repton and we know he fell out frequently with the Burtons. The profession as a whole envied and hated him because he had risen

as much by favouritism as by his own endeavours, and the lesser kind of architect was usually glad to speak in his disfavour. As he grew older, he was adept at making spontaneous promises and then not keeping them. Nash was also full of conflicting tendencies, and the contradictions were stressed by the circumstances of his life. The extent to which he was involved in the warfare of speculation and finance caused the opportunist in him to be constantly awake and watching for a cue in the circumstances which formed themselves round the other side of his character.[2] With the death of George IV in June 1830, Nash's career virtually closed, with a full year of acrimony and recrimination following. The king's notorious extravagance had generated much resentment and Nash was now without a protector. The Treasury started to look closely at the cost of Buckingham Palace. Nash's original estimate of the building's cost had been £252,690, but this had risen to £496,169 in 1829; the actual cost was £613,269 and the building was still unfinished. This controversy ensured that Nash would not receive any more official commissions nor would he be awarded the knighthood that other contemporary architects such as Jeffry Wyattville, John Soane and Robert Smirke received. Nash retired to the Isle of Wight to his home, East Cowes Castle. He died in May 1835. Few people noticed the passing of the famous architect. He had quickly faded out of public view after George IV died, and the last glimpse of him was distorted by the shadows of parliamentary censure. His bland obituary recorded in the *Annual Register*, 'As a speculative builder, this gentleman amassed a large fortune; but

as an architect, he did not achieve anything that will confer upon him lasting reputation.' *John Bull* on the other hand published a long appreciation, written in a generous vein: 'In private life Mr Nash was a warm and sincere friend; his mind, active and comprehensive as it was, was singularly natural and simple; his conception was quick and clear; his thoughts were original, and his conversation was both instructive and pre-eminently agreeable'. The writer tactfully passed over architecture in stressing the town planning achievements. 'Look at the manner in which the interior of St James's Park was, in a few months, converted from a swampy meadow into a luxurious garden, and then, let the reader ask himself whether the metropolis is or is not indebted to the taste and genius of the much traduced object of this notice.'

'Much traduced [maligned]' he may have been, though he had shown himself a match for the most formidable critics. It was only when he had died that slander and contempt were able to fix themselves to his name. Nash embodied everything that the nineteenth century hated about the eighteenth; so when the Victorians remembered him it was only to spurn him or to use his memory as a scarecrow to frighten young architects away from stucco. In the years when a complete and intimate memoir could have been written, nobody had the sympathy or curiosity to write it. But taste slowly changed; and as the real Nash was forgotten and some of the things he stood for crept back into the ring of favoured values, a new picture formed itself. As Summerson concluded, today the name of Nash is

accorded more honour than his contemporaries would have believed possible.

Mordaunt Crook describes Nash as a 'master pragmatist, a virtuoso of scenographic art' and ranks Nash with Wren as a maker of modern London with his 'genius ... essentially opportunism writ large'.[3] Nearly two centuries after his death, the name of Nash is more securely a part of the history of British architecture than ever. The obvious tribute to his talent was the decision not to destroy the Regent's Park terraces. Nash's London architecture has never been much admired by those who analyse his designs, but even the most pedantic critic did not fail to recognise his brilliance in town planning. In 1857 at a meeting of the Royal Institute of British Architects Nash's name came up and Mr William Tite, a prominent architect, said, 'Mr Nash had then succeeded Mr James Wyatt, who had been Surveyor General, and although Mr Nash's style of architecture was anything but bold, his style of dealing with the improvements of the metropolis was so, and deserved the gratitude of this generation.' At the same meeting C. R. Cockerell recorded, 'With all his defects, Nash was a courageous little man, and it was a matter of regret that no proper biography of him had appeared.' James Pennethorne, to whom a gold medal was being presented at the meeting and who had to bear much of the adverse criticism of his late master's work, 'wished to express his gratification at the remarks of the Chairman, Mr Tite, and Mr Cockerell, with reference to Mr Nash. There had been much difference of opinion with regard to the merit of that architect, and it was particularly agreeable to him,

after a lapse of thirty years, to hear his works spoken of as they deserved'.

Charles James Mathews, father of an erstwhile pupil of Nash, used the vexed word 'genius' in his appraisal of his son's old master, 'his genius lying less in Classical detail than in bold conception and general arrangement'. Nearer to our own times the word has been given a sterner meaning and Sir Edwin Lutyens, when writing of Philip Webb's talent in 1915, said, 'I did not recognise it then to be the internal youth of genius, though it was conjoined with another attribute of genius-thoroughness!' Of all Nash's attributes, thoroughness was not one; careful detailing was almost always sacrificed to the total effect. The work for which he is most remembered represents the dying-fall of classicism, the high Indian summer of a long tradition. Not one of his London buildings would stand comparison with the epic architecture of St Petersburg or Paris. Nash produced something far less splendid, but utterly suited to London and its times. He was essentially a 'man of the times', being able to see at once the broad problems involved. Moreover he had the drive and enough talent to grapple with them; thus his temperament was perfectly matched to his task. Had he been intellectual and scholarly his output might have been dimmed, his adventurous spirit inhibited. Many men of exceptional creative ability are two people – the artist and the man – but Nash the artist was also Nash the man and every aspect of his life bore this out.[4]

An assessment of Nash's contribution to architecture, however, cannot rest only on his achievements as a town planner. In his work, as in his life, there were brilliant

moments. The broad picture of his achievements is often lost in the pedantic search for perfect detail, although, some forty years before his birth, Alexander Pope had challenged such ideals when he wrote,

> Most critics, fond of some subservient art,
> Still make the Whole depend upon a Part.
> They talk of principles, but notions prize,
> And all to one lov'd Folly sacrifice.

The liberality of the genius employed is manifested in the generous conglomeration of styles which is everywhere apparent in Nash's Regent's Park. The park is a place to return to again and again, whether it is to admire Nash's terraces and villas, to sit in the garden of St John's Lodge, to look upon the splendour of the geraniums in the urns of the Avenue Gardens, or just to wander in and enjoy the 400 acres of open parkland, with the pertinacity of John Fordyce, the genius of John Nash and the determination of the Prince Regent spared and adorned for us all.

Notes

Introduction

1. Parker, E. and M. Tait, *London's Royal Parks* (Think Publishing, 2006).
2. Summerson, J., *Georgian London* (London: Shenval Press, 1945).

1 Early Days and Rural Pastures

1. Saunders, A., *Regent's Park: A Study of the Development of the Area from 1086 to the Present Day* (Newton Abbot: David and Charles, 1969).
2. Dugdale's *Monasticon*, Vol. 1, p. 445.
3. *Calendar of Inquisitions Post Mortem*, Vol. 4, p. 314.
4. Saunders, A., *Regent's Park* (1969).
5. Probate Court of Canterbury, Fetiplace, 1511, f. 7.

2 Hunting Grounds and the Tudors

1. Dugdale's *Monasticon*, Vol. 1, p. 445.
2. New York, Folger Library MS L b41.

3. Saunders, A., *Regent's Park* (1969).
4. *Ibid.*
5. *Weekly Account*, 4 October 1643.
6. Cecil, E., *London Parks and Gardens* (London: Archibald Constable & Co. Ltd, 1907).
7. PRO 30/32/44, pp. 82–84, 152.
8. Saunders, A., *Regent's Park* (1969).

3 Growth and Expansion

1. Sheppard, M., *Regent's Park and Primrose Hill* (London: Francis Lincoln Ltd, 2010).
2. Williams, G., *The Royal Parks of London* (London: Constable, 1978).
3. Conway, H., *People's Parks: The Design and Development of Victorian Parks in Britain* (Cambridge University Press, 1991).
4. Lasdun, S., *The English Park, Royal, Private and Public* (London: Andre Deutsch Ltd, 1991).

4 A Royal Partnership: The Prince Regent and John Nash

1. Saunders, A., *Regent's Park* (1969).
2. Mordaunt Crook, Professor J., *London's Arcadia: John Nash & the Planning of Regent's Park* (The Annual Soane Lecture, 2000).
3. Summerson, J., *John Nash* (2nd ed., 1949).
4. Mordaunt Crook, Professor J., *London's Arcadia* (2000).
5. Summerson, J., *John Nash* (2nd ed., 1949).
6. Mordaunt Crook, Professor J., *London's Arcadia* (2000).

7. Summerson, J., *John Nash* (2nd ed., 1949).
8. Mordaunt Crook, Professor J., *London's Arcadia* (2000).
9. *Gentleman's Magazine* clviii (1812), i, p. 34 and clviv (1812), ii, p. 370; *Parliamentary Debates* xxiii (1812), col. 879: 2 July 1812.
10. *Parliamentary Debates* xxii (1812), col. 1150–51: May 1812.
11. Erickson, C., *Our Tempestuous Day – A History of Regency England* (Robson Books Ltd, 1986).
12. Mordaunt Crook, Professor J., *London's Arcadia* (2000).
13. Elmes, J., *Metropolitan Improvements II* (1827).
14. PRO, CRES 2/742.

5 Regent's Park: A Lesson in the *Picturesque*

1. *The Glenbervie Journals*, ed. F. Bickley (1928) Vol. 2, p. 199. Entry for 16 August 1816.
2. Farington, J., *Diary XIII*, 4585–6: Sunday 18 September 1814.
3. Mordaunt Crook, Professor J., *London's Arcadia* (2000).
4. Ollier, C., *Literary Pocket Book* (1823).

6 Nash to Nesfield

1. Robinson, H. C., *Diary, Reminiscences, and Correspondence* (ed. T. Sadler) (1872) Vol. 1, p. 310.
2. Saunders, A., *Regent's Park* (1969).
3. *Ibid.*

4. Elmes, J., *Metropolitan Improvements II* (1827).

5. Saunders, A., *The Regent's Park Villas* (London: Bedford College, 1981).

6. Samuel, E. C., *The Villas in Regent's Park and their Residents* (London: St Marylebone Society, Publication No. 1, 1959).

7. Summerson, J., *John Nash* (2nd ed., 1949).

8. d'Arlincourt, C., *The Three Kingdoms* (1844), Vol. 1, pp. 24–25.

9. Hunt, L., *The Townsman*, Nos 2, 3 and 4. Reprinted in *Political and Occasional Essays* (1963).

10. *Westminster Review* (1834), p. 502. Report from the Select Committee on Public Walks.

11. Thornbury, W. and E. Walford, 'The Regent's Park', *Old and New London*, Vol. 5, p. 266.

12. Cecil, E., *London Parks and Gardens* (London: Archibald Constable & Co. Ltd, 1907).

13. *Ibid*.

14. Thornbury, W. and E. Walford, 'The Regent's Park', *Old and New London*, Vol. 5, p. 262–86.

15. Saunders, A., *Regent's Park* (1969).

16. *Punch*, January–June 1842.

17. *Mogg's New Picture of London and Visitor's Guide to its Sights* (1844).

18. Cunningham, P., *Handbook of London* (1850).

19. Ridgway, C., *William Andrews Nesfield, Victorian Landscape Architect* (York: Papers from the Bicentenary Conference, The King's Manor, 1994).

20. *The Gardener's Chronicle*, 15 August 1863, p. 771.

21. *Ibid*.

22. Ridgway, C., *William Andrews Nesfield, Victorian Landscape Architect* (York: Papers from the Bicentenary Conference, The King's Manor, 1994).

23. Newspaper article *c.* 1863, Marylebone Library.
24. *Regent's Park: The English Gardens – Historic Outline and Management Proposals* (Land Use Consultants, January 1995).
25. *The Gardener's Chronicle*, 17 September 1864.
26. *The Garden*, 22 August 1874.
27. *The Garden*, 1874, p. 173.
28. *The Gardener's Magazine*, 1875, p. 274.
29. *The Garden*, 22 August, 1874.
30. Crest 2/1741.
31. Crest 6/Vol. 163, p. 333.
32. Saunders, A., *Regent's Park* (1969).
33. Dickens, C. (Jr), *Dickens's Dictionary of London* (1879).

7 The Demand for Parks

1. Conway, H., *People's Parks: The Design and Development of Victorian Parks in Britain* (Cambridge University Press, 1991).
2. Lasdun, S., *The English Park, Royal, Private and Public* (London: Andre Deutsch Ltd, 1991).
3. *Westminster Review*, April 1834, p. 511, criticising the Report for only suggesting walks.
4. *Manchester Courier and Lancashire Advertiser*, 10 August, 1841.
5. *Hansard*, 1839, p. 442.
6. Lasdun, S., *The English Park, Royal, Private and Public* (London: Andre Deutsch Ltd, 1991).
7. *Hansard*, 1841, p. 1068, 'Metropolis Improvement'.
8. *Report of Commissioners*, 1844, Vol. XXIV, Commission for Inquiry into the State of Large Towns and Populous Districts.

9. An Act for Promoting Public Health, 1848.
10. The Finsbury Park Act, 1857.
11. The Metropolitan Works Act was passed in 1887.
12. Cecil, E., *London Parks and Gardens* (London: Archibald Constable & Co. Ltd, 1907).
13. *Ibid.*
14. *Ibid.*
15. *Ibid.*
16. *Ibid.*
17. Webster, A. D., *The Regent's Park and Primrose Hill* (London: Greening and Co. Ltd, 1911).

8 The Twentieth Century: A Park for the People

1. Webster, A. D., *The Regent's Park and Primrose Hill* (London: Greening and Co. Ltd, 1911).
2. *Ibid.*
3. *Ibid.*
4. *Ibid.*
5. Saunders, A., *Regent's Park* (1969).
6. *Ibid.*
7. Conville, D., *The Park: The Story of the Open Air Theatre, Regent's Park* (London: Oberon Books, 2007).
8. Mitchell, Sir P. C., *The Zoological Society of London – Guide to the Gardens and Aquarium – Regent's Park* (31st ed.: London, 1934).
9. *Ibid.*
10. Gorell Report, Cmd 7094, p. 10.
11. Gorell Report, Cmd 7094, p. 7.
12. Gorell Report, Cmd 7094, p. 3.
13. Saunders, A., *Regent's Park* (1969).
14. *The Regent's Park and Primrose Hill Royal Parks Survey,*

William Gillespie and Partners (London, July 1981, for the Directorate of Ancient Monuments and Historic Buildings, Department of the Environment).

15. *Ibid.*
16. *Ibid.*

9 Decline and Revival

1. Fieldhouse, K. and J. Woudstra (eds), *The Regeneration of Public Parks* (London: E & FN Spon, 2000).
2. *The Regent's Park and Primrose Hill Royal Parks Survey, William Gillespie and Partners* (London, July 1981, for the Directorate of Ancient Monuments and Historic Buildings, Department of the Environment).
3. *Ibid.*
4. *The Avenue, Gardens Regent's Park – Feasibility Study* (Land Use Consultants, November 1992).
5. *Regent's Park: The English Gardens – Historic Outline and Management Proposals* (Land Use Consultants, January 1995).
6. http://www.rudi.net/node/6684. Terry Farrell and Partners, 27 June 1995.

10 The Management of a Twenty-First-Century Royal Park: The Park Today

1. Sheppard, M., *Regent's Park and Primrose Hill* (London: Francis Lincoln Ltd, 2010).
2. The Regent's Park and Primrose Hill Operations Plan 2009.
3. *Ibid.*

4. Regent's Park Conservation Area Appraisal and Management Strategy, adopted 11 July 2011.
5. Trench, L., *Buildings and Monuments in the Royal Parks* (London: The Royal Parks, 1997).
6. Mordaunt Crook, Professor J., *London's Arcadia* (2000).
7. *Ibid.*
8. *Ibid.*
9. *Ibid.*

11 Primrose Hill

1. Sheppard, M., *Regent's Park and Primrose Hill* (London: Francis Lincoln Ltd, 2010).
2. *Eighteenth Report of Commissioners of His Majesty's Woods, Forests and Land Revenues.*
3. Webster, A. D., *The Regent's Park and Primrose Hill* (London: Greening and Co. Ltd, 1911).
4. *The Regent's Park and Primrose Hill Royal Parks Survey, William Gillespie and Partners* (London, July 1981, for the Directorate of Ancient Monuments and Historic Buildings, Department of the Environment).

13 The Nash Legacy: The Liberality of the Genius

1. Summerson, J., *John Nash* (2nd ed., 1949).
2. *Ibid.*
3. Mordaunt Crook, Professor J., *London's Arcadia* (2000).
4. Davis, T., *John Nash, The Prince Regent's Architect* (London: Country Life Ltd, 1966).

Bibliography

A Picturesque Guide to the Regent's Park, with accurate descriptions of the Colosseum, the Diorama, and the Zoological Gardens (London: Regent's Park, 1829).

Billington, J., *London's Park & Gardens* (London: Frances Lincoln, 2003).

Cecil, E., *London Parks and Gardens* (London: Archibald Constable & Co. Ltd, 1907).

Cole, N., *The Royal Parks and Gardens of London, Their History and Mode of Embellishment* (1877) (Kessinger Legacy Reprints).

Conville, D., *The Park: The Story of the Open Air Theatre, Regent's Park* (London: Oberon Books, 2007).

Conway, H., *People's Parks: The Design and Development of Victorian Parks in Britain* (Cambridge University Press, 1991).

Crouch, R., *London's Royal Park – An Appreciation* (London: HMSO, 1993).

Culbert, C., *The Royal Parks of Central London* (Photo Precision Ltd. 1972).

Cunningham, P., *Handbook of London* (1850).

Davies, H., *A Walk Round London's Park – A Guide to its Famous Open Spaces* (London: Arrow Books Ltd, 1984).

Davis, T., *John Nash, The Prince Regent's Architect* (London: Country Life Ltd, 1966).

Edgar, D., *The Royal Parks* (London: WH Allen, 1986).

Eighteenth Report of Commissioners of His Majesty's Woods, Forests and Land Revenues.

Elmes, J., *Metropolitan Improvements II* (1827).

Erickson, C., *Our Tempestuous Day – A History of Regency England* (Robson Books Ltd, 1986).

Fieldhouse, K. and J. Woudstra (eds), *The Regeneration of Public Parks* (London: E & FN Spon, 2000).

Lasdun, S., *The English Park, Royal, Private and Public* (London: Andre Deutsch Ltd, 1991).

Macfadyen, D., *A Guide to The Regent's Park & Primrose Hill* (Essential Books Ltd, 1999).

Mitchell, Sir P. C., *The Zoological Society of London – Guide to the Gardens and Aquarium – Regent's Park* (31st ed.: London, 1934).

Mordaunt Crook, Professor J., *London's Arcadia: John Nash & the Planning of Regent's Park* (The Annual Soane Lecture, 2000).

Parker, E. and M. Tait, *London's Royal Parks* (Think Publishing, 2006).

Public Park Assessment – A Survey of Local Authority Owned Parks Focusing on Parks of Historic Interest (London: Urban Parks Forum, May 2001).

Regent's Park: The English Gardens – Historic Outline and Management Proposals (Land Use Consultants, January 1995).

Ridgway, C., *William Andrews Nesfield, Victorian Landscape Architect* (York: Papers from the Bicentenary Conference, The King's Manor, 1994).

Samuel, E. C., *The Villas in Regent's Park and their Residents*

(London: St Marylebone Society, Publication No. 1, 1959).

Saunders, A., *Regent's Park: A Study of the Development of the Area from 1086 to the Present Day* (Newton Abbot: David and Charles, 1969).

Saunders, A., *The Regent's Park Villas* (London: Bedford College, 1981).

Sheppard, M., *Regent's Park and Primrose Hill* (London: Francis Lincoln Ltd, 2010).

Suggett, R., *John Nash: Architect* (Royal Commission on the Ancient and Historical Monuments of Wales, 1995).

Summerson, J., *Georgian London* (London: Shenval Press, 1945).

Summerson, J., *John Nash* (2nd ed., 1949).

The Avenue, Gardens Regent's Park – Feasibility Study (Land Use Consultants, November 1992).

The Regent's Park and Primrose Hill Royal Parks Survey, William Gillespie and Partners (London, July 1981, for the Directorate of Ancient Monuments and Historic Buildings, Department of the Environment).

Trench, L., *Buildings and Monuments in the Royal Parks* (London: The Royal Parks, 1997).

Webster, A. D., *The Regent's Park and Primrose Hill* (London: Greening and Co. Ltd, 1911).

Williams, G., *The Royal Parks of London* (London: Constable, 1978).

Index

Abbess of Barking 18
Abbey Lodge 82, 100–1
Abbey of Barking 18
Albany Cottage 76, 82, 94, 99
Alice de Vere 19
Anjou, Duke of 24
Augustus Street 102
Avenue Gardens 134–7, 140–1, 169, 194, 202–11, 222, 233, 268

Bandstand explosion 215
Battersea Park 149, 159, 163
Bird Sanctuaries Committee 192, 215
Birkenhead Park 198
Boleyn, Anne 21
Bowen, Elizabeth 185, 251–252
Broad Walk 172, 173, 191, 194, 233

Bubb, J. G. 184
Burdett-Coutts Fountain 143, 173
Burton, Decimus 72, 74, 76, 81, 82, 84, 87, 89, 91, 92, 94–5, 97, 99, 100, 108, 111, 119, 128–30, 145, 180, 184, 188, 226, 235, 252
Burton, James 73, 74, 83, 87, 92, 128

Cambridge Gate 145, 184, 187, 189
Cambridge Terrace 184, 187, 189
Carey, John 26
Cary, Sir Edward of Berkhamsted 24
Catherine of Aragon 21
Charles I 25
Charles II 27, 149

Chester Terrace 73, 83, 84, 122, 184, 238–9
Clarence Terrace 83, 123, 184, 251–252
Clutton, John 132
Colosseum 75, 84–5, 121–2, 141, 144–5
Cornwall Terrace 73, 81, 84, 123, 184, 226
Cromwell, Oliver 26–7
Crown Estate Paving Commission 225–6
Cumberland Market 101
Cumberland Place 184
Cumberland Terrace 83, 122, 184, 187, 189, 233

Denny, Sir Anthony 22
Derby Arboretum 155–6
De Sandfords 18
de Soissons, Louis 184, 186–9
Diorama 75, 85–6, 144
Doric Villa 99

Edgar, King 18
Edward VI 23
Elizabeth I 24
Elmes, James 76, 80, 85, 94–7
English Gardens 140, 210, 211, 222

Faber, Dr Oscar 185
Farrell, Terry 215–7, 221
Finsbury Park 161–3
FitzStephen, William 18
Fordyce, John 32–4, 37–9, 50
Forsett, Edward 24

George II 36
George III 36, 59
George IV 37, 103
Gloucester Gate 143, 184, 234
Godfrey, Sir Edmund 245
Goetze, Sigismund 93, 191, 194, 236–7
Gorell, Lord 183, 185, 186
Green Park 11, 35, 51, 128, 149, 152
Greenwich Park 12, 35
Grove House 76, 82, 92–4

Hampton Court 21
Hanover Gate 82, 100
Hanover Lodge 76, 82, 95, 213
Hanover Terrace 73, 82, 177, 184, 255
Henry VII 18
Henry VIII 14, 21, 23
Heritage Lottery Fund 219
Hertford Villa 82

Hobson, Thomas 19, 20, 22
Holford House 76, 82, 99, 177, 183, 190
Holme, The 75, 76, 87–8, 190, 206
Hornor, Thomas 84
Hyde Park 11, 21, 25, 35–6, 51, 81, 128, 149, 152, 229, 246

James I 24
Jenkins and Gwyther 70, 105

Kemp, Edward 124
Kennington Common 153
Kensington Gardens 12, 35, 199
Kent Terrace 82, 184, 188

Leverton and Chawner 39, 41, 50, 51
London Central Mosque 135
Loudon, J. C. 36, 131, 132, 154, 155, 165, 199

Mary Queen of Scots 23
Marylebone Gardens 30, 35
Marylebone Park 14, 22,

23, 25–77, 30–1, 33–5, 38, 50, 53, 59, 150
Mayor, Charles 67
Middlesex Forest 14
Morgan, James 44, 66

Nash, John 13–128, 149
Nesfield, Markham 135, 136, 140–1, 149, 210–1
Nesfield, William Andrews 130–3, 141
Nesfield, William Eden 131
Nonsuch 21
Nuffield Lodge 94, 213

Open Air Theatre 178–81, 193, 208
Osborne, Sir Thomas 28

Palladianism 41–3
Park Crescent 184, 187, 188, 189
Park Square 72–3, 188
Park Terrace 82
Park Village East 102, 213
Park Village West 102, 213
Parris, Edmund Thomas 84, 145
Payne Knight, Richard 45
Pennethorne, James 159
Perceval, Spencer 52, 58–9

Picturesque 39, 42–43, 45, 60–1, 75–6
Planting 67–71
Portland, Duke of 31, 32
Poynter, Ambrose 82
Price, Sir Uvedale 45, 131
Primrose Hill 135, 160, 189, 191–3, 156, 207, 217, 222–3, 230–1
Prince Regent 48–9, 59–60
Public Park Assessment 200

Queen Mary's Rose Garden 93, 208, 236

Readymoney, Sir Cowasji Jehangir 143
Regent's Park canal 57–8, 67, 101–2, 190, 213
explosion 146
Regent's Park landscape 105–10
Repton, Humphry 45, 55
Royal Botanic Society 108–19
Royal Parks Agency 219, 221, 225, 229
Royal Parks Review 215–6

Savage, Thomas 24
Select Committee for Public Walks 151

Skating tragedy 145
Slaney, R. A. 151, 152, 155, 156, 158, 165
South Villa 91–2, 171
St Dunstan's Villa 97–8, 176, 177
St James's Park 11, 35–6, 47–8, 51, 149
St John's Lodge 73, 89–91, 98, 177, 207, 211–12, 237, 268
St Katharine's Hospital 82–3, 183, 190–1
Strode, Sir George 25, 27
Sussex Lodge 100, 189
Sussex Place 73, 81–2, 184, 187
Sydney, Sir Henry 23

Terry, Quinlan 214
Toxophilite Society 106–7, 178, 207, 230
Tree Committee 192, 194
Tyburn 18, 19, 20, 21, 22, 23, 25

Ulster Place 184
Ulster Terrace 184
Victoria Park 143, 149, 155, 158–9, 162–3, 167

Wandesford, John 25, 27

Webb, Colonel William 26
Webster, A. D. 169, 172–3,
 176, 201, 208, 241–2,
 245–9
Wells, H. G. 177, 251,
 255–6
Westmacott's Swan Fountain
 143
White, John 32, 33, 34, 63–4
William of Normandy 18
Wyatt, James 49

York Gate 107, 184, 187,
 188, 189
York Market 101
York Terrace 73, 75, 80,
 99, 131, 177, 184, 187

Zoological Gardens
 119–20, 182–3
Zoological Society 82, 105,
 119–20, 181–2, 193

Also available from Amberley Publishing

TYBURN

The Story of
London's Gallows

ROBERT BARD

Also available as an ebook
Available from all good bookshops or to order direct
Please call **01453-847-800**
www.amberleybooks.com

Also available from Amberley Publishing

*Everyday life in the teeming metropolis during Pepys's time
in the city (c. 1650-1703)*

'A fast-paced narrative with a real sense of history unfolding' GILLIAN TINDALL

Samuel Pepys's London was a turbulent, boisterous city, enduring the strains caused by foreign wars, the
Great Plague and the Great Fire, yet growing and prospering. The London of Wren, Dryden and Purcell was
also the city of Nell Gwyn, an orange seller in the theatre who became an actress and the king's mistress; of
'Colonel' Thomas Blood, who attempted to steal the crown jewels from the Tower and yet
escaped punishment; and of Titus Oates, whose invention of a Popish Plot provoked a major political crisis.

£10.99 Paperback
146 illustrations
256 pages
978-1-4456-0980-5

Also available as an ebook
Available from all good bookshops or to order direct
Please call **01453-847-800**
www.amberleybooks.com

Also available from Amberley Publishing

— BRIAN GIRLING —
LOST LONDON
IN COLOUR